KAREN MAHONY

# THE
# VICTORIAN ROMANTIC
# TAROT

*This book is for Asa, with love.*

MAGIC
REALIST
PRESS

A Magic Realist Press Publication
(the Magic Realist Press is an imprint of Xymbio Ltd.)
6-9 Bridgewater Square
Barbican, London, EC2Y 8AH
United Kingdom

Written and designed by Karen Mahony.
Illustrated by Alex Ukolov, baba studio.

baba studio
Břetislavova 12
Mala Strana
Prague 11800
Czech Republic

www.victorianromantic.com
www.magic-realist.com
www.baba-store.com
www.fairytaletarot.com
www.fantasticmenagerie.com
www.bohemian-cats.com
www.tarotofprague.com

Printed and bound in Prague by Omikron, Czech Republic.

British Library Cataloguing in Publication Data.
A catalogue record for this publication is available from
the British Library.

ISBN 1—905572—02—6

# CONTENTS

# AKNOWLEDGEMENTS

We'd like to thank the following people who have kindly and patiently given support and encouragement.

First and foremost Chris Blair, for some sharp editing and good laughs.
Rachel Pollack, especially for her patence, her art and her ardor.
Diane Wilkes, for unflagging interest and pertinent questions.
Monicka Clio Sakki Rafaeli, for understanding the crazy journey.
Many, many Live Journal friends, for their liveliness and sense of fun.
Aeclectic Tarot Forum, always a source of inspiration and learning.

We also have to thank our senior cat Minnie, who has supervised every stage of the book, purring all the way and only occasionally lying on the keyboard by accident.

# INTRODUCTION:
## *The Victorian Romantic Tarot*

When Alex and I first decided to do this deck, we were driven, quite simply, by finding a remarkable old edition of a book of art engravings published in Germany in the late nineteenth century. Looking through the very dusty pages, we were excited by the pictures that we found there. So much of the work we saw had been largely overlooked or even denigrated by formal art history. Neither Pre-Raphaelite or Impressionist, it mostly fell into the categories of Victorian genre painting, or Victorian Classicism, which is nowadays quite unfashionable. Yet it was often done with extreme technical skill and, it seemed to us, with narrative flair too. These were paintings that, first and foremost, told stories.

We found many images that reminded us of traditional tarot symbolism—The Devil, The High Priestess and The Hermit were all there in the pictures. But also there were scenes that Pamela Colman Smith, artist of the 1909 Rider Waite Smith cards, might have recognised from her own Minor Arcana images—everyday people in houses, streets and gardens, knights and queens of past cultures, figures of myth and more mundanely, circus, sideshow, masquerade and theatre people. It was quite a mix, a spectrum of the imagery that interested and inspired the nineteenth century. It was exciting to realise that these were exactly the kind of pictures that Arthur Waite and "Pixie" Smith, the designers of the RWS, would have been completely familiar with; European salon art at its most accomplished and popular.

So we began searching and collecting, gathering as many books as we could find that contained high quality engravings from this period. As we gradually unearthed material—mainly published in Germany, the Czech Republic and England, although the artists were from all over Europe and the USA—we got more and more enthralled by the possibilities of the deck. We found engravings that were emotive, gorgeous and memorable, and as we began making them into sketches for the cards, we realised how strong this deck could be in cartomantic readings; these images not only spoke, they sang, laughed and cried. Their realism was easy to relate to, but could be provocative and unsettling, as well as captivating and charming.

As with the making of any tarot, there have been a lot of decisions to make along the way—for instance we found many pictures of children that might have fitted the Six of Cups, and numerous beautiful couples suitable for The

Lovers. We made our final choices based on both the strength of the image and its theme and—so that the deck would be easy to learn—its relation to the traditional Rider Waite Smith structure that this deck follows. Sometimes we changed our interpretation considerably from the original scene that the picture illustrated; our Knight of Pentacles, for example, does not require knowledge of the scene in the *Faerie Queene* poem that it depicts. Other times we adapted the image substantially to make it fit our intention for a card, combining images from many engravings and always remembering that tarot is first and foremost a working tool for divination, meditation and, arguably, fortune-telling. As with all our decks, we designed so that there is a balance between beauty and usability, tradition and new ideas, the demands of the theme itself and the requirements of the familiar tarot structure.

### Nineteenth century art: sensible or sensual, prim or passionate?

The art that we found ourselves working with wasn't at all the prim and proper, "buttoned-up" stuff that many people now associate with Victorian popular illustration and advertising. The reality is that nineteenth century art in Europe and America was often highly sensual and even, at times, salacious. We discovered many images that were passionate and highly charged. Some were gorgeous, lavish, sensual and celebratory; others, sadly, were voyeuristic and depicted women as objects rather than people. Artists and critics of the time tended to be rather defensive about this, and luminaries such as Philip Rathbone, Chairman of the British Architectural Association, wrote learned papers with titles like, "The Mission of the Undraped Figure in Art" that set out to explain that such work was entirely respectable, morally uplifting and, most important of all, not at all titillating. Nevertheless, one only has to look at some of the images—male as well as female (though naked young women in a passive position are a far more common subject than unclothed men are) to see that there was a great vogue for showing attractive, mostly female, nudes in as alluring a way as possible. Robert Browning, a genuine champion of women and their rights, wrote a poem about the obvious hypocrisies:

*She.* Yet womanhood you reverence,
So you profess!
*He.* With heart and soul.
*She.* Of which fact this is evidence!
To help Art-study,—for some dole
Of certain wretched shillings, you
Induce a woman—virgin too—
To strip and stand stark-naked?

*He.* True.

*She.* Nor feel you so degrade her?

Robert Browning, "The Lady and the Painter"

This presented us with another whole set of questions that we needed to address. We loved the sensuality of nineteenth century art at its most glorious and luscious—but we didn't want to fall into the trap of what one modern art historian [Richard Jenkyns, *Dignity and Decadence*] has called the "bourgeois pornography" of presenting women as objects and victims. Our answer was to include several beautiful images of lightly-dressed women, nymphs, fairies and mermaids, but avoid any whom we felt looked victimised; except for one, the bound slave-girl in the Eight of Swords card. In this case her apparent passive willingness to remain enslaved is a necessary part of the card's meaning.

We've also been pleased to use several strong pictures of confident, independent-looking women. Our Queens of Swords and Wands give the impression of being entirely in control of their own lives and destinies, while the show-girls of the Four of Wands are joyfully outrageous. As for The Devil, well, in this deck she's shown as a woman, and a dangerously attractive one, no helpless girl this!

Beyond issues of the depiction of women, and how they show women's changing role in the nineteenth century, there is much else in this deck that reflects the huge developments, shifts and alterations of both lifestyle and thought that made up this era. Those who lived in the nineteenth century tended to regard it as a time in which science overcame superstition and fact reigned over fantasy:

> Between the mother, with her fast-perishing lumber of superstitions, folklore, dialect, and orally transmitted ballads, and the daughter, with her trained National teachings and Standard knowledge under an infinitely Revised Code, there was a gap of two hundred years as ordinarily understood. When they were together the Jacobean and the Victorian ages were juxtaposed.
>
> Thomas Hardy, *Tess of the d'Urbervilles.*

Yet, the fact is that the nineteenth century, time of the industrial revolution, scientific discovery and profound technological development, also saw a revival of interest in all things Gothic and, in Sigmund Freud's phrase, "The Uncanny". Classic Gothic Revival novels including Mary Shelley's *Frankenstein* (1818), Robert Louis Stevenson's *The Strange Case of Dr. Jekyll and Mr. Hyde* (1836), Edgar Allan Poe's *Tales of the Grotesque and Arabesque* (1839) and, most famously of all, Bram Stoker's *Dracula* (1897) were all the products of the

nineteenth century. This fascination for the supernatural and uncanny can be seen clearly in the images that we've used for cards such as The High Priestess, The Magician and the Nine of Swords.

Besides the Gothic, however, a list of just a few of the subjects mirrored in nineteenth century art—and hence in our deck—could include:

- The Arts and Crafts movement, the romanticising of the medieval age.
- Victorian Classicism, idealisation of the ancient Greek and Roman eras.
- Monarchism versus revolutionary movements.
- The craze for all things Egyptian.
- Industrialisation—and its mirror-image, rural romanticism.
- The growing sentimentalisation of childhood.
- The rise in popularity of circuses and sideshows.
- Freud and psychoanalysis.
- Attitudes to marriage and relationships between men and women.
- Questions around wealth; riches, poverty and charity.

It's a rich and wildly varied mix, ranging from issues of fundamental social changes to comparatively trivial trends and fashions, and the cards reflect this. Of course, you can happily ignore the social history and just read the deck from the pictures; that's not only valid, it's actually sometimes a good decision when using cards with such strong imagery as these. But I hope that as you read this book, some of the nineteenth century associations will add a further depth—or simply some interest and amusement—to your use of this tarot.

Finally, it's worth just briefly remembering that in the nineteenth century books about cartomancy and fortune-telling were popularly considered a dangerous influence, as this scene from *Tess of the d'Urbervilles* illustrates:

> Tess, ... went first to the outhouse with the fortune-telling book, and stuffed it into the thatch. A curious fetishistic fear of this grimy volume on the part of her mother prevented her ever allowing it to stay in the house all night, and hither it was brought back whenever it had been consulted.
>
> Thomas Hardy, *Tess of the d'Urbervilles.*

However, I hope that nowadays the only danger that lies in this book is that it might be read as giving the only definitive and "correct" way to work with *The Victorian Romantic Tarot* cards. The truth is that the meanings and descriptions

here are intended merely as a guide to prepare you to start out on your own journey with these cards. I hope you'll go far in exploring for yourself the abundant, nostalgic and evocative imagery of *The Victorian Romantic Tarot*. This is a deck that will respond fully to an intuitive, exploratory approach.

## A note about the structure of this companion book.

I've designed this book to be as usable as possible, whether you are an experienced tarot reader or a complete beginner. For each card there are keywords and phrases that will initially get you off to a quick start, and later, once you're familiar with the deck, they can be used to jog your memory.

I've also included a short list of suggested meanings for reversals (cards that appear in a spread upside down). Reversals are notoriously variable in interpretation depending on their placement in relation to other cards, so please take my suggestions as just that—suggestions rather than firm definitions. Mainly, what you need to know about reversals is that they should alert you to look at a card with a different perspective than usual. Contrary to popular opinion they aren't always negative, they do, however, indicate that a slightly "topsy turvy" way of interpreting the card should be considered. If you decide to use reversals—and you don't have to—the most important thing is to enjoy the perception, depth, and even, on occasions, humour that they can add to a reading. Don't be intimidated by a reversed card but see it instead as an invitation to use your intuition in a quirky or imaginative way.

There is also a longer discussion piece for each card that may spark some new associations for possible interpretations. I've often included a short quote or reference to a nineteenth century association for the card correlation or image, as these can open up some slightly less obvious ways of thinking about it.

Finally, there is some brief information about the source of the imagery. These vary greatly in their level of detail as some of the original artists are famous while others are now quite unknown. I hope, however, that they will provide at least a starting point for more research into any artists whose images particularly appeal to you. Please do bear in mind though that many of these cards have been substantially recomposed (in some instances from as many as four or five different engravings) so you may find many of the original images significantly different from our cards.

# A SHORT HISTORY OF TAROT

A secret magical system from ancient Egypt—a way to hide the Templar's arcane knowledge in the form of a pack of cards—old, mysterious imagery brought to Europe by the gypsies centuries ago? All these have been proposed as the origins of tarot. The rather mundane truth is that the tarot, as far as we can tell from the available historical facts, only began to be seen as a popular device for cartomancy (divinatory reading with cards) in the late eighteenth century. Before that it was mainly used simply for playing a game involving trump cards, a little like modern-day Bridge. The origin of the word "tarot" is itself obscure but it may well be derived from the Italian verb "taroccare" which means "to reply with a stronger card", as the game was essentially designed around the twenty-two trumps.

There is some evidence that tarot was also used for parlour games of fate and fortune, such as describing people's characters, (these were called *tarocchi appropriati*). It is thought too that playing cards were used for divination as early as 1487, so it's likely that tarot cards—as one form of playing cards—were also used to some extent. But the tarot deck was not seen as especially or uniquely tied to divination until Etteilla (Jean-Baptiste Alliette) and Court de Gébelin, both French late eighteenth-century occultists, assigned divinatory meanings to the cards, and gave them a romantic occult history for which there was probably no factual basis. It was Antoine Court de Gébelin who was largely responsible for the idea that tarot was Egyptian in origin and incorporated Egyptian occult symbols and ideas. But even more significant to the history of the esoteric tarot was Etteilla, who first published astrological correspondences for the cards, assigned links to the four elements, and made the first tarot deck designed (in fact significantly redesigned) especially for cartomantic use. This opened the way for a popularisation of the use of cards—both tarot and oracle decks—for divination and fortune-telling in nineteenth century Europe.

In the nineteenth century the use of cards for divination became relatively well-known as a part of the great "occult revival" that took place at this time—perhaps as a reaction to the Enlightenment period that preceded it. James Webb, a twentieth century historian who specialised in the history of the occult, has lamented that, "after the Age of Reason came the Age of the Irrational." (*The Occult Underground*). Maybe we could more kindly say that after the Age of Reason came the Age of Intuition and Magic—it all depends on your point of view. What's certain is that there was an explosion of interest

in many aspects of Hermeticism, magic, alchemy and all things occult and esoteric during this time, and cards, including tarot cards with their wonderfully evocative imagery, became a fairly popular device for divination in some parts of Europe.

In the early twentieth century this growing interest resulted in the publication of an enormously influential set of cards now known as the Rider Waite Smith (RWS). This was developed by Pamela Colman Smith (who did the paintings) and Arthur Waite, and published by Rider in 1909. Waite and Smith were members of the Golden Dawn esoteric society (the poet W. B. Yeats was another well-known member who probably advised on the design of this tarot). Like most traditional tarots the RWS deck consists of twenty-two trump cards (the twenty-two cards used in the game of tarot to trump other cards) and fifty-six others divided into four suits: Wands, Swords, Cups and Pentacles (originally known as Coins or Discs), each with four Court cards (Page, Knight, Queen and King). But the RWS cards differ fundamentally from nearly all of the earlier tarot decks because every card is fully illustrated with a picture that depicts an evocative scene or story. This was the first 78-card occult tarot deck to put pictures on the lesser cards in this way and this made it relatively easy for a beginner to understand and memorise their meanings. Waite and Smith also changed the names of some of the trumps and reordered them slightly. Because this was a deck designed for cartomancy and not for game playing, the ordinary suit cards were termed the "Minor Arcana", and the "trumps" were called the "Major Arcana"—Arcanum means "secret" in Latin.

The appearance of the Rider Waite Smith deck further popularised tarot. Arguably this popularisation meant that "divination", which originally meant a way of making contact with the divine, became generally regarded as meaning merely fortune-telling. In fact, by 1920, Jessie Weston was writing, "Today the Tarot has fallen somewhat into disrepute, being principally used for purposes of divination." (*From Ritual to Romance*). It wasn't really until the 1970s that tarot began to be explored and discovered in much more psychological and therapeutic terms, as a means for self-analysis and exploration. Even more recently, since the opening of this century, some serious tarot scholars and readers have begun to revive and reform the idea of tarot used for divination—looking at what a "conversation with the divine" might actually mean, and questioning the idea that we must necessarily focus on psychology and reject any notions of contact with spiritual mysteries when using the cards. It looks as though the next chapter in the history of the tarot will be an interesting one indeed.

To return to more mundane matters however, I should add that the RWS has become the most popular model for modern tarots—probably mostly because its use of illustrations for every card opens the possibility for evocative and imaginative card design and highly intuitive image-based card readings (more of this in the section on "Reading with the Cards"). *The Victorian Romantic Tarot* broadly follows this system, although with significant, and I hope thought-provoking, variations.

# LEARNING THE TAROT

There are many approaches to learning tarot, and many good courses available, online and in book and seminar form. The first step is always the same though, simply to get to know the cards and the range of interpretations that can be applied to them. This doesn't just mean reading a book, or books, and memorising the meanings. It also means finding your own interpretations, and understanding the range of possibilities that you feel comfortable applying in your readings.

At first, this can look like a daunting task. Seventy-eight cards may sound a lot, especially as each has a number of possible meanings depending on where it appears in a spread and, of course, the question being asked. However, don't be put off by all this, learning the cards isn't nearly as difficult as it might seem.

Firstly, the principal meanings of the Major Arcana often relate very closely to their names (though the names shouldn't be taken too literally, e.g. the Death card is not usually about physical death). As these twenty-two cards are very distinct from each other, and have very separate and clear meanings, it isn't too hard to acquire a basic understanding of all of them.

The easiest way to familiarise yourself with the fifty-six Minor Arcana cards is to remember that they are grouped in various ways. Firstly, each suit has particular characteristics that apply to all the cards in that suit (summaries of these are given at the beginning of each suit). You will also find that cards with the same number will have some similarities. I've devoted a separate section to reading the Courts, but for now, in summary, here is a brief outline of the main characteristics indicated by all of the suit cards:

**King.** Social and family responsibilities. Self-confidence, power and authority. Success, authority, maturity, discipline. Self-restraint, sometimes self-sacrifice.

**Queen.** The qualities of the suit at their best and most balanced. Creativity, moderation, tolerance, openness and sensitivity to others. Real-world wisdom. Practicality mixed with compassion. Intelligence mixed with sensitivity.

**Knight.** Energy, drive, forcefulness and responsibility—in certain contexts the Knights can indicate a lack of these qualities rather than an abundance of them. Action and impetuosity. Self regard, showiness, display.

**Page.** Discovery, including self-discovery. Exploration, study, enthusiasm and keenness, risk-taking, beginnings, news and messages. The beginning of learning and study. Issues around experience and effectiveness, both of which may be a little lacking.

**10.** The completion and strongest expression of the characteristics of the suit—for better or worse. Ending a phase or an activity. Preparing to go to the next stage. A peak or trough. A summation or an ending.

**9.** An awkward time. Compromise, struggle, burdens. Growth and maturation through experience, though this process may be harsh.

**8.** Movement, speed and change—or being held back from these. Collecting ideas and tasks. Events, ideas, opportunities—all happening at once.

**7.** Victory, recognition, individuality and a period for making important choices. Maybe some confusion associated with choice.

**6.** Communication and social responsibilities. Doing the right thing, even if it's not the easy option. Transitions of a relatively minor sort.

**5.** Loss, conflict, challenges, hard choices. Fighting with yourself and others. Struggles both psychological and physical.

**4.** Structure, stability, caution, boredom, groundedness. Balancing security against risks, or excitement against conformity. Playing safe.

**3.** A strong expression of the suit—this can be good or bad. Issues and events that involve other people. Cooperation or conflict. Strong feelings of joy or sorrow.

**2.** Union, balance. Taking decisions between two distinct options. Dealing with emotional or physical forces that seem to be pulling in different directions. Trying to juggle or balance opposing desires and impulses.

**Ace.** Beginnings and new possibilities. Creativity, forcefulness, usually in a good way. Energy, opportunity, fresh starts.

These characteristics may seem very varied, or even in some cases contradictory. You'll find, however, that as you become experienced it will be clear which meanings are particularly indicated in each reading.

### Keeping a tarot journal

Keeping a journal is a great way to watch and record the ways in which your reading style progresses and changes over time. This can be on or off-line – the tarot "blog" has become increasingly popular recently and is a great way of also getting input and feedback from others. The process of journaling can be very simple, just a matter of writing down some notes about the spreads you try so that you can review your progress. The interesting thing is that you can see that over time your understanding of the "standard" meanings will improve and, just as importantly, that you will begin to develop your own intuitive interpretations and read in your own individual way. Good readings depend a great deal

on being able to recognise meaningful patterns and themes in a spread. You will gradually find yourself becoming more confident about choosing from the range of possible meanings so that the readings make sense and feel "right".

Another good way of practising is to draw one card each day (or once every few days if time is tight) and simply consider it in detail, writing down your thoughts as you go. *The Victorian Romantic Tarot* cards are quite narrative, many of them look like a scene from a story, and you may find it fun, and useful, to imagine the tale contained in each card. You will find that if you do this regularly over a period of time your knowledge will broaden and you'll also feel more confident as you develop your own relationship with the cards. This can add tremendously to the potential sensitivity and subtlety of readings.

The journal is a private learning tool, not something that has to be presented to others, so it doesn't have to be beautifully written or presented—though if you want to make it an artwork, then by all means do. Work in the way that makes most sense to you. If you like to sketch, scribble or add pictures to your journal (or links if it's online), that's great. For a physical journal do what you relate to best, whether that means using a cheap notebook or a very special and lavishly decorated volume. You can throw the journal into your bag to carry around with you, or keep it wrapped in precious fabric on a special shelf. It really doesn't matter as long as it's evocative and meaningful to you. Do what feels best—there are no rules, the only aim is to enhance and develop your own intuition and knowledge.

# READING STYLES, SPREAD STYLES

Formerly, none but courtesans here drew the cards; now, almost every female, without exception, has recourse to them. Many a fine lady even conceives herself to be sufficiently mistress of the art to tell her own fortune; and some think they are so skilled in reading futurity in the cards, that they dare not venture to draw them for themselves, for fear of discovering some untoward event.

Francis W Blagdon, *Paris As It Was and As It Is* (1803).

Nowadays there are many different styles of reading tarot. Some readers stick closely to the book meanings, others ignore these completely and simply look at the images on the cards in order to read intuitively—perhaps applying a unique meaning for cards in each reading. Other people develop their own standard meanings, which may or may not vary significantly from the traditional ones. Readers may also apply other systems such as numerology, colour theory, kabbalah, astrology and interpretations based on the elements associated with the cards. In this section I want to discuss some basics of reading, and also look at a range of spreads. If all this seems confusing, don't worry; it really isn't necessary to "enhance" tarot with many layers from different methodologies, and in fact it may even, for an intuitive, instinctual reader, be a drawback to do so. Begin with the interpretations given in this book combined with your own personal response to each card. I won't go into the use of additional systems here, but information on these is available in many books should the time come when you want to learn more about these—but please don't feel it's in any way obligatory or that it will necessarily make you a better reader.

## Introducing Spreads

A huge number of "spreads", or ways of laying out the cards for a reading have been developed. Some of these, like the Celtic Cross, are traditional and widely used, while others are much more recent and generally less known. The older traditional spreads have been well tested, and I think they tend to work well and give informative readings. However, many people question the usefulness of the Celtic Cross, particularly for a beginner, and find it rather complicated and vague. Whether you decide to use traditional or more modern spreads really just depends on what you feel comfortable and confident with. Don't feel you have to limit yourself to spreads that someone else has taught you, it can be a creative and useful exercise to design your own.

The best way to decide which spreads work for you is to try some out. Many people advise that you begin with some very simple spreads and then slowly progress to the more complex layout made up of many cards. If you are interested in seeing the wide range of spreads in use, looking at some of the online tarot forums is a good place to start. Many of them have whole sections in which spreads, old and new, are discussed. There are also some excellent books devoted purely to designing tarot spreads. To get you started, though, at the end of this section there are suggestions for sample spreads that you should find both useful and easy to use.

## Using a Significator at the start of a reading

> While in Cheltenham, Mrs. Byron consulted a fortune-teller respecting the destinies of her son, and according to her feminine notions, she was very cunning and guarded with the sybil, never suspecting that she might have been previously known, and, unconscious to herself, an object of interest to the spaewife. She endeavoured to pass herself off as a maiden lady, and regarded it as no small testimony of the wisdom of the oracle, that she declared her to be not only a married woman, but the mother of a son who was lame.
>
> John Galt, *The Life of Lord Byron.*

When I first read this (above), I was surprised that the fortune-teller saw Lord Byron only as a lame boy rather than a future famous poet, it's not the image that most of us have of him. So how do you see yourself, or how does your querent see him or herself? It can be very useful to begin a reading by considering this question. It isn't a once and only decision about identity; what we really want to know when we sit down to do a reading is how we perceive ourselves in the situation that we're currently asking about. Are we the person taking action, the one being acted upon, the hero or heroine, or just a bit-player in the drama? Are we aggressor or victim, leader or follower, teacher or student, lover or beloved?

One way of answering this is to begin a reading by asking the querent to choose a card to represent him or herself. This is called the Significator. It's intended to be the card that shows how they see themselves in the specific situation that they are asking about. There are many ways of picking the most appropriate card for this purpose. Some readers will ask the querent to pick a card at random, or choose any card that seems suitable (probably judging mostly by the picture on it). However, the most common method is to show the querent all the male Court cards if he is a man or boy, or all the female

Court cards if she's a woman or girl (in *The Victorian Romantic Tarot* you can use the Pages as either male or female cards). Sometimes it seems appropriate to take out only the Page cards for a boy, the Knights for a young or early middle-aged man, or the Kings for an older man. Similarly this means that you can select only the Page cards for a girl or a young woman and the Queens for an older woman. Personally, I prefer not to stereotype by age in this way, but many readers use this method. The querent is asked to look at the proffered cards and choose the one that they feel fits them at this particular time. They can do this simply by picking out the picture that seems most appropriate, you don't have to explain the tarot meaning of each card.

One big issue is that this is rather gender biased. After all, in a reading the tarot cards should not be taken to refer to a person of any particular gender, regardless of the person shown in the picture (e.g. The Magician and Hermit cards can refer to a woman, The Empress and High Priestess to a man). So why should the Significator card be chosen only from the Court cards that show a particular gender? It's a good question, and an interesting example of the way in which modern thinking is questioning some of the traditions of the tarot. In fact it's entirely acceptable (and nowadays the practice of many readers) simply to pull all sixteen of the Court cards out of the pack and present these to the querent, with instructions to choose one based only on intuition, rather than by whether the card happens to show a man or a woman. This often produces interesting results, and certainly gives the querent a good range of images from which to choose. Although the Significator takes no explicit part in most readings, it is well worth taking a moment or two to think about the card chosen, and perhaps to discuss it. This can give useful information about your querent's particular concerns, and help to reveal how they see themselves in their current situation.

### Seeing a pattern, making a story

The main issue in interpreting any reading is to be able to recognise and interpret significant patterns. If you approach a reading simply as a succession of separate cards, it can feel like a meaningless and contradictory hodge-podge. But when you can pull it together into a coherent pattern, meanings emerge and begin to make sense. Patterns can show themselves in a number of ways. I've seen readings that are mostly composed of a single suit, readings that contain a high proportion of Major Arcana cards, readings that have three of the Aces, or an unusually large number of Courts. All these can be read as being significant. When you first look at a reading you may sometimes get the feeling that it is a jumble of cards that doesn't say anything at all. But look

again, and begin to search for patterns. It can be quite surprising how these can leap forward and suddenly reveal some significance that was not apparent at first.

A few suggestions to help recognise such patterns:

- Look at the proportion of each suit in the spread. Are there an unusually high or low number of any one suit?
- Count the number of Majors, and number of Courts. Are the Courts mainly of one type, e.g. Knights or Queens?
- Are there a lot of suit cards of any one number? e.g. many Tens, or Fives, or Aces?
- Look at the pictures—are they making up a pattern? For example, which way are the figures and faces turned, do certain elements or colours seem to stand out or be repeated?
- Look at the pictures again—in detail this time. Is it possible that the same person appears twice? What about the places shown, do they tell you anything? Are the images set in the daytime or at night? Does a particular set of colours appear repeatedly, or a particular theme; perhaps there is a high proportion of mythic characters, or circus performers, or couples or...

Initially this might seem daunting; it sounds like an awful lot to have to take into account. But the idea isn't to try to use all of this in any one reading—these are just some possibilities to consider as you look over a spread. You'll find that some elements leap out while others don't, so go with your own hunches and intuition. There is no right and wrong in reading style, and in the end it mostly comes down to what your gut instinct tells you. Take a little time to scan the whole spread and see if any insights strike you. It's very useful to keep looking at the pictures—maybe you begin to notice that they seem to make up fragments of a story? What could the story be? What does it tell you? What do you *feel* about this reading?

## Beginning a reading

The S——'s came, and after dinner we began to tell fortunes and laughed almost as much as we did before, that is, the others did, but I could not. Then we poured melted wax into cold water (it is the shadow that is looked at). I had in succession a lion couchant with one of his front paws extended, holding a rose; isn't it odd? Then a great heap of something surmounted by a garland held by Cupids...

I looked with all my eyes, without stirring, almost without breathing. In the proper costume of night-gown and unbound hair. But everything was very vague; it quivered, danced, formed, and reformed every instant.

Mary J. Safford (translator), *Marie Bashkirtseff (From Childhood to Girlhood)*

Nowadays we see tarot less as foretelling fortunes and more as a way of reconsidering different aspects of a question and looking at future options. Fortunately, we don't usually do it in the "proper costume of night-gown and unbound hair"! But the amusing extract above does bring up a serious issue; many people who aren't familiar with modern tarot approaches still find the idea of a card reading—or any form of divination—frightening, occult and somehow likely to lead to dire consequences. They can be scared of seeing something "bad" in the cards. When you're reading, it's often good to bear this in mind, especially if you're working with a querent you don't know well. It can be useful to explain, at the beginning, that nothing that the cards show is inescapable fate; a reading merely presents some probabilities, and it's up to the querent to decide which of these to follow or avoid. I also like to state clearly that I read precisely what I see in the cards rather than giving my personal opinion. This is important as after all, the way the cards fall is the heart of what makes a reading relevant. Interpret the spread objectively and don't be tempted to override what you see in order to offer your own advice— it's not what the querent is asking for when they come to you for a reading.

The general instructions that I give here are only my preferred method. Many readers do things differently with equal success. If I'm using a Significator (I don't always), I place it on the table, and then ask the querent to put the other cards back into the pack. I then ask the querent to shuffle the cards well. While they are doing this, I suggest that they focus and think hard about their question and how it effects them. It sometimes helps if you point to the Significator card, if you're using one, and say something like "This is you. Please look hard at yourself and focus on what you want to know." Explain that they should keep shuffling until they feel the time is right to stop. At this point, ask them to cut the pack into three stacks and place each stack on the table (alternatively you can miss this out and just ask them to hand you the shuffled deck). Pick up the stacks in whatever order feels right to you (don't shuffle again) and lay out the spread. Personally, I lay it out face up, as I like to see the whole spread before I read any one card. However, some readers will lay out the cards face down and turn over the cards one at a time as they interpret them To me, this makes it harder to see the overall pattern, but others say it

has the advantage of allowing you to focus on each card as its revealed. As ever in tarot, try out different methods and go with what feels most effective to you.

As you work your way through the reading, do talk about it with the querent. Some people like to participate a great deal, others less so, but whenever possible, get some input and feedback as you go along, and make sure that the reading is being understood and absorbed. By the way, if your querent wants to make notes, this can be very helpful, and some readers will also tape a reading so that there is a record to refer to later if further questions arise.

## Reversals

Should you use reversals in a reading? In other words, should your interpretation take into account whether cards are laid out upside down in a spread? It's a constant source of debate among people who read tarot—and there is no right answer. People read well both with and without taking reversals into account; as with so much in tarot, it's very much a matter of personal style.

Reversed cards are popularly considered a "bad" sign but in fact an experienced reader will tell you that this isn't the case at all. Reversals simply indicate the need to take a different perspective on a card's more usual interpretation—often a reversal is simply advising the reader to look again and consider a wider set of possibilities. They can indicate a blockage, a barrier or simply a weaker presence—which means that a reversed Devil for example, may actually be read in a more positive light than normal. Perhaps it shows that temptations are there, but they're quite easily overcome? When a card is reversed try to see it in a fresh perspective—think through the range of possible interpretations of the card and recognise which of these may fit the context.

I've given suggestions for reading the reversal of each card, but they really should only be taken as a starting point. Reversals do tend to open up and even play with the meanings of a card, and so they are particularly variable. Take the whole context into account when a reversal comes up in a spread, and be prepared to go with your instinct. The only important thing to remember is not to automatically read a reversal as negative, it can be quite the opposite.

If all this seems complicated, don't worry. You can easily ignore reversals and read them in the same way as right-side-up cards—many people do this and still read superbly. But if you do embrace the idea of reading reversals with this deck, look at it as liberating rather than demanding. See it as a way of letting yourself explore the undersides and more hidden aspects of the cards. You may be surprised at what you discover.

## The Reader in a position of trust

Having talked about the practicalities and methods of reading, I'd like to add one crucial point. You will find that when you do any reading that is at all serious in intent, your words may be given a lot of weight by the querent. I've seen querents intently noting down everything said, and going over all aspects in the minutest detail. We've also all come across people who talk about how much a tarot reading they had years ago influenced their lives. Of course not everyone takes a reading this seriously, but in some situations it's treated as a lifeline for a querent, seemingly offering answers to problems that are unpredictable and overwhelming. If someone who you feel is in a really disturbed state approaches you for a reading, it may be best simply to say no as kindly as possibly. In other less drastic circumstances, when you nevertheless feel that the querent may be basing important decisions on the reading, do explain carefully that nothing is set in stone, and that a good reading simply shows a range of likely options, none of which are definite or fated to happen.

One last point finally. It's usually wise to turn down any reading where the querent is asking for legal, medical, financial or other critical information or advice that should come from a professional in the field. In such matters, it makes far more sense to advise them to see a qualified specialist and to use the reading for more general queries about the situation.

## Working—and playing—with the pictures

Tarot, like anything else, tends to go through phases in the popularity and fashion of certain styles of reading. In the late twentieth century it became increasingly common to see other divinatory systems added or applied to the cards; Hebrew letters (associated with kabbala), planetary and astrological attributions, numerology, crystal working and colour symbolism have all been used. Sometimes symbols of these other systems have been added by the tarot designer to the picture on the cards, other times they aren't shown visually, but are simply applied to cards during reading. There's absolutely nothing wrong with doing this; kabala, astrology and some forms of numerology have a long history of association to tarot (going back at least to the late eighteenth or nineteenth centuries), and newer systems also work very well for many people.

However, at their least helpful, these layers of attributions can become like a complex spreadsheet of meanings that readers may feel they are somehow obliged to learn and reel off. For some this is daunting, for others, stifling. So without suggesting that you throw away or ignore other systems, I'd like to urge you to try setting them aside at times—together with all the keywords in this book—and instead draw directly from your own intuitive feelings. It can

be a very liberating way of opening up your own instincts and insights. You can develop this more intuitive, personal approach by reading directly from the pictures, just by looking at them and allowing yourself to free-associate with whatever they bring to mind. Doing this can be delightfully playful, and since it doesn't demand that you learn anything by heart and there are no right or wrong meanings, it can also open up some ways of seeing and understanding the cards that you may be surprised and pleased by.

## Reading with *The Victorian Romantic Tarot*

A pack of cards is a book of adventure, of the kind called romances. It is so far superior to other books of a similar kind that it can be made and read at the same time... It is a marvellous work, also, in that it offers a regular and new sense every time its pages are shuffled. It is a contrivance never to be too much admired, because out of mathematical principles it extracts thousands on thousands of curious combinations, and so many singular affinities that it is believed, contrary to all truth, that in it are discoverable the secrets of hearts, the mystery of destinies and the arcanum of the future.

Anatole France, *The Queen Pedauque*

Drawing from an exceptionally rich source of imagery, there is a strength of story-telling and an emotional impact in these cards that makes this a reading deck with a distinctive and powerful voice. The pictures are emotive, funny, touching and wise by turns—and offer much to the reader who wants to explore layers of possible interpretation. If you are already familiar with tarot, you should find it easy to apply RWS interpretations to this deck, though I'd also urge you to combine them with intuitive readings based on your response to the pictures themselves. *The Victorian Romantic Tarot* is a good deck with which to try reading intuitively, as the images are particularly evocative and emotive, and also in many cases, visually echo one another in ways that can be delightfully illuminating.

# AMPLE SPREADS

The spreads I've given here are generally fairly short. However, if you do want to try out a classic like the eleven-card Celtic Cross it's very easy to find numerous versions of this in tarot books and on the web.

## The One-card Draw

Many people draw a single tarot card regularly, perhaps at the start of a day or a week, or simply when they want to quickly get an insight into a question. *The Victorian Romantic Tarot* cards work well for a one-card draw because their imagery is rich and allows for nuances and layers in interpretation. To draw, all you need to do is focus on your issue or question, shuffle, and pull a card out of the deck. Now you have a choice. You can either concentrate your attention on the card imagery and, perhaps, its "usual" interpretation in the RWS scheme (and if you go this way remember that the keywords in this book can be a useful stimulus) or you can go much further and more deeply into the card by looking at the image. The best way to illustrate this is with some examples:

What do I need to consider today?

How can I make this week go well?

It's late evening, what lessons can I draw about what happened during the day?

I'm seeing old friends for dinner tonight, I'd like some general advice about the meeting.

I have an interview with my boss this afternoon. What issues should I focus on?

## The Three-card Spread

This is a good beginner's spread as it is simple and straightforward. However, its use isn't just limited to beginners. Many people continue to use just three cards, often for "everyday" reading, finding the quickness and clarity appealing. The cards are laid out in a row – it doesn't matter if it's vertical or horizontal. Here are some alternative ways to read them (it's of course best to decide which you are going to use before you shuffle and lay out the cards). Between them they cover many of the issues one might ask about:

1. The situation underlying the question or issue.
2. Problems, or issues that may hinder.
3. Opportunities, or things that may help.

1. Body; the physical or material issues.
2. Mind; the intellectual or analytical factors.
3. Spirit; the spiritual or "soul" factors.

1. Self; how you are or how you see yourself in this situation.
2. My angel; the good influences you can build on.
3. My devil; the bad influences you should avoid.

1. Past, as it relates to your question or issue.
2. Present.
3. Future—remember that this is not a "prediction" so much as an indication of what you may need to think about.

## Five-card Spreads

Five-card spreads are also very popular. For many readers they seem to offer a good compromise between a very short spread – which almost inevitably lacks some detail – and one of the long, but sometimes rather complex layouts. In fact, the five-card spread is so useful that many readers, even experienced ones, will use it most of the time as their spread of preference.

There are many variations on the five-card spread – you will find a great number on any reputable tarot forum or online discussion group. Indeed, as you get accustomed to using five cards, you may well want to devise your own variation (inventing your own spreads is often a great way to come up with a method that really suits a particular situation well). I'm giving just one classic and one new variation on this spread here. The new one is the spread I devised for our first tarot deck, *The Tarot of Prague*, and it's particularly useful to use if you are considering making a distinct change or step forward in your life. It works very nicely with any deck.

First, though, a simpler classic five-card spread. This is good to use if you want to do a fairly quick reading that still covers most of the important information about a situation.

The cards are simply put in a row, horizontally or vertically, as you prefer:

1. Factors in the past that have influenced the situation.
2. Significant issues in the present.
3. Hidden or unconscious influences that should be considered.
4. Advice, and/or possible actions.
5. Probable outcome if the advice is followed.

## The Prague "Threshold" Spread

The Prague "Threshold" spread is a slightly more specialised five-card spread originally devised especially for use with our first deck, *The Tarot of Prague*. It can give insight when you are on the threshold of a significant change in your life. It focuses on the issues surrounding this step, and the probable outcome.

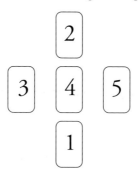

1. Where you are now. The current situation.
2. What lies on the other side of the gateway, i.e. the outcome of this step.
3, 4, 5. The gateway.
3 and 5. Issues you need to consider or actions you need to take (the two pillars of this gateway). The left-hand card (3) is more likely to refer to mental or intellectual processes, the right-hand card (5) to actions.
4. The influence that lies over the steps being taken (the lintel of the door).

## Two Spreads designed for use with *The Victorian Romantic Tarot*

It's fun sometimes to use spreads designed specifically for a new deck. I've therefore devised two simple spreads which work particularly well with the Victorian Romantic cards. The first is, appropriately enough, concerned with romance. The second is a more general spread. I've given examples of both spreads in use in actual readings.

## The Romance or Relationship Spread

This is quite a long spread that uses eight cards, but it's simple and straightfor-ward to interpret. In the layout here I've shown the spread as if it's being done by a woman asking about her relationship with a lover, but the genders should be changed according to circumstances, and the "me" of the example will naturally be changed to "you" when you are reading for a querent. It's also worth remembering that this spread does not have to be used for a romantic relationship, it also works very well if you want to examine a working partner-ship or a platonic friendship. You can see the suggested layout below.

1. My main role in this relationship.
2. My lover's main role.
3. The underlying fundamentals.
4. My hopes for the relationship.
5. His hopes for the relationship.
6. My worries about the relationship.
7. His worries about the relationship.
8. Advice for improving the relationship.

## Sample Reading using the Romance or Relationship Spread

This was a reading done for a woman who was in a generally good relationship that had been going on for some years. She wanted to explore the situation in general, rather than look at any particular issues. These are the cards:

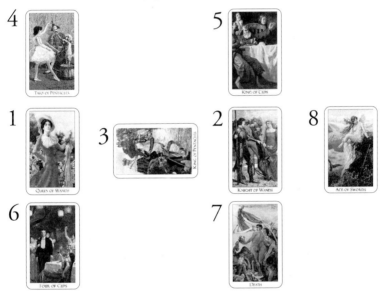

1. My main role in this relationship: **Queen of Wands**
2. My lover's main role: **Knight of Wands**
3. The underlying fundamentals: **King of Pentacles**
4. My hopes for the relationship: **Two of Pentacles**
5. His hopes for the relationship: **King of Cups**
6. My worries about the relationship : **Four of Cups**
7. His worries about the relationship: **Death**
8. Advice for improving the relationship: **Ace of Swords**

The combination of the Queen of Wands and the Knight of Wands is immediately interesting in these positions. It suggests that the relationship is fundamentally a good match, and one in which the woman may be the slightly more "senior" partner—she may lead this partnership and make many of the decisions. Both Queen and Knight of Wands tend to be active, energetic and attractive people, so this relationship is likely to have good physical compatibility and these two people both find each other appealing. They are also well attuned in terms of their active interests such as sport, travel or attending events. However, the Knight of Wands, particularly in this deck, is someone who may be inclined to have a series of love affairs, all of which he's sincere about at the time, but none of which he's fully committed to. There may be implied issues about faithfulness, although if anyone can keep the Knight faithful to herself, it's this Queen. His days of roaming may now be in the past, though this isn't certain.

There are a high proportion of Court cards in this spread. Courts tend to show the influence of a person or personality type, rather than a more general event or circumstance. The King of Pentacles as the fundamental underlying this relationship could therefore show someone—in this case a practical businessman type—who is playing a central part. In *The Victorian Romantic Tarot* the King of Pentacles is a bit trouble-worn and weary, though obviously prosperous and very comfortable. Maybe he represents the parent of one of the two partners in this relationship. Is he exerting a lot of influence somehow? Pentacles often concern money and materialism so there is a suggestion that the wealthy family background of one partner may be a very important factor in the whole relationship. Is this good or bad? This would be a good question to take further and explore.

The hopes for the relationship that the querent and her partner have are noticably different. Her card is the Two of Pentacles, which shows that she looks forward to being able successfully to juggle her various roles and responsibilities. His is the King of Cups, which indicates that he hopes to be able to give up his wilder creative dreams and settle into the position of the responsible, caring head of the family. What conclusions can we draw from this? On the positive side, both partners are looking towards the long-term. He is thinking about the days when he'll need to take on more duties and provide for a larger family, she seems to be hoping that she can combine the varied roles that will demand—possibly she is thinking in particular of managing the roles of wife, mother, career-person while still pursuing her various other interests. However, they do seem to be have two rather different ideas of the future, his

may be a more conventional one in which he sees himself as "breadwinner", while she clearly does not anticipate giving up activities such as her job and her hobbies. It might be good if they sat down and exchanged views on how they see their future together, just to ensure that there is a good understanding about this.

Their worries about the relationship should also be discussed as, again, these differ strongly. Whereas the woman is concerned that once they have achieved success together and appear to "have it all", she will become bored. Her lover wonders if the relationship may never get to that point, and worries that, on the contrary, it may in fact end, that the whole thing may "die" (an alternative reading is that he worries that it will make him fundamentally change his identity, although I felt that the simpler and blunter interpretation was the more likely one in this situation). So she sees stability, but wonders if it will be stifling, while he is insecure about the longevity of their partnership. It would be good to talk this over and see what can be done to deal with both sets of anxieties.

The advice card is the Ace of Swords. An interesting card to see at this point as it's about strong intellectualism and new beginnings. In our *Victorian Romantic Tarot* it shows a fairy sitting nonchalantly on a high cliff, so there is a touch of magic implied. My reading of this is that the woman querent should use her considerable powers of analysis and clear thinking to get this relationship off to a bright new start. It seems as though there is some general muddle and misunderstanding and what's needed is to cut through all this and be very clear about where the partnership stands and where it's going. Perhaps, like the fairy on the Ace of Swords, the woman should "rise above" all the hassle of everyday for a while and take some time to think things through. The Ace of Swords is a strongly positive card in most readings, so as an advice card it indicates optimism about this relationship. Clearly there are some issues in which these two partners may be at cross purposes, but it's equally clear that the way ahead is promising, if they clarify their thinking now.

## The Looking Back, Looking Forward Spread

*The Victorian Romantic Tarot* is a modern interpretation of historical pictures; when we were designing it we wanted to achieve an atmospheric, somewhat nostalgic deck that is nevertheless relevant to today's questions. So this spread, which asks us to look back, then forward from our current position, seems to suit the deck well.

This spread asks you first to look at aspects of yourself as you are now and as you want to be, and then to look at past experience as it may help or hinder

you. It's a very good structure for a reading if you suspect that there are things in your past that are holding you back or, alternatively, if you feel that some of the beneficial things you've learned are not being fully used. It uses six cards laid out as follows:

1. Where I am now.
2. Where I want to be.
3. and 4. Looking back:

> What I should take from my past.
> What I should leave behind.

5. and 6. Looking forward:

> What I should anticipate and plan for.
> How my past experience can help me in the future.

## Sample Reading using the Looking Back, Looking Forward Spread

This reading was done for a man who was an expatriate enjoying his new life but unsure of what might come next and what decisions, if any, he should be making about future plans.

1. Where I am now. **The Hierophant**
2. Where I want to be. **The Page of Wands**
3. and 4. Looking back:

> What I should take from my past. **The Hanged Man**
> What I should leave behind. **The Five of Cups**

5. and 6. Looking forward:

> What I should anticipate and plan for. **The Nine of Cup**
> How my past experience can help me in the future. **The Eight of Cups**

The Hierophant as the first card made a lot of sense as this man was a teacher by profession. In *The Victorian Romantic Tarot* this card shows an authoritative but very friendly tutor working with two pupils. This seems straightforward in interpretation and clearly confirms that the role of teacher is important and central to this querent's self-identity.

The Page of Wands as the indicator of where he wants to be is more surprising and opens up some provocative questions. The image shows a cheeky, confident young Page who clearly expects to be the centre of attention. It seemed to point to the querent wanting to throw off some of his responsibilities, be more lively and "showy" for a while, and perhaps start some new activities in his life. This particular Page can often signify news and messages, and I did wonder if this querent was rather bored and wanting some news that would liven things up. He may also want to relive certain aspects of his energetic youth. Certainly, it points to someone who wanted to find ways of being a learner and pupil rather than always being the teacher.

The Hanged Man indicates a period of stillness, contemplation and a degree of self-sacrifice. Clearly this querent had gone though such a phase and has now learned from it. The reading advises him to meditate quietly on the memory of this—it will prove valuable to him.

Looking at the next cards, however, we see that he should leave behind a certain tendency to look on the down-side of things or to dwell on a loss. Significantly, the Five of Cups and the Eight of Cups (the card in the sixth position in this spread) have a strong visual similarity in this deck, and so the interpretation is clearly that the sense of loss that seemed so hard to deal with in the past should teach him in the future to know when to walk away from a situation. It's probable, though not certain, that this is about relationships (both these cards in this deck specifically depict issues around a love affair). Generally the advice is not to end up in the same situation again.

What should he plan for? The answer indicated is simple and cheerful. He should anticipate the ability to fulfil basic, straightforward wishes—going out for a meal, seeing friends, spending some time in the pub; nothing complicated. In fact, this particular querent did like to go to a regular bar and would often sit on his own, working or chatting to people who happened to be there. The image on the card shows someone on his own at a pub table, gazing into his tankard and seemingly quite content. It seems as though the future, for our querent, is going to be "more of the same" and probably this is no bad thing.

# THE MAJOR ARCANA

The twenty-two cards of the Major Arcana tend in many ways to be taken more seriously and to be given more importance in an interpretation of a reading than the Minor cards. This is because they are seen as powerful archetypes, that is, representations of an idea or a concept rather than of more mundane events in everyday life. The Majors are therefore usually given spiritual as well as mere "fortune-telling" significance. They are taken, in a reading to refer to the transforming and significant shifts in our lives, and to higher aspirations and influences.

Arthur Waite talked in his seminal book *The Pictorial Key to the Tarot* about the "higher intention" of the Major Arcana and it's often said that only these cards go beyond the rather day-to-day issues of past, present and future actions to address the underlying meaning and purpose of life.

Originally, when tarot was played as a game like Bridge (which in fact it still is in much of Europe) the order of these cards signified which could "trump" the other—i.e. which was of more value. The sequence went from the first card, The Magician, at the bottom of the hierarchy, to the last card, The World, at the top. The Fool was a "wild card" that did not have a fixed place in the order.

It's common, even fashionable, nowadays for people to think of these twenty-two cards in a different way, as a sequence showing a philosophical and spiritual progress through life, "The Fool's Journey". However, others would argue that this is a modern invention that may not work for every reader. We don't number our Major Arcana cards and would encourage you to decide for yourself whether you want to interpret them according to number and sequence, or to take them as individual cards whose meaning reflects the nuances and influences of whatever cards fall around them in each reading. Neither is right or wrong, better or worse..

# THE FOOL

## Keywords and phrases

Foolish wisdom • Chaos and freedom • Taking a risk that looks silly • Stepping into the unknown • Trusting in fate and fortune • Throwing yourself into the arms of luck • A leap of faith • Fortune favours the innocent fool.

## Suggestions for reversals

Inability to take a risk • A risk that does not pay off • Foolishness or stupid actions • Throwing caution to the winds in a very small way.

THE FOOL

The Fool is a card that has changed its meaning over the years, and still continues to change. Like the Death card, The Fool seems to cause endless debate. Originally, in early cards, it probably simply showed a madman, someone wandering aimless and homeless, a figure of pity, fun and derision pursued by yapping dogs. But madness and spiritual enlightenment are often closely associated, and as time has gone on, the Fool of tarot has come to be seen as the personification of blind trust and foolish wisdom, someone who takes silly risks—and not only gets away with this, but actually benefits from it, sometimes in spiritual ways.

When we were working on our *Fairytale Tarot* I realised that the character on this card is seen again and again in fairytales. He (or occasionally she) is usually the third child, the one who is thought to be a simpleton, yet the only one to succeed in some impossible quest that's set. This success comes simply (and the pun is intentional) because she or he trusts the various unlikely helpers encountered on the way, and instantly opens up to them, shares with them, and follows their eccentric and risky instructions. Crucially, he is outside normal society—perhaps even ridiculed—and this isolation and "otherness" is precisely what allows him to break the rules and ultimately achieve the impossible.

The court fool—the jester or buffoon who was so lowly and unthreatening that he alone was allowed to speak truth to the nobleman or monarch whom he served—is one of the earliest forms of clown in the West (in fact, nearly all cultures manifest some equivalent to the fool or jester role). He too, was so

much a loon and social outcast that he was allowed to ignore the normal rules of hierarchy and respect. Later, especially through the influence of Comedia Dell'arte—the Italian "theatre of humour" that featured distinctive costumed clowns—the clown changed and became more standardised into a few distinct types.

The type of clown shown on our card is a "white-face", who wore neat make-up (similar to that of a mime artist today) but outrageous clothing. The white face pretends to be foolish, but is actually highly skilled in acrobatics—he makes spectacular tumbles and somersaults all look easy. Here, he's in the classic pose of the tarot Fool—about to step blithely off a height. In this case though, he is on a small platform, not a cliff as shown in the traditional image, and we know that if he falls off he simply will display some acrobatic antics before bouncing back. The crowd are obviously enjoying the performance, but at the same time they would, in the nineteenth century, have regarded the clown as pretty much an outcast, as this scene from Dicken's *Hard Times* demonstrates all too well, as the heroine finally reveals the awful truth about her background:

> 'We travelled about the country, and had no fixed place to live in. Father's a;' Sissy whispered the awful word, "a clown".
>
> Charles Dickens *Hard Times*

Yet as someone outside society, the clown or jester was able to both say and do things that others simply couldn't get away with.

When this card comes up in a reading it can tell you that this may be the time to take what looks like a foolish step into the unknown, or to act like someone unconstrained by the normalities of respectable or polite behaviour. You might choose to try out some new work or hobby that will seem crazily unconventional to others. Or you may dress much more outrageously than usual, or decide to try out a wild new haircut. In more serious matters, The Fool can advise you to follow your heart and do something that you really desire, even if it doesn't seem logical or sensible. Remember though that everything should be done in a spirit of fun, not with wilful self-indulgence or in a way that might hurt others. With this in mind, this card tells us that if we take a risk in the right spirit of playful clowning, or joyful innocence, it will probably all work out.

## Sources

From an engraving based on a painting by Viennese artist, Otto Walter (1853-1904).

> CIRCUS, n. A place where horses, ponies and elephants are permitted to see men, women and children acting the fool.
>
> *The Devil's Dictionary.*

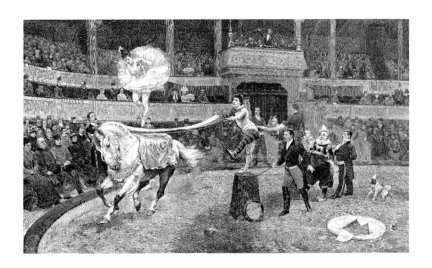

# I THE MAGICIAN

## Keywords and phrases

Brilliance, wizardry • A spark of inspiration • A flash of creativity • Trickster and performer • Magic at your command • Alchemical transformation • Acquiring the ability to do almost anything, but there are risks attached.

## Suggestions for reversals

The trickster side comes to the fore
• An inspiration that doesn't last long
• Creative abilities that are slightly frustrated
• An attempt to do something transformational that does not quite work out.

THE MAGICIAN

Our Magician card shows Doctor Faust sitting in his laboratory, surrounded by the accoutrements of magic and alchemy—among them a skeleton, a bellows, strangely shaped vessels, a globe and a chalked pentacle on the floor. It's believed that the literary figure of Faust was based on one Dr. Johann Georg Faust (approx. 1480–1540) who was a failed alchemist and magician of dubious reputation who was thought to have finally acquired real power through a pact with the Devil. The name Faust comes from the same root as the German word for "luck"—a quality, interestingly, that we associate also with the games of chance played by the tarot Magician.

Alchemists have always been complex and contradictory figures in Western culture—admired and reviled, envied and distrusted—and the meanings of The Magician card are similarly contrary. The tarot Magician is in part the genuine thing, someone who has power and control over both the forces of nature and those less tangible forces of creation and inspiration. But he is simultaneously a trickster—one minute showing you a genuine piece of magic, the next a tawdry illusion. The real trick, for those of us who meet the Magician in our lives, is to be able to tell real from fake, but it isn't easy. When this card heralds the apparent manifestation of magic and inspiration we may find ourselves in the position of those who witnessed the transmutation of base metal into gold—at once amazed and sceptical. Is this real, or is it fool's gold? How can we tell?

In the Golden Dawn esoteric system, the Magician card was associated with Mercury (Hermes), the god who acted as a messenger between the gods and humans. Hermes was also the god of alchemists, as well as gamblers, travellers,

poets, inventors and thieves. There was a strong interest in alchemy among nineteenth century hermeticists and occultists and that luminary of the Golden Dawn, Arthur Waite (who in 1908-9 co-created what's now known as the Rider Waite Smith deck) wrote a book, *Alchemists Through the Ages*, that detailed the careers of some of the most noted alchemists, some of which he regarded as genuine, while others were dismissed as charlatans and tricksters.

With such contradictory interpretations being possible, when this card comes up in a reading, it's particularly important to be aware of the context. This means not only considering carefully other cards that fall around it, but also the broader sense of the querent's situation. Is the burst of energy that the card symbolises something actual, or just a mirage? We've all had the experience of feeling that we've discovered some marvellous truth or seen the way forward in a project, only to wake up the next day and realise that it may not have been such a great idea after all. On the other hand, real moments of revelation or inspiration do happen, and they can allow us to achieve things we previously thought impossible. Which is this Magician promising—creative magic or a cheap trick? The answer may not be straightforward, and it's always worth bearing in mind the Magician's association with poets and artists—the truth may lie not in logic but in something more elusive, emotive and poetic. So allow your intuition to take charge when you need to decipher the Magician's meaning.

Before we leave this card, I'd like to consider one more aspect of it—one that isn't often talked about. This is the association between The Magician and The Devil cards. In choosing to show our Magician as Faust we make a direct link between the two figures, for Faust is famous for having sold his soul to the Devil. Does this have anything to tell us about how to interpret The Magician card? I'd say yes, very much so. Like an alchemist or a magician, the Devil, in folk belief, is a trickster and a gambler who promises much but may cheat you at the last minute. Both are figures of magic and desire, both move between the earth and other worlds—though the magician is a conduit to higher powers, while the Devil dwells below, in Hell. Both offer an illusion that you can control them—but prove to be beyond any human-made rule or contract. Both tempt you with power—but may only grant it to you temporarily.

So should we avoid the Magician as we shun—if we have any sense—the ploys of the Devil? No, because at its best the Magician card tells us that inspiration and wizardry are within our grasp—we may be able to touch the divine or reach for the stars. But just remember that the tarot Magician is also a prankster. He won't, like Satan, ask for your soul, but he may well pick you up only

to let you down again with a bump. Welcome the Magician, especially when you need to find a burst of creativity or a moment of genius—but never take his patronage for granted. It may, after all, be gone again in a flash.

## Sources

This card is based on an engraving from a painting by German artist Fritz Grotemeyer (1864-1947), titled "Faust in his study".

Alchemists and magicians have been a source of fascination for centuries, and the nineteenth century was no exception. The rise in interest in magic and the occult that occurred in the form of the literature and art style known as "Victorian Gothic" inevitably meant that alchemy featured fairly often as a theme.

> The names of the Divine Being, angels and devils, the planets of the solar system (including sun and moon) and the days of the week, birds and beasts, colours, herbs, and precious stones—all, according to old-time occult philosophy, are connected by the sympathetic relation believed to run through all creation, the knowledge of which was essential to the magician; as well, also, the chief portions of the human body, for man, as we have seen, was believed to be a microcosm—a universe in miniature.
>
> H. Stanley Redgrove, *Bygone Beliefs*.

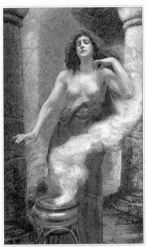

# II THE HIGH PRIESTESS

## Keywords and phrases

Spiritual wisdom from within • Divination and foresight • Touching life's mysteries and hidden knowledge • Following your own path to a strong and individual spiritual vision • Finding your own way to wisdom.

## Suggestions for reversals

Becoming too introverted and "precious" about your spirituality • An immature "higher wisdom" that needs to be developed • The need to apply more logic and rationale • A time to be more involved in formal institutions again.

THE HIGH PRIESTESS

Many tarot renditions of The High Priestess show her as a rather stiff and forbidding figure, so our choice of this sensually beautiful young witch is somewhat unusual. Witches are more usually associated with The Moon card in tarot, and sometimes (though debatably) with the Queen of Wands, whereas The High Priestess, who in the pre-twentieth century tarot was generally called the "La Papessa" (female pope) is traditionally shown as a formal and rather forbidding priestess.

But the woman on this card, conjuring spirits and visions from the smoky brazier in front of her, symbolises the oracular (divination) aspects of The High Priestess particularly well. This isn't the classic Northern European witch-as-hag that we might expect. She has distinctly oriental or Egyptian characteristics—perhaps she is supposed to be a Roma (gypsy) witch? Certainly, she is presented as a figure of dangerous but fascinating exotica—she's a female counterpart to The Magician as well as to her more traditional partner in tarot, The Hierophant. In the nineteenth century, a growing fascination with all things Gothic and supernatural incorporated a rediscovery and reinvention of the figure of the witch. In books from this time, such as Marion Crawford's *The Witch of Prague*, the witch is often depicted as a shockingly liberated and independent woman, unnaturally sensual and beautiful, but also dangerous because of her seductive appeal. This is the very model of the witch priestess we show on this card.

Solitary, working alone as an adept of hidden mysteries, she demands that we

connect to the magical and occult sides of the Priestess's spirituality. Her brazier even reminds us—very graphically—of the fact that in ancient Greece, the Delphic Oracle sat in a cauldron with three legs when she made her predictions. Like both the Oracle and the tarot Magician, she acts as a conduit between earth and higher powers, although in this case the connection is through divination, literally conversing with the divine—a process of mystery, art and veiled truths.

The High Priestess traditionally symbolises inner wisdom and mysteries that are not institutionalised through a church or an approved structure. She is an oracle who is consulted, not a priest who leads. She has no pastoral flock—instead she may admit—at her own volition—devotees and seekers. While she is, in some respects, a teacher, her teaching is likely to take forms that are hard to decipher and demand much from the recipient. This is entirely appropriate, because The High Priestess card symbolises the need to seek wisdom that is mysterious, spiritual and intuitive—a poetic wisdom rather than one that's communicated in a series of instructions.

Our High Priestess's sensuality and sexiness are qualities associated with witches but as I've mentioned, they certainly aren't seen in, for example, the traditional Marseille or Rider Waite Smith depictions of the card. This may provoke some surprising, but enlightening, insights about this figure. She looks at us directly in a way that's both seductive and a little frightening—very unlike the reserved High Priestess of most tarots. She seems to invite us in, and yet what she has to show is veiled in the smoke that drifts from her brazier. Expect to find wisdom here in the form of visions, prophecy and poetry. It won't be easy to interpret, but if you allow it to, the art of divination that this card symbolises will touch your spiritual side in a way that analysis and logic cannot.

## Sources

The image is an engraving from an original painting by British/German artist Herbert Horwitz (we have no dates for this artist). It is titled "The Witch".

# III THE EMPRESS

## Keywords and phrases

Nurture and maternity • Delight in animals, plants and all things natural • Femininity as an archetype or an ideal • Growth and fertility.

## Suggestions for reversals

The need to be less intuitive and more logical • Issues about fertility and children • Some minor problems about connecting with nature • Natural creation of a minor kind, such as the development of a small patch of garden.

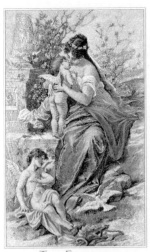

THE EMPRESS

Mother Nature, fertility, abundance and life—The Empress represents these most earthly aspects of creation. She isn't complex or hard to understand, and yet she can inspire awe—the awe of looking at a flower, a landscape, a new-born child. She represents natural creation—not the brilliant flash of inspiration of The Magician, but the no-less magical wonders of nature; birth, growth, new life. After the many-layered spiritual and visionary enchantments of The Magician and The High Priestess, The Empress brings us down to earth again, although here "earth" is a mythical garden full of statuary and blossom.

To quote Walt Whitman, the nineteenth century American writer, "After you have exhausted what there is in business, politics, conviviality, and so on—have found that none of these finally satisfy, or permanently wear—what remains? Nature remains." It's this idea, of Nature as the heart and soul of our existence, something that can satisfy us in ways that few other things can, that's the fundamental message of this card.

The image shows a classical scene that's nevertheless very warm—this is no remote goddess, she hugs and kisses Cupid while an angel watches the gentle courtship ritual of two doves at her feet. Cupid's quiver of arrows also lies there, temporarily abandoned although he will no doubt soon fly off again to shoot his darts of love. Interestingly, the presence of Cupid in this picture links The Empress with Venus—in Greek mythology Cupid was usually described as the son of Venus. This is significant because Venus is the planetary correspondence usually assigned to this card. Arthur Waite wrote:

> The Empress signifies the door or gate by which an entrance is obtained into this life, as into the Garden of Venus.
>
> Arthur Waite, *The Pictorial Key to the Tarot.*

The cherub emphasises the link to our Queen of Cups card, which also features a cherub. The Empress and Queen of Cups are often seen as reflections of one another—The Empress is the archetype and idea, the Queen the manifestation of the idea in real life. So where The Empress might signify the concept of Nature and natural things, the Queen of Cups might perhaps stand for a particular person who is a talented and devoted mother, or possibly a gardener or animal expert; someone very much in touch with nature in an everyday way.

When The Empress appears in a reading she speaks of harmony with the earth and all its living things. She may well announce new life, in the form of birth or pregnancy, or simply issues of motherhood, nurturing and fruitfulness. Remember though that the tarot Empress is deeply emotional and instinctive. When she comes into your life, welcome her abundant love, but also be aware that you may need to balance it with a little hard-headed rationale and logic. As ever with the tarot, the message is that a synthesis of opposites often works best in our everyday lives.

### Sources

This is taken from an engraving based on a painting by Austrian artist, R. Rossler (we have no dates for this artist), titled "Feelings".

> Do you know Mother Nature? She it is to whom God has given the care of the earth, and all that grows in or upon it, just as he has given to your mother the care of her family of boys and girls.
> You may think that Mother Nature, like the famous "old woman who lived in the shoe," has so many children that she doesn't know what to do. But you will know better when you become acquainted with her, and learn how strong she is, and how active; how she can really be in fifty places at once, taking care of a sick tree, or a baby flower just born; and, at the same time, building underground palaces, guiding the steps of little travellers setting out on long journeys, and sweeping, dusting, and arranging her great house,—the earth.
>
> Jane Andrews *The Stories Mother Nature Told Her Children*

# IV THE EMPEROR

## Keywords and phrases

Artifice and invention • The power and strength of rational argument • Predictable structures and patterns • Reason and Logic • Authority and man-made status.

## Suggestions for reversals

Letting go of strict logic and connecting more with instinct and intuition • Losing some authority—which may or may not be a good thing • Structures begin to break down and become more fluid and flexible.

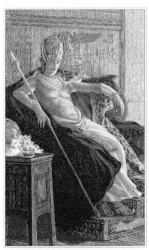

THE EMPEROR

The Empress and Emperor of the tarot can be read as husband and wife in some decks—but in our two images it's clear that they are a world apart. In fact Arthur Waite, in his *Pictorial Key*, said clearly that the two "do not precisely represent the condition of married life" and in our deck they are certainly from different cultures and empires. The Emperor is an Egyptian pharaoh, remote, powerful and formal—although he looks quite kindly he is set absolutely apart on his throne. The Empress, in contrast, is a rather sentimentalised figure drawn from classical mythology, surrounded not by real-life possessions and signs of power, but by cherubs, the angelic symbols of love.

In terms of what they signify, Emperor and Empress form the opposite points of a spectrum. While she is all things natural, he stands for artifice and man-made devices. Her behaviour is instinctual, his is driven entirely by rationalism and logic. We can even see the difference in their hands; hers are bare, his covered in rich rings and cuffed with gold bracelets, one of which is like a piece of armour.

Living in a world in which technology seems to be destroying the natural world, many of us nowadays have a tendency to react negatively to the Emperor card. Cold artificiality seems very unattractive to us and the sheer insistence on logic that The Emperor represents seems to go against many of our instincts about the importance of feelings and intuition. But it's good to remember that the Emperor and Empress are opposites, but not in opposition. Ideally, they should work together, and in balance.

The Victorians were fascinated by Egypt, which was held as part of the British Empire from 1882 until 1922, although ironically it wasn't until 1923 that complete "Egypt mania" took off in Britain, with the discovery of Tutankhamun's spectacular tomb in 1922. However, much earlier in the nineteenth century, fuelled by the art and artefacts brought back to Europe after Napoleon's invasion of Egypt in 1798, there was a craze in Europe for depictions of Egypt and for the use of Egyptian symbolism. In fact pyramids, obelisks, sphinxes and Egyptian-style columns even became quite a popular theme in nineteenth century graveyards, where they can still be seen to this day.

It's worth pointing out there is a correspondence between our image of an Egyptian pharaoh and the Rider Waite Smith Emperor, who although European in appearance, carries a stave in the shape of a *cruz ansata*, or Ankh, the mysterious Egyptian symbol which in modern times has been used as a symbol of the afterlife.

## Sources

This is based on an engraving of a painting by French orientalist painter and sculptor Jean-Jules-Antoine Lecomte de Nouy (1842-1923), titled "The Melancholia of the Pharaoh". Lecomte de Nouy specialised in pictures of women in erotic poses, and the full engraving shows the pharaoh's harem and female slaves—some of them lightly clad—trying to entertain him.

> Imagine the greatest figure in the world—such a figure as this Rameses was in his day—with all might, all glory, all climbing power, all vigour, tenacity of purpose, and granite strength of will concentrated within it.
>
> Robert Hichens, *The Spell of Egypt*.

# V THE HIEROPHANT

## Keywords and phrases

Instruction and guidance • Structure and formal organisation • Authority • Becoming a student or disciple • Following, or becoming, a teacher, leader or priest • An established institution • Legal rules and legislation.

## Suggestions for reversals

A teacher, but not a "guru" or guide • Leaving a formal institution to seek more personal paths to knowledge • Doubts about a structure or organisation • A need to look within, rather than relying too much on being told what to do.

THE HIEROPHANT

The Hierophant was originally called The Pope on early medieval and Renaissance tarot decks, and it still tends to carry with it an association, for some readers, with formal, even forbidding, establishment and authority. Many people feel a sense of discomfort when this card comes up in a reading, they feel that the message it carries is repressive, and it's often cited as a card to which modern tarot readers have problems relating, whatever their religious affiliations. Yet we should give The Hierophant another chance. After all, most of us realise—unless we are advocates of total anarchy—that institutions, organisations, and structures are necessary. In many circumstances, the best way to develop and learn is studentship at a recognised educational establishment or with an acknowledged, qualified teacher. At its best, this does not restrict our freedom, on the contrary we can acquire knowledge that opens up more choices and opportunities.

Our Hierophant is an elderly Islamic scholar who is teaching two small boys. Do the boys look cowed or scared? Far from it; they seem serious, but comfortable and relaxed; one sits cross-legged absorbed in his book. This Hierophant is no strict martinet, we feel that his teaching can fascinate—although we also sense that he rarely has problems with discipline, and he naturally commands respect.

Attitudes towards gender and education is one issue that frequently arises with The Hierophant card, and should perhaps be discussed more often. Certainly this image cries out for us to consider the role of women and men in formal learning. Nowadays, rightly or wrongly, in the West we think of serious Islamic

teaching as being focused on boys. We imagine that girls are given a far less intellectual and formal education. In some Islamic societies (in common with many other so-called "fundamentalist" religious societies of many faiths and creeds) this may be true—sadly. But it's heartening to look at the very different situation described, for example, in that classic, *The Arabian Nights*. Here is an amusing conversation between a merchant and the very refined female slave he has just purchased. The woman turns out to be not merely well educated, but a veritable wonder of knowledge and learning, and she is honoured and respected as such:

> "Tell me, dost thou know the Koran by heart?" "Yes," answered she; "and I am also acquainted with philosophy and medicine and the prolegomena of science and the commentaries of Galen, the physician, on the canons of Hypocrites; and I have commented him and I have read the Tazkirah and have commented the Burhán; and I have studied the Simples of Ibn Baytár, and I have something to say of the canon of Meccah, by Avicenna. I can ree riddles and can solve ambiguities, and discourse upon geometry and am skilled in anatomy. I have read the books of the Sháfi'í school and the Traditions of the Prophet and syntax; and I can argue with the Olema and discourse of all manner learning. Moreover I am skilled in logic and rhetoric and arithmetic and the making of talismans and almanacs, and I know thoroughly the Spiritual Sciences and the times appointed for religious duties and I understand all these branches of knowledge."... Now when the merchant heard this, he cried out "Brava! Brava! Then O happy he in whose palace thou shalt!" Thereupon he brought her paper and ink case and a pen of brass and bussed the earth before her face to do her honour.
>
> *Richard F. Burton* The Book of the Thousand Nights and a Night

It's true that the "male" cards of the Major Arcana more often stand for external action, formality, institutions, recognised structures, and the power of will, logic and rationale. The "female" ones, on the other hand, tend to signify issues of inner thought, community, informal groups and ways of thinking and doing, and the power of cooperation, intuition, feeling and sensitivity. However, in The Hierophant, as in all these cards, it's important not to take gender for granted in an interpretation. The Hierophant could take the form of the influence of an institution run by women, for example, or one might decide to take formal instruction from a female professor or priest.

Whatever form The Hierophant takes, this card usually advises a period of studentship, apprenticeship or a course of following formal rules and structures. Of course, remember that it can, in some circumstances, point to yourself as Hierophant rather than student. Perhaps you have a lot to teach and much knowledge to pass on? But whether you are teacher or pupil, this card's appearance indicates that you should work in a conventional, recognised organisation. This is a time to conform to systems, rules and authority—at least for a while.

## Sources

Based on an engraving taken from an original picture by C. Hirsch (we have no dates for this artist) titled "Teaching the Koran". This painting was exhibited in Paris in the late nineteenth century, but we can find very little other information about it.

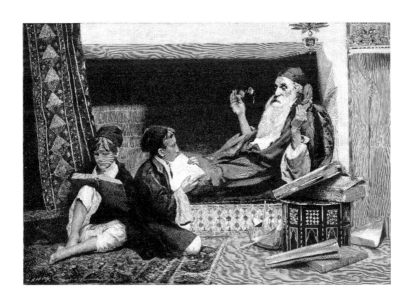

# VI THE LOVERS

THE LOVERS

## Keywords and phrases

Active passion—for a person or possibly for an activity or interest • Making a choice in a highly-charged relationship • Finding a soul-mate • A perfect partnership, with a great deal of feeling on both sides • Faithfulness, "faithful onto death" • Love both sensual and spiritual.

## Suggestions for reversals

A minor passion, it may not last • Finding it hard to make a choice in an emotional situation • Love that turns out to be a flirtation or a crush • Making the wrong choice, being with someone who is not quite a soul-mate.

Dante and Beatrice walk together through a garden. She gazes upwards—to heaven. He looks at her thoughtfully, and with a trace of sadness.

The story of Dante and Beatrice is one of the most famous and enduring love stories in the world. Dante first met Beatrice when he was just nine years old and she was eight. For years he thought of her and tried to occasionally see her from afar, but he didn't actually speak to her until fully nine years later, when she greeted him in the street. This brief meeting inspired him to write the first sonnet of his *La Vita Nuova*, still considered one of the greatest romantic poems of all time. In it, he complains that Beatrice shows no interest in him, merely finding him absurd:

> You laugh with the other ladies and mock my appearance; and do not think, lady, what it is that renders me so strange a figure at the sight of your beauty.

In fact, Beatrice married another man, and died very young, in her mid-twenties. The scene shown on this card, the two of them quietly and intimately together, probably never took place in real life. But even after her untimely death, Dante continued to idolise the young woman (although he too married and had children) and in his *Divine Comedy*, he imagines meeting her in the afterlife, where, as a perfect soul, she accompanies him to heaven. The *Divine Comedy* had an impact on the Arts which is hard to overstate, for centuries it was a major theme for artists and writers.:

Dante's "Divine Comedy" is another publication of which the illustrations have been a constant source of artistic discussion and dissension; ... Dante has influenced every great artist on the Continent since his own day.

*The Art Journal*, 1899.

It was Dante, above all others, who made the theme of love and lovers so prevalent in the art of the Middle Ages and the Renaissance and perhaps it's hard for us now to grasp the extent to which Dante was responsible for the huge importance of love as a subject in the Arts—it is, after all, something we take entirely for granted these days.

When you draw this card in a reading, remember that although it refers broadly to love and passion, it's not necessarily about a romantic or amorous partnership, but may signify any strong and intense emotional commitment or ardour—for a person, a project, a cause, perhaps even for a place. Love comes in many forms, and even a single love, like that of Dante for Beatrice, can change over time. After all, Dante's love changed from that of a child, to an impassioned young man, and then, later, to a love that was almost a form of worship—unearthly and venerated.

Remember too, that the card, in earlier pre-twentieth century decks such as the Marseille, used to show a man choosing between two women—one of the interpretations was therefore about choice. The story of Dante and Beatrice is also, tragically in some ways, about choice; Beatrice did not, in fact, choose Dante, she married another young man, so although we see them together in this card, the historical reality was quite different. Bear in mind, in a reading, that The Lovers can talk of an important decision, usually an emotional one, and often between two alternatives or people. Choose wisely and well, for this is a card that stands for that most major driver in our lives, true love.

### Sources

This is based on an engraving of a painting by Italian romantic artist Cesare Saccaggi, (1868-1934), who painted sensitive portrait, genre and landscape scenes in gentle pastels and water-colours. The picture is titled "Dante and Beatrice".

Saccaggi, was born at Tortone in Italy in 1868 and was a student of the Royal Albertine Academy. After studying in Paris he exhibited at the Salon des Artistes Français. He won several medals for art. The principal collection of paintings by this artist is kept by the Municipal Museum of Turin.

We've used another Saccaggi picture as the basis for the Page of Cups.

THE LOVERS

# THE LOVERS—alternative

*This card is part of the Gold Edition of The Victorian Romantic Tarot, it isn't included with the standard deck.*

## Keywords and phrases

Passion—for a person or possibly for an activity or interest • Making a choice, perhaps a hard one, in a relationship • Devotion to another, maybe against all odds • Finding a soul-mate • A perfect partnership, with a great deal of feeling on both sides • Sexuality, fierce passion and love • The selflessness *and* selfishness of love • Changing yourself in order to be with your lover.

## Suggestions for reversals

A minor passion, it may not last • Finding it hard to make a choice in an emotional situation • Love that turns out to be a flirtation or a crush • Making the wrong choice, being with someone who is not quite a soul-mate • A love that isn't going to work out, perhaps the situation is simply too problematic.

This is a very different visual interpretation of this card, and the range of possible interpretations in a reading is subtly different. Instead of idealised earthly lovers, it shows a Greek God, Bacchus (God of wine and intoxication) and a mermaid or water nymph. The title translates as, "He half pulled her out, she half pulled him in". It's gorgeous, but also slightly disturbing, for how are these lovers, one so much of the earth and the other bound to the water, ever to remain together? If you look closely at the picture, you can see that Bacchus has caught the mermaid— literally fished her out of the water. But instead of being angry she is clearly enchanted with her handsome young captor, and in any case, as the picture's title tells us, she is probably as likely to take him into her element as he is to pull her on to dry land. Looking at the mermaid's body though, it seems as though her tail is changing into legs—is she transforming into a land-creature in order to be with her lover? Maybe of the two, she is the one more willing to undergo a fundamental change in order to make this relationship possible?

It's a rather humorous picture, but at the same time it provokes questions: Will she literally leave her natural element to be with Bacchus? Or is this passion

just a fleeting moment, will the mermaid turn tail and swim away before she becomes human? Can either of these two partners really be trusted? After all, both the God of Intoxication and a siren mermaid are mythical figures known for turning men's heads and tempting them into danger. Overall, this card is much more sensually and sexually charged than the Dante and Beatrice one (which, after all, refers to a love that was chaste) and it carries with it a warning of the risks of being carried away by sheer desire. Passion can take many forms, some more intense or more long-lasting than others. This Lovers card shows a frozen, and perhaps fleeting, moment of enormous passion, whereas our Dante and Beatrice card depicts a lover famous for his life-long total commitment to one woman. Both have their own truth and validity, although they speak of different aspects of love. The Dante and Beatrice card carries more of the traditional meaning for the tarot Lovers, but Bacchus and the mermaid reminds us that love can be wild and risk-taking, and can bring together unlikely partners.

If you have both these cards in your deck, you can choose which Lovers to include for readings— but you may well find it illuminating to try out both and see, when they appear in a spread, how they can subtly alter the interpretation of what love truly is.

## Sources

Based on an engraving of a painting by the German artist, Georg Papperitz (1848-1918). Papperitz painted lush, sensual pictures, often of women.

> Love seeketh not Itself to please,
> Nor for itself hath any care;
> But for another gives its ease,
> And builds a Heaven in Hell's despair.
>
> So sang a little Clod of Clay
> Trodden with the cattle's feet:
> But a pebble of the brook,
> Warbled out these metres meet.
>
> Love seeketh only Self to please,
> To bind another to Its delight:
> Joys in another's loss of ease,
> And builds a Hell in Heaven's despite.

William Blake, "The Clod and the Pebble", *Songs of Innocence and Experience.*

# VII THE CHARIOT

## Keywords and phrases

Willpower • Total focus • War, battles, imposing your will be force • Knowing where you are heading • An almost ruthless determination • Single-mindedness • Reaching your goal, no matter what • Unstoppable drive • Being warlike and certain you are right • Travelling to a known destination—nothing is going to stop you.

## Suggestions for reversals

Losing some of your drive • Heading off in slightly the wrong direction • Wanting to take a break and be a little more light-hearted • Willing to be flexible and make compromises • Losing your way, literally or metaphorically • Unsure of your direction, some confusion about where you are heading • An inability to enforce your will—this may be a good or bad thing.

THE CHARIOT

The Chariot is the card of willpower and determination. It's also often associated with war and battles—certainly it symbolises someone who is absolutely dead-set on getting their own way, and who may well ride rough-shod over others to achieve this. In some respects it's the complete antithesis to The Fool—while he blithely takes a leap into the unknown and expects it all to work out, The Chariot driver leaves nothing to chance, everything is under control, intentional, on-track. No foolishness or frippery allowed.

However, in contrast to the traditional Chariot card, which in older decks shows a stiffly dressed military figure driving a chariot (drawn by horses or, in the RWS version, sphinxes) straight towards the viewer, ours is a rather more romantic and even lyrical image. The armoured driver and her frowning deputy still show a steely focus, but their other two companions are altogether less tense and—it seems—more inclined to relax a little and enjoy the ride. And what a ride! This chariot is a gloriously Baroque confection that flies through the night air drawn by small, though fierce, winged lions.

In a reading, I'd encourage you to veer from convention a little (how very appropriate for The Chariot!) and ask yourself if the main meaning of the card is about the focused drive of the charioteer and her cross little steeds, or lies more with the rather playful young women who are alongside her. Certainly,

there are times in life when we need to be utterly determined and single-minded—ignoring all distractions and concentrating on the goal, not the process. But there may be other moments when we can achieve our ends in a rather less focused and ruthless manner, and perhaps with a little more fun along the way.

## Sources

This is taken from an engraving based on a painting by Madelaine Lemaire (1845-1928) a French artist and illustrator who was particularly known for her flower paintings. Popular and respected in her day, she has become much less widely known since. A pity, as her work has a distinctively elegant fantasy style that's very appealing.

Jove is my brother;
Mine eyes are the lightning;
The wheels of my chariot
Roll in the thunder,
The blows of my hammer
Ring in the earthquake!

Force rules the world still,
Has ruled it, shall rule it;
Meekness is weakness,
Strength is triumphant,
Over the whole earth
Still is it Thor's-Day!

Henry Wadsworth Longfellow, The Challenge of Thor".

STRENGTH

# VIII STRENGTH

**Keywords and phrases**

Calm strength—even under pressure
• Patience and persistence • Courage and
fortitude • Conviction of purpose • Gentle but
forceful • Taking control of things around you,
calmly and quietly.

**Suggestions for reversals**

Wanting to take a break and be a little more
light-hearted • Willing to be flexible and make
compromises • Unsure of your direction,
some sense of being "lost" • An inability to
enforce your will—this may be good or bad.

Strength, in the tarot, is not about physical
force or power, it's about something much
more powerful; the inner fortitude that comes from calm confidence and a
complete belief in yourself. In the tarot the virtue of Strength has, over the
centuries, been shown in a variety of ways; by a scene of Hercules overcoming
the Nemean lion, or sometimes by an armed woman holding a stone pillar (a
popular symbol for Strength in the Renaissance). But an image of a lady
subduing a lion has for a long time been the most popular way of depicting this
card, probably because a calm woman bending a fierce beast to her will makes
such a powerful symbol of mental, rather than physical, force. It demonstrates
that true strength lies in the mind, not the body, and that courage and patience
are its close allies.

In our image, there are several lions, male and, more unusually in this card,
also female lionesses. They are all together in some place surrounded by harsh
stone walls, and yet the lady herself wears an elegant evening dress and looks as
though not a hair of her head is out of place. The scene is on one level reminis-
cent of the story of Daniel, the biblical hero who was thrown into a lion's den
as a punishment, but was untouched by the beasts. It also recalls the fairy story
of "Beauty and the Beast" (we in fact used this story as the Strength card in our
*Fairytale Tarot*) in which it is Beauty's faithfulness, love and bravery that not
only protect her from the enchanted lion's animal nature, but actually restore
him to full humanity.

In a reading, this card points to an ability to deal with difficult, or even
threatening, situations with a calm courage. It's about drawing on your inner

resources and taking charge of events, sure that you can meet the challenge. It also often indicates answering violence with non-violence. This doesn't mean giving in or surrendering, far from it. You can win some fights simply by being the person who doesn't need to resort to physical force. It takes courage and a strong self-belief to do this, but it's often far more effective not to enter the battle, but instead to take control calmly but firmly.

## Sources

The lions on this card were mostly sourced from an engraving of a painting by German artist Albert Baur (1835-1906), titled "Daniel in the Lions' Den". The female figure is from an engraving based on a painting by Italian artist Giovanni Secchi (we have no dates for this artist) titled "A Victim for the Goddess."

# IX THE HERMIT

### Keywords and phrases

Withdrawal from the world • Setting out alone on a spiritual quest • Withdrawing from the world • The passing of time may bring wisdom • A time of inner searching.

### Suggestions for reversals

Emerging after a period of voluntary isolation • Denying the passing of time, wanting to stay young forever • Seeking help and companionship • A short retreat or withdrawal from the world.

THE HERMIT

The tarot Hermit card used to sometimes be titled "Time" and our image of the Hermit has the attributes of the traditional Father Time—a scythe, similar to that carried by figures of Death, and an hourglass. In the Renaissance, time was often associated with death, for entirely obvious reasons, so their iconography is somewhat similar. The same symbolism was also used for Saturn, the planet of old age, and in fact the picture on which our card is based is a portrayal of Saturn, complete with wings (time, after all, flies), rather than Father Time.

So the tarot Hermit is associated, symbolically, with old age, time and death. Just as the Death card reminds us that all living things must change, and ultimately die, so The Hermit, in the form of Time, reminds us that all things are subject to the passing of the years. The Victorians were fond, at New Year, of depicting Old Father Time as the old year, cradling the infant new year in his arms, as part of a never-ending cycle of growth, decay and renewal.

Time marches on—that's inescapable, and we all grow old. Is this necessarily a depressing thought? In these times of frantic searching for eternal youth, it may seem so, but in fact The Hermit is a gentle and positive card if you are open to its message. It tells us to use our time well, and to find space to contemplate and consider spirituality. It asks us to spend at least some of our life seeking the more profound answers about the world and our purpose in it—something done best apart from the crowd and the bustle of day-to-day concerns.

There is a modern tendency to confuse solitude and loneliness—we are almost afraid to be seen to be on our own in case people will think us misfits or unpopular. But when you think about it, this is ridiculous. We can't live in a

constant hubbub of noise and activity—and we certainly can't easily meditate in such a situation. The search for higher meaning can be hard—the sharp rocks in this image may stand as symbols of that. It can feel isolating and demanding, and yet, if we never attempt to seek the truth, can we truly say we've lived well?

## Sources

The Hermit was one figure from a much larger picture by Eduard Veith (1856-1925), titled "Saturn and the Four Seasons of the Year".

> Is man a mere mortal animal, or an immortal soul? Is his flesh meant to serve his spirit, or his spirit his flesh? Is pleasure, or virtue, the end and aim of his existence? The hermits set themselves to answer that question, not by arguing or writing about it, but by the only way in which any question can be settled—by experiment. They resolved to try whether their immortal souls could not grow better and better, while their mortal bodies were utterly neglected; to make their flesh serve their spirit; to make virtue their only end and aim; and utterly to relinquish the very notion of pleasure.
>
> Charles Kingsley, *The Hermits.*

# X WHEEL OF FORTUNE

THE WHEEL OF FORTUNE

## Keywords and phrases

The ups and downs of fate and fortune
• The role of chance • Lady luck's fickleness
• A stoke of good or bad fortune • An
unpredictable event • Destiny • Cycles of
change.

## Suggestions for reversals

A matter of fate or fortune—maybe you feel
your luck is poor? • Things don't change, your
luck stays the same • Feeling that you can
influence your own fate • Someone may be
trying to control your fortune rather than
letting it take its course.

Often tarot asks us to think about the conse-
quences of our actions and our decisions. However, when we meet The Wheel
of Fortune, the message is that there are some things that just happen, without
any obvious chain of cause and effect, and we have to be prepared to deal with
cycles of fate and fortune that are beyond our control—for good or ill.

The image on this card appears to show a piece of very good fortune; the
young man, a humble bird-catcher, is surprised at being offered a crown. It's
pure fairytale—and in fact there is a second piece of good luck hidden in the
picture too; the little bird looks as though it will escape, entirely forgotten in
the excitement of the moment.

If you know The Wheel of Fortune cards in the very early, fifteenth and
sixteenth century, decks, then you'll immediately be reminded of the theme
that appears on them. There is a figure shown that's ascending, on top of,
descending, and underneath the wheel. On some versions there are captions in
Latin to explain the meaning of this more clearly: "I shall reign", "I reign", "I
have reigned", "I don't reign". On our card, we see the moment in which the
young man realises, "I shall reign" but one wonders if the wheel will turn once
more in the future and his fortunes will again change.

Fate and fortune are part of the lives of every living thing. We have ups and
downs in terms of relationships, work, our interests, our health—and many
such events don't seem to have a reason other than pure chance. Knowing that
at any moment we could be struck by good or bad luck is part of being human,

and most cultures abound in symbols and personifications of fortune, and charms, amulets and icons designed to influence fortune. Even people have been seen as inherently bringing good or bad luck with them; there are many superstitions about this, particularly in association with the arts and theatre, and also with activities perceived to be dangerous such as sea voyages:

I tell you
It was a lucky day when first she set
Her little foot upon the Swallow's deck,
Bringing good luck, fair winds, and pleasant weather.
Henry Wadsworth Longfellow, "The New England Tragedies".

When we read this card in a spread it tells us that we are about to feel (or have felt) the hand of fickle fate—but in what direction? Will the Wheel bring us gains or losses? The cards that fall in close proximity will often give the answer. Remember that the Wheel traditionally turns clockwise, so cards to the left of this one may indicate the past, and cards to the right, the future. Remember too that while fortune isn't always fair, it often works in unexpected ways, and something that can seem at first like bad luck can result in a surprisingly good outcome. As the old saying goes, "Fortune favours the brave". Don't be afraid of this card when you see it, but instead accept that luck is part of life.

## Sources

Based on an engraving of a painting by German artist Hermann Vogel (1855-1921) titled "Heinrich the Fowler". Heinrich was a ninth and tenth century German monarch. He acquired his nickname because when nobles went to tell him that he had inherited the crown, he was discovered out mending the nets with which he hunted birds.

> As we read its [*Mirror for Magistrates*] sombre pages we see the wheel of fortune revolving; the same motion which makes the tiara glitter one moment at the summit, plunges it at the next into the pit of pain and oblivion. [] It gives us a strange feeling of sympathy to realise that the immense popularity of this book must have been mainly due to the fact that it comforted the multitudes who groaned under a harsh and violent despotism to be told over and over again that cruel kings and unjust judges habitually came at last to a bad end.
>
> Edmund Gosse, *Gossip in a Library*

# XI JUSTICE

JUSTICE

## Keywords and phrases

Taking responsibility for the consequences
• Reaping what you sow—for good or bad
• "Truth will out" • Justice will be done
• Fair-mindedness and fair play.

## Suggestions for reversals

Rough justice • Unfairness of some kind
• Avoiding justice—for better or worse • Some
sort of corruption or attempt to pervert justice
• Not getting your deserved reward—or your
punishment.

Justice comes after The Wheel of Fortune,
telling us that in the traditional tarot trumps
sequence, fairness, cause and effect, and what
we might now call "karma", were considered more powerful than the mere
whims of chance (in the original card game, the trumps were laid out in order
of their increasing value or ability to "trump" one another). In other words,
whatever ups and downs fate and fortune throw at us, justice still reigns—we
can't just excuse our actions by pleading bad luck.

The figure of Justice herself is one of the ancient Virtues that can still be seen
frequently as a statue or painting in many modern contexts—especially in law
courts where she is shown blindfold, holding scales and wielding a sword.
We're so familiar with this depiction that we perhaps don't think much about
it any more—or just see it as a familiar signpost for legal institutions. The
image we've chosen is more unusual and perhaps quite startling. It brings to
the fore the link between Justice and the concept of good and evil. Here we see
Justice as a beautiful angel; she's just vanquished a devil, who cringes before
her. We can think of him as representing unfairness, bias, prejudice, malprac-
tice—all the things that contribute to injustice. Under the foot of Justice is a
broken sword by which sit two doves, symbols of peace. The message here is
that true justice brings about peace and calm— or, as we might express it
nowadays "closure", while injustice tends to provoke strife and fights.

Justice isn't just about punishing evil, rewarding good is just as much a part of
it, and an aspect that's at times forgotten. When this card comes up in a
reading it's time to consider all the many faces of justice or "fair play".
Whether you are the one on the receiving end, or the person dispensing justice

to others, moderation and fairness in both reward and punishment is always the best way.

## Sources

This is adapted from an engraving of a painting by E. Butler titled "Angel of Peace". In the original painting the angel held an olive branch in her hand.

> Is yours the God of justice and of love?
> And are your bosoms warm with charity?
>
> Say, does your heart expand to all mankind?
> And, would you ever to your neighbour do—
> The weak, the strong, the enlightened, and the blind—
> As you would have your neighbour do to you?
>
> Acton Bell, "A Word to the 'Elect".

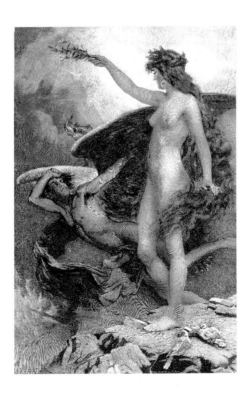

THE HANGED MAN

# XII THE HANGED MAN

### Keywords and phrases

Transcendence and illumination • Spiritual surrender • Sacrifice—usually of the ego • Letting go of material concerns • Enlightenment—perhaps by seeing things a whole new way • Detachment from selfish considerations • A state of mental suspension from everyday things • Letting go.

### Suggestions for reversals

A small sacrifice • Coming back to the world after a period "in suspension" from life • Finding it hard to let go • Remaining attached to the everyday world.

The Hanged Man is one of the more curious images of the Major Arcana. Most of the other images can be found in other contexts, many of them, like Justice, The Devil or Death, are familiar from much medieval and Renaissance iconography. But the origin of the imagery of The Hanged Man is much more mysterious. He may originally have been a representation of "Shame" or "Treachery", there is quite a lot of evidence to support this. But in modern times, that meaning has been completely replaced by a more positive, and also more spiritual interpretation. We now think of The Hanged Man as showing someone who is making a willing sacrifice in order to gain enlightenment. He is literally isolating himself from the world and forcing himself to see things for a while in a "topsy turvy" way in order to discover a new way of viewing the world and his place in it. He is, in fact, hoping to become a "seer" someone who sees the truths beneath the surface of life.

Our image shows The Hanged Man suspended by a simple rope loop to an old stone bridge. Behind him, the landscape is rugged and empty of people. He holds one hand to his forehead, in a gesture that emphasises the trance-like depth of his thoughtfulness. It's a depiction that makes a link between The Hanged Man and The Hermit. Both have separated themselves off from other people in order to delve deeply into their own minds. Both have also cut themselves off from any luxuries or comforts. But whereas The Hermit takes a patient, step by step road to enlightenment, The Hanged Man chooses a more violent and extreme way—literally turning his world upside down.

When interpreting this card, remember that it tends to have this element of sacrifice or self-inflicted pain about it. The important point is that this pain or discomfort has been undertaken voluntarily, not imposed by someone else. It's also taken for a purpose, this isn't the card of someone who "self harms" in a neurotic or disturbed way, rather it may point to a person going into a difficult and isolated situation in order to learn from it. It might indicate someone who goes on a challenging retreat; taking the decision to spend time away from earthly pleasures such as food, drink, materialism or sensuality. It could also show someone who sacrifices themselves for a higher cause, or for other people. The Hanged Man might be someone who gives up their leisure time to work (probably in a quiet way) for a charity or a campaign, or who voluntarily goes without possessions or comforts that they feel damage the environment. The poet Percy Bysshe Shelley once wrote that the whole idea of chivalry was based on self-sacrifice. It's interesting to reflect on the story of the Grail Knights, who went out on their quests alone, knowing that they would face hardship, deprivation and danger, but feeling it was worth it in pursuit of the Holy Grail, spiritual symbol of Christ's own self-sacrifice. Whether or not you are Christian, the Grail is a powerful symbol of the pure spiritual quest against all odds, and as such is in many ways a good illustration of the ultimate meaning of The Hanged Man.

Finally, remember that although this card indicates a strong and spiritual individual, while they are going through a "Hanged Man" time they may not be at all easy to live or communicate with. If there is such a person in your life, you may simply have to accept their decision to go into a state of suspension from everyday matters. Wait patiently until the time comes for them to rejoin the world again—remember that better understanding will emerge from this time of trial.

## Sources

The figure of The Hanged Man himself is taken from an engraving by Gabriel Mar and Gustav Closs and was an illustration to a 1898 edition of Christoph Martin Wieland's (1733-1813) popular romantic epic *Oberon*. We've used another illustration from this book for our Judgement card.

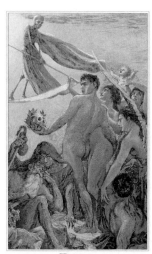

DEATH

# XIII DEATH

## Keywords and phrases

The death of a strong part of one's identity
• A physical or spiritual death • The absolute
closure of a cycle or phase in your life
• A difficult transition, but one that prepares
you for new ways of living.

## Suggestions for reversals

A minor loss of identity • Refusing a change
that challenges your sense of self, wanting to
remain exactly the same • Avoiding a life-
threatening situation, perhaps surviving a "near
miss" • Denying death—not wanting to ac-
knowledge its existence • Clinging to the way
you used to be, resisting the need to move on.

Death is probably the most discussed, most feared and most mythologised card
in the whole tarot deck. We've all seen films in which the old-lady gypsy tarot
reader turns over the cards and, horrors! it's the Death card that's revealed.
Cut to shocked expressions and scary music. So right away, let's deal with the
main question about this card, can it stand for physical death? Yes, of course it
can, death is a part of life, and the tarot deals with all aspects of life, including
its end—is that really anything to be frightened of? But the card has a range of
meanings, and in readings it mostly stands for more metaphorical or symbolic
forms of death, such as the death of part of your identity, or the abrupt ending
of a period of your life. The card is about profound change, the kind of change
or transition that really touches your sense of self. While this may not be easy
or comfortable, it can be very positive. Sometimes we need to let one part of
us "die" in order to grow into a new identity or role.

Traditionally, the tarot Death card, in common with other medieval allegorical
images of death, emphasised the universality of death—showing that no-one,
from peasant to priest to monarch, could escape. Our card picks up this
tradition and also shows a number of people, young and old, and including an
angel, surrounding a naked man who holds a skull in his hand. It's reminiscent
of the stance that we associate with Shakespeare's character Hamlet, who in
one famous scene in a churchyard holds up the skull of an old acquaintance,
and muses on the nature of death and decay. It's a scene that's been lampooned
endlessly—parodied in films, novels and in comedy routines. Why do we like

to laugh at such scenes? Is it because the idea of death frightens us, so we make fun of it in order to feel more in control? The image of this card in our tarot is solemn and serious, but it's also theatrical—this is not a real death that we see, but rather an allegory of the idea of death.

Above the group of people in this image the traditional figure of Death sweeps across the sky holding his scythe. The traditional pre-RWS tarot Death usually showed a skeleton with a scythe mowing down people, who lay on the ground, powerless to stop the carnage. It's an image so horrific that again, it almost provokes nervous laughter in some people.

The English Victorians seem to have distanced the idea of death by turning it into a ritual and, in some senses, a public performance. The strictest rules of mourning applied in polite society, with codes for dress and behaviour laid down for both mourners, and those around them. Here are firm instructions on the matter from the indefatigable Mrs. Beeton:

> In paying visits of condolence, it is to be remembered that they should be paid within a week after the event which occasions them. If the acquaintance, however, is but slight, then immediately after the family has appeared at public worship. A lady should send in her card, and if her friends be able to receive her, the visitor's manner and conversation should be subdued and in harmony with the character of her visit. Courtesy would dictate that a mourning card should be used, and that visitors, in paying condoling visits, should be dressed in black, either silk or plain-coloured apparel.
>
> Mrs. Isabella Beeton, *The Book of Household Management*

This was also a historical period notorious for the invention of minor cults such as the "death photograph", which involved taking a sentimentalised portrait photograph of the newly deceased, a practice which seems morbid to modern eyes, but which in the nineteenth century seemed an acceptable form of remembrance. It can be startling to realise that attitudes to death have changed so much in just the last century.

I've talked about physical death, and in a reading, don't completely block any possibility that this could be indicated (and if you think it is, please consider carefully if or how to communicate this to the querent). But remember that other interpretations are far more likely. Is the querent, or someone close to them, involved in a major transition in their life? Are they having to give up a part of their identity that they cling to? Will they have to let go of some aspect of self that has been central to their self image? This may be no bad thing; as

we move through our lives we often have to make difficult but necessary changes in the way we see ourselves—one has to move from child, to teenager, to adult, and on into old age and along the way we may take on many roles such as lover, student, worker, parent, carer or friend. Each transition may be smooth, or it may alternatively be something that is struggled with and avoided before final acceptance. The Death card in tarot points to a period in your life that may well feel like a small death, but remember, it also promises a new life to follow, and perhaps a better one. Embrace the change and use it well.

## Sources

The main figures are taken from an engraving based on a painting by German painter and sculptor Gustav Eberlein (1847–1926), titled "Fantasy". We added the more traditional figure of the Grim Reaper in the sky.

TEMPERANCE

# XIV TEMPERANCE

**Keywords and phrases**

The middle way • Moderation and balance • Harmony through flexibility • Compromise and conflict-avoidance • Order and harmony • Strength through flexibility—in the Zen manner • Not rocking the boat • A steady calmness.

**Suggestions for reversals**

Seeking the middle way but finding it hard to give up immoderate behaviour • Things fall out of harmony and become more chaotic • Risks of a row or a quarrel, but it hasn't yet happened • Being attracted to extremes • Refusing to compromise.

Our Temperance card varies a good deal from either the traditional RWS card or, indeed, from the classical ways of depicting this virtue. Instead of showing an angel pouring liquid between two cups, we've chosen to show her (or him, angels have no gender) calmly standing at the rudder of a boat. One hand is stretched out in what looks like a gesture of either peace or blessing. It's twilight, a time that is, appropriately, not quite day or night—Temperance represents synthesis, moderation and the middle way between polar opposites.

This is a calm, quiet image that brings to mind a whole new set of metaphors for this card, such as "steering a middle path", "not rocking the boat" and, a great Scottish saying, "He that winna be ruled by the rudder will be ruled by the rock." This last one is particularly interesting, as it brings to mind the contrast between lack of self-control—as symbolised by The Devil card—and the self-restraint and moderate behaviour symbolised by Temperance.

The image we've chosen also links, visually, to the Six of Swords, which shows a boat moving through waters, though in the Minor card it isn't steered by an angel. Both cards are about moving quietly through life, although the Six of Swords refers much more specifically to getting through a difficult period, whereas Temperance, as an archetypal Major, refers to the need for Temperance in general, in both your own life and in the world around you. This can mean a whole range of things to different people—abstaining from over-eating or drinking, controlling an urge to spend too much, being faithful to a sexual partner, not bursting into anger at an insult, being tolerant of other's beliefs—

and much else. In the nineteenth century, however, all over Europe and America, temperance came specifically to be associated with abstinence from alcohol as the "Temperance Movement" became hugely active. Whatever your view of this, it does seem rather a pity that it's distorted the general view of temperance, which we still tend to associate more with issues of alcoholic intoxication than anything else. When you look at this card, and at the calm, quiet angel steering a middle path, remember that temperance and moderation can apply to many aspects of life.

## Sources

This is adapted from an engraving based on a painting by H. Arlin, titled "Flight from Egypt". In the original picture Mary, Joseph, the baby Jesus and a calm little donkey are all in the boat, which an angel is guiding to safety.

# XV THE DEVIL

## Keywords and phrases

Something wickedly tempting • Giving in to
bad behaviour • Seduction • Addictions and
compulsions • Acting against your better
judgement.

## Suggestions for reversals

Resisting temptation • Fighting back against
an addiction • Enjoying some of the good
aspects of giving in to sheer indulgence
• Refusing seduction, looking instead for love
• Struggling against your inner demons and
compulsions.

Showing the Devil as a woman is unusual not
only in tarot, but more generally in art. We're
used to thinking of Satan as a rather suave but lusty man—in modern portray-
als he is often shown as being distinctly sexual, albeit in a dangerous or even
repellent way. But remember that Lucifer was a fallen angel, and as we all
know, angels are not of any particular gender. So it's perfectly logical to
imagine the Devil appearing as a female—and interesting to wonder why we so
rarely consider this possibility.

Does it change your view of this picture to know that the artist was a woman?
And a woman who appears to have been exceptionally emancipated. Even
before realising that the "Georges" who painted this was not a man, one of the
things that attracted us to this depiction of The Devil was that it shows a
woman who, rather than being manipulated by evil, or used as mere bait, is
the personification of the power of wickedness in her own right. Knowing that
it is the work of a woman who was known for her powerful paintings of strong
female figures only adds to the fascination.

This card traditionally warns us of temptation, giving in to unhealthy desires,
and generally losing control in a dangerous manner. The woman in the image
seems to hold out so many offerings—the beauty of flowers, the lure of money,
and, it is implied, the attraction of physical passion. Yet ironically we can
simultaneously read this image as telling us that wickedness can bring both
independence and liberation—this devil-woman seems utterly confident. In
fact in some contexts this card can be read as offering freedom—sometimes
we need to give in to our desires to shake loose of old repressions. But be

careful about being seduced into reading the card this way in all but the most exceptional circumstances. In the main, like it or not, The Devil card warns of being trapped and controlled—the older tarot images of this card often show a man and a woman held in chains by a terrifying horned devil. The message is that what's offered to us as liberation—and which of us hasn't imagined all the things we'd be able to do if we were richer, more beautiful, more powerful, more loved?—is in reality a trap. When we look closely at the figure on this card we see that she is crushing white lilies, symbols of purity, under her feet. Follow her, we are being told, and your pure intentions, your morality and your ethics, may end up broken and destroyed.

## Sources

The original painting from which the engraving used is taken, is by Mlle. Georges Achille-Fould, (1865?-1951). This interesting French woman painter (Georges can be a woman's name in France) won respect as an artist very early in her life—she exhibited a painting "In the Market Place," at the Paris Salon of 1884 when she was described as being "still in short skirts". She was a pupil of several well-known teachers and won many art awards during her career. Achille-Fould's mother was an art critic and wrote her articles under the pen-name "Gustave Haller"—like many intellectual women of the time one assumes she may have had to pretend to be a man in order to be taken seriously. The preface to one of her books was written by Georges Sand, the French bohemian novelist and feminist. All in all it seems as though the young Georges had an artistic, intellectual and far from conventional background.

Later in her professional life, Georges Achille-Fould mainly painted scenes of ordinary life and portraits. Her most famous, one might even say notorious, picture was a portrait of Rosa Bonheur, the renowned painter of animals. In the portrait, which is set in her studio, Bonheur wears the man's clothes which she customarily preferred, and looks confident, calm, and every inch an artist at the peak of her career. It's a strikingly warm and honest portrayal of a woman who was considered by some to lead a rather shocking lifestyle.

# XVI THE TOWER

## Keywords and phrases

Cataclysmic change • Explosive events coming suddenly • Feeling as though everything has fallen to pieces • Dramatic disruptions and upheavals • A necessary shake-up in order for things to change • A sudden release of emotions that you've been bottling up.

## Suggestions for reversals

Some minor projects or relationships fall apart, but not in an important way • You narrowly avoid a catastrophe • Things begin to recover after a period of chaos • Ignoring or refusing a major change • Inner confusion or anger that you don't express.

THE TOWER

We sometimes use the expression "A shipwreck" to describe something—a project, a relationship or an event—that's turned out to be a complete disaster. It's certainly a graphic description. But in this card the image of a shipwreck is literal. We see the scene after the ship has gone down and only two survivors are left, clinging to a piece of wreckage. They are battered and exhausted, but they are alive.

The Tower is another of those cards in tarot that can alarm people (fortunately there really aren't very many in the deck that can be seen as "bad" in this way). One of the unnerving things about this card is that it points to events that are unexpected, it's this that seems to scare people—after all, none of us much like unpredictable changes in our lives. But does anyone get through life without some catastrophes occurring, large or small? Can we really expect to be able to predict and control everything that happens in our lives? There is a realism in this card, because it reminds us that things can come and hit us "out of the blue", but it also, crucially, tells us that we can survive such events, in fact coping with a disaster of some sort can teach us to be stronger, more resilient and more accepting of life's ups and downs.

There is a nuance in this card that it's easy to miss at first. The piece of mast that the man and boy have strapped themselves to has formed the rough shape of a cross. In the original engraving this association is more clear—the figures of Virgin and Child are seen in the distance at one side and the original is titled "Stella Maris" (the Star of the Sea) the name by which the Virgin Mary is

often referred to by seafarers. You may not be a Christian, but in any case I think the symbolism here has something to add to the meaning of the card; it tells us that in times of disaster, when our resilience is stretched to the limit, it may be faith that gets us through. Whether your faith is a formal religious one or simply a more personal set of beliefs, or simply takes the form of faith in your own abilities and determination, holding it strongly and being able to call upon it in difficult times can be a tremendous source of strength.

## Sources

This image is taken from an engraving based on a painting by Virginie Demont-Breton and, as mentioned above, it was originally called "Stella Maris". The artist became known in particular for her pictures of fisherfolk and their families, and also for her depictions of motherhood. She exhibited widely in Europe, won many awards and rose to the position of President of the Union of Women Painters and Sculptresses. She was also the second woman to receive the cross of the French Legion of Honor.

It's a curious fact that one of Van Gogh's works, "The Man is at Sea", was copied from a painting by Demont-Breton.

> I declare this tower is my symbol; I declare
> This winding, gyring, spiring treadmill of a stair is my
> ancestral stair;
>
> William Butler Yeats, "Blood and the Moon".

> Tossing as if old ocean's foam
> Were rocking to its highest home;
> Moaning as if the sea bird's wail
> Were screaming o'er the tattered sail;
> And ev'ry ship were tempest toss'd,—
> Its rudder gone,—its pilot lost;
>
> Abigail Stanley Hanna, *Withered Leaves from Memory's Garland.*

# XVII THE STAR

## Keywords and phrases

Health and healing • Hope and optimism • The dawn of better times • Peace and serenity.

## Suggestions for reversals

Improving health, though there may still be some problems • A short period of peace and serenity • Finding it hard to maintain your hopefulness • Striving to find the "happy ending" but you're not quite there yet.

The Star is one of the most welcome cards to see in a spread, as it is rarely anything but very positive, even when reversed. It's a card about hope and health, and the profound and lasting happiness that comes from both

THE STAR

physical and mental well-being. It has a serenity about it that, coming immediately after the chaos and shock of The Tower, reminds us that optimism and hope can get us through the hardest of times and lead us on to new beginnings.

Our Star stands in a deep pool, surrounded by blue lotus flowers. She seems self-contained, not gazing out at us, but rather lost in her own thoughts, which are obviously happy. In the RWS version of this card, the Start pours water from two jugs—one on to the land and the other on to the water. Here, the stream of water instead comes from the land—gushing out of a rock—and pours into the stream in which the Star stands.

The lotuses can be associated to Nefertem, the Egyptian God of the blue lotus, the early morning sun and also of both beautification and healing. The Egyptians believed that even the perfume of this flower (which is indeed divine) could bring healing. Incidentally, in the traditional RWS card, there are no lotuses, but there is an Egyptian reference in the form of an ibis (hardly visible on a tree in the background of the card), sacred to Thoth, so the reference to Egyptian symbology in our card does link subtly to the RWS tradition.

It can be useful, when interpreting this lovely card in a reading, to consider the many different ways in which hope may manifest itself in our lives. The nineteenth century novelist Marion Crawford wrote, "The most miserable of all the hopeless ones are those that wilfully turn their backs on Hope when she stands at the next corner holding out her hand rather timidly." [*The Little City*

*of Hope*] and indeed, we all know that it can sometimes be hard to recognise and embrace hopefulness during a period of despair or depression. Hope comes in many forms. In some readings, this card may advise us that we can find it in faith, a belief that things will work out because a deity watches over us. But hope may also be entirely secular in nature, simply an inner source of inspiration, optimism and, sometimes, resilience in the face of difficulties. We may be given hope by a person or an event that comes at the right time. Or we can find hope in ourselves, and sometimes against all logic and in spite of the most testing circumstances. Hope can be self-fulfilling, because it can simply be by continuing to hope that we save ourselves and survive through hardships. Even in the darkest times, hope can usually be found, shining out like a star and helping to guide us to renewed happiness.

## Sources

This is based on an engraving from a painting by Leopold Schmutzler (1864-1940) titled "Sea Rose". Schmutzler was an Austrian painter who specialised in elegant high-society scenes and portraits of beautiful women in rococo or empire style. His pictures are in numerous museums in Germany, Austria and Hungary.

# XVIII THE MOON

### Keywords and phrases

Magic, enchantment and mystery • Wild imaginings, both visionary and somewhat frightening • Mental disturbance, confusion • Spells and illusions • Illusions and visions—good or bad.

### Suggestions for reversals

Confusion, delusions • Attempts at witchcraft, playing unwisely with the occult • Resisting any contact with your intuition or sixth sense • Insisting that you know the realities, though the true situation may be more hidden or mysterious.

The Moon card often provokes an emotional reaction when it appears in a card reading. It's a card that many people love the imagery of, and yet it's also one that can provoke anxiety. The response to its appearance can sometimes be summed up as, "What a beautiful card, but how I wish it hadn't come up in my reading." Why is this? Well, it all seems to come down to the way you feel when faced with illusions, visions, fantasies and imaginings, because The Moon is about all of these, for good or ill. Sometimes it can point, also, to a "sixth sense" or psychic abilities. It's the card of the "See-er" who can gaze at things beyond our material world. If you're confident about the nature of your visions and dreams, and about your ability to put them to good use as creative or intuitive inspirations, then The Moon has nothing threatening about it. But if you are feeling disturbed, a little unbalanced, or just that you could do with a good dose of reality in your life, this card can seem like a frightening portent of madness or delusion. The moon itself has, for a very long time, been associated with lunacy (from the word "luna", the moon) and also with witchcraft and shapeshifting, such as the transformation of man to wolf in the werewolf legend, and this can all seem rather alarming when this card appears in a significant position in a reading.

I find it a shame that in modern times the Moon card seems to have gradually become more of a threat than a promise. Maybe with so many people struggling with their own need for groundedness and self-confidence, it can be seen as an unhelpful vision of weirdness or "otherness". But personally, I often welcome this card. We need fantasy and dreams in our lives, and it can be

good to embrace things that are not altogether of this material world.

The image we've chosen for The Moon shows a woman who seems slightly distanced from reality, almost as though in a trance, she gazes into nothingness and combs her long hair. Her comb and pearls suggest the lorelei, or siren, the German equivalent of the mermaid, who lured men to their doom if they allowed themselves to be seduced by her. The crescent moon on her head suggests classical depictions of "Night" and also of Artemis, the virgin goddess of the hunt and of the moon. There is then, something of the siren and the goddess in this figure. She's alluring but dangerous, as dreams and visions themselves are. When The Moon comes up in a reading, you may welcome the other-worldly imaginings and fantasies that she offers, but it's also perhaps wise to be aware of the risks of being seduced by them. For if you are once drawn fully into a world of illusions, it may be hard to find the way back to reality.

## Sources

The Moon herself is based on an engraving from a painting by German artist Otto Theodore Gustav Lingner (1856-?), titled "Lorelei". The background is composed from other engravings.

> "What have you looked at, Moon,
>     In your time,
>     Now long past your prime?"
> "O, I have looked at, often looked at
>         Sweet, sublime,
> Sore things, shudderful, night and noon
>         In my time."
>
> "What have you mused on, Moon,
>     In your day,
>     So aloof, so far away?"
> "O, I have mused on, often mused on
> Growth, decay, Nations alive, dead, mad, aswoon,
>         In my day!"

Thomas Hardy, "To the Moon".

# XIX THE SUN

### Keywords and phrases

Happiness and joy • Confidence, everything looks bright • Success and optimism • Things turn out well • Enlightenment, seeing the real situation • Clarity and a flash of understanding. • A feeling of freedom and lightness, anything's possible.

### Suggestions for reversals

A lesser happiness • Things become clear, but only for a time • A small celebration • You appear confident, but there are some uncertainties underneath the facade • Success, but there is more work to do • Showing off, being too egotistical and sure of yourself.

THE SUN

This is one of the most joyful cards of the Majors; coming after the intrigues and ambiguities of The Moon, The Sun speaks of clarity, understanding and a sharp and joyous perception of the beauties and opportunities of life. It indicates optimism and certainty—you're free of the restrictions of muddled thinking or confusion and things seem easy, clear and very positive right now. When this card appears in a reading it can tell you that it's time to take a step towards more freedom and happiness. It may point to a project you've been working on that suddenly flows easily and becomes successful, or that relationship that reaches a wonderful stage of being clear of obstacles and misunderstandings. Or it may refer to how you feel within yourself, as you see things with a bright new hopefulness that makes you brimful of confidence.

The woman on this card rides a white horse and holds a hoop of spring flowers over her head. She's accompanied by a cherub who flies ahead of her. All around are more spring flowers and bright sunshine. The floral hoop made of a bough from the May tree is actually a traditional part of the May Day or Beltane celebrations, which mark the end of the winter half of the year and the beginning of the summer half; it heralds bright days to come.

By the way, the fifteenth century Visconti-Sfroza deck includes a Sun card that shows the sun being carried across the sky by a cherub. The cherub in our card therefore makes a nice connection to this earliest of tarots.

## Sources

This is taken from an engraving of a painting by German artist Alfred Schwarz (1867-1951). Schwarz specialised in painting portraits, usually of society ladies. From 1888 to 1896 he showed work in the Berlin Academy Exhibitions and from 1904 and 1910 he exhibited as part of the Berlin Art Exhibitions.

> "When we get there it's 'most sure to be fine,
> And the band will play, and the sun will shine!"
>
> Thomas Hardy, "In a waiting-room".

# XX JUDGEMENT

## Keywords and phrases

Awakening to a new life • Rebirth and renewal • Finding an alternative way of living • Feeling refreshed and rehabilitated • Putting the past behind you and going on to a whole new existence • Shaking off guilt or regret and realising that "today is the first day of the rest of your life".

## Suggestions for reversals

Denying or resisting the possibility of a new life • Clinging to the past • Repeating old cycles, finding it hard to break from them • Being judged harshly, possibly being punished for old mistakes.

JUDGEMENT

The tarot Judgement card traditionally shows an instantly recognisable biblical "Last Judgement" scene, in which an angel sounds a trumpet to waken the dead who are rising for their Day of Reckoning. The picture we have chosen is gentler and doesn't have a Christian iconography, but it conveys the meaning of this card—essentially about beginning a new life—with great charm. The young couple are kneeling, not in front of an angel, but instead before the Fairy King and Queen, Titania and Oberon. They are being blessed by other fairies—though in fact the harp-playing fairies are very much in the traditional style of angels—and are clearly about to arise to begin a glorious new life. Are they being judged? Certainly they are being acknowledged for their actions—and found worthy of reward.

The Judgement card comes at the end of the Major Arcana, the last card before the transcendental happiness and bliss of The World. It's a call to leave behind the trials and tribulations, the triumphs and disappointments of the Major Arcana journey, and to step forward as a changed person into a timeless joy. Of course when this card appears in a reading it may not promise nirvana, but Judgement does at the very least herald a new beginning and a feeling of rebirth or the revelation of new possibilities. It signals an opportunity to rediscover or reinvent yourself in a fundamental way.

A whole new start can be daunting—as we all know, change is challenging, even when it's also thrilling and full of promise. The couple in this image look awestruck as well as joyous. But when you're interpreting this card, remember that

it indicates a tremendous opportunity to walk away from past actions, concerns and burdens and begin life anew. Don't be scared about what you've already left behind, instead look forward and anticipate what lies ahead.

**Sources**

The original engraving is by Gabriel Mar and Gustav Closs and was an illustration to a 1898 edition of Christoph Martin Wieland's (1733-1813) popular romantic epic *Oberon*.

> "Peace! Peace!" he cried, "when we are dead, the Day Of Judgement comes, and all shall surely know Whose God is God."
>
> Percy Bysshe Shelley, "Canto 10".

# XXI THE WORLD

**Keywords and phrases**

Reaching a state of complete happiness
• Rapturous joy • Sheer happiness—dancing
through life • Ultimate fulfilment, reaching
your life's goal.

**Suggestions for reversals**

Happiness, but of a lesser sort • Fulfilment,
but only in some areas • Denying the culmina-
tion of something important • Joy from
everyday things rather than from deeper
spirituality • Reaching a satisfying state, but
you still feel something is missing.

The final card of the Major Arcana is The
World, a joyful celebration of arrival, fulfil-
ment and achievement. It's a time of sheer elation. If you read the Majors, as
many modern tarotists do, as a sequence that shows the Fool's Journey through
life, then the World card is the happy conclusion, the successful end of an
earthly and spiritual journey. Traditionally, it shows a figure—a man, a woman
or a rather androgynous figure, according to different decks—dancing. At each
corner winged creatures watch; there are four of them, lion, angel, bull and
eagle, symbols of the Christian evangelists.

In our image, the creatures are replaced by women and cherubs both of whom
fly through the air. The whole orientation of the picture is slightly disorientat-
ing—where is the ground and where is the sky? It's reminiscent of the trompe
d'oeil paintings found on the dome of ancient churches, in which we see
figures ascending or descending between Earth and Heaven. Indeed, the World
card speaks very much of this connection—a time when you feel that you can
touch a higher spirituality and find your personal form of beatitude or heavenly
ecstasy. You may well be unsure if your feet are touching the earth!

In our modern times this kind of mystic transcendence can be alarming or
even a little laughable. We aren't usually prepared to deal with it. Aren't we
always urged to keep our feet on the ground, to be practical, to be realistic?
The message in the tarot Majors is that it's only by experience, both good and
bad, challenging and familiar, that we can prepare ourselves for such a mo-
ment.

Many readers seem to shy away from the more spiritual aspects of this card and instead focus on it as an ending, a final stage in a process or the conclusion of a sequences of events. It can be all of these, but we shouldn't lose sight of the fact that transcendent, intangible joy is at the centre of The World card's meaning. When this card appears in a reading, look for an event or experience that generates a feeling of immense happiness, spiritual joy and fulfilment. Remember though that this can come from very simple things as easily as from grander events. We may feel in touch with the sublime when we do something as ordinary as going for a walk in the park on a spring morning, sharing a meal with friends and family, or like the women on this card, gathering a basket of glorious flowers.

## Sources

This picture is from an engraving by Gabriel Ferrier (1847-1914), originally entitled "Flowers".

Gabriel Ferrier was a French portraitist, still-life and genre painter, and also worked as a decorator. He won the Grand Prix de Rome in 1872, then taught at the Ecole des Beaux-Arts. Interestingly, he once produced his owen interpretation of Leonardo Da Vinci's "Mona Lisa". This copy is now in the documentary collection of the Louvre in Paris.

Sweet joy I call thee:
Thou dost smile,
I sing the while;
Sweet joy befall thee!

William Blake, "Infant Joy", *Songs of Innocence and Experience.*

# THE MINOR ARCANA

The Minor Arcana, the fifty-six cards that make up the four suits—Wands, Swords, Cups and Pentacles—of the tarot, concern day-to-day life and events, people and influences in the real world. This doesn't make them inherently less important than the Majors; on the contrary, many of us find ourselves often more concerned with the immediate and tangible than we are with higher matters of spirituality or universality. It's the suit cards that concern the more material and mundane world of body and mind rather than the ethereal, elevated soul and spirit world of the Majors. In a reading the Minors should therefore be regarded as the real-world manifestations of the Majors' higher ideals. As such, they speak of the things that touch our lives in a very immediate way and this means, for better or worse, that they can cover all sorts of issues from the broad-ranging to the trivial. In some readings they carry a surprising amount of irony, humour and playfulness, though they can also offer blunt advice and quite precise warnings on occasion.

The four suits of the Minor Arcana each have their own general characteristics, represented by one of the four elements. Here is a summary of the correspondences, together with some brief keywords (the characteristics of each suit are dealt with in more detail later):

> Wands: Fire—energy, action, impulse, passion, drive, forcefulness, charisma.
> Cups: Water—emotions, feelings, sensitivity, intuition, the arts, flexibility, passivity.
> Swords: Air—thought, intellect, analysis, reason, logic, conflict, anger, willpower.
> Pentacles: Earth—practicality, skills, reliability, hard work, material and financial matters, conscientiousness, routine.

> Some decks assign Air to Wands and Fire to Swords, but this is much less common.

The numbered cards—Ace to Ten—of each suit also have similarities that work across suits. The Aces, for example, tend to be strongly energetic cards that point to beginnings and opportunities while at the other end of the sequence the Tens all indicate the characteristic of the suit culminating in an extreme—this can be positive or negative. In my explanation of each card I've aimed to being out these correspondences, and also to clarify the individual focus of each card.

Descriptions of the Courts can be found in the section on Court Cards on page 178.

> Cup, Lance, Dish, Sword, in slightly varying forms, have never lost their mystic significance, and are today a part of magical operations.
>
> W. B. Yeats

> The memory kept by the four suits of the Tarot, Cup, Lance, Sword, Pentangle (Dish), is an esoterical notation for fortune-telling purposes.
>
> W. B. Yeats

# MINOR ARCANA: WANDS

Wands' element is Fire—energy, action, impulse, passion, drive, forcefulness, charisma.

The fiery and passionate Wands suit refers to events and actions that are enthralling and full of life and energy, just as fire itself can be. The cards may refer to new projects, plans and ambitions, and also celebration, victories, opportunities and excitement. But no card in the tarot is either all good or all bad, and Wands cards also have their potential down side; fire if left to run wild, is dangerous and all-consuming, and many of these cards may indicate qualities or events that are full of passion but hazardous if not treated with due caution and care. We're often told, after all, not to play with fire..

This suit is not about mental or physical conflict, as the Swords can be. But any energy, even of the less aggressive kind that we see in Wands, does need to be kept under control. When we consider the Wands cards we see constant tensions between the desire to spring into instant action and the less thrilling, but necessary, need to conserve energy and plan ahead. There needs to be a balance between these; when there is either too much spontaneity or not enough, then opportunities that require not only drive and energy but also planning and foresight, can quickly come to nothing.

The Ace of Wands is the great "get up and go" card—bursting with energy, vitality and a burning desire to get things moving. In both the Two and Three, we see expansiveness and dreams of exploration—though these more likely to be acted on and made real in the Three. By the Four we see some "Devil may care" carnival atmosphere—anything goes and there is a lot of joy in kicking off daily responsibilities for a while. But the Five shows the irritations and setbacks that may follow when you rush into things with no thought of the consequences—or of the need to pre-plan; it's a card of petty struggle and wasted energies. The Six is more positive, things are back on course, challenges and difficulties have been conquered, a great deal has been achieved and there is some self-congratulation all round. Perhaps it came too soon though, because the Seven shows hard fighting, and while enemies are successfully defeated, it takes a lot of energy. The Eight showers down opportunities, things that you've striven for come to a conclusion at last, but there's so much going on that instead of resting you just keep on going. In the Nine the constant action has begun to take its toll, you feel you can't stop, though you also know that sooner or later you may have to. You're getting worn out. The Ten—the

culminating card of this active suit—shows the outcome of driving yourself ever onwards, taking on more and more, forcing yourself to keep going. The final state is exhaustion, a feeling of burden, a nostalgia for times when you could rest, relax and just forget all the things you're supposed to be doing.

In general, Wands cards indicate an abundance of life and passion in life and often a good deal of optimism. With the benefit of Wands' influence and energy, new projects can be quickly got off the ground and actively developed into something great. Sheer verve and enthusiasm can make things happen, and this, together with the ability to be flexible and to adapt and invent if things later need to be changed, makes Wands powerful movers and doers. Wands are adaptable, bursting with original ideas and always full of life and energetic abilities, although sometimes they are overly optimistic about the sheer amount they can take on.

In *The Victorian Romantic Tarot*, the Wands show confident, lively figures who are independent and energetic. There's a lot of dynamism in the images on some of these cards, and a certain self-assurance also. In a reading you may expect these Wands cards almost to jostle to be noticed.

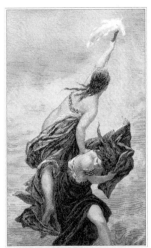

# ACE OF WANDS

### Keywords and phrases

A new opportunity that inspires energy and enthusiasm • Optimism, doing something novel and unexpected • Inventions and innovations • Bravery and courage in the face of something new • Machismo and forcefulness.

### Suggestions for reversals

An opportunity comes to nothing • A new project stalls because of lack of energy • A show of machismo that is unpleasant and achieves nothing • Tiredness, perhaps just temporary—but don't begin new enterprises just yet.

The Wands suit stands for fiery action, a blaze of energy, and the Ace of Wands is the card that signifies its birth. It holds out the promise of tremendous drive and power. Things will get off to a spectacular start, taking off like a rocket. However, remember that all this activity can soon lead to burn-out if you don't handle the sheer rush with some control and moderation—fireworks are great, but they don't last long. This small warning aside though, it's a wonderful card to see when you are beginning an enterprise or project that will demand a good deal of energy—such as starting a business, undertaking extensive travel or taking on a new leadership role. Just make sure that you have some plans in place to build on these thrilling beginnings.

Our image of this Ace shows two women, or nymphs, literally flying upwards into the sky, holding aloft a burning torch. No earth can be seen, instead they are surrounded by mist and sunlight. This card, with its usual image of a burning or blossoming wand, is often taken to show potency or virility—it can be quite a "male" card in the context of some readings, although in our image this interpretation is tempered by the fact that it's female figures who hold aloft the torch. The burning torch is a powerful and popular symbol in its own right, still used extensively both graphically and in actual physical form—the Olympic torch that lights the Olympic flame being one of the most striking examples. The torch signifies life, and the life-force, and promises a surge of action. It has also been used as a symbol of anything that is fiercely attractive and sensual; appropriately, as Wands cards often have a touch of fiery passion about them:

Somebody, I think, has called a fine woman dancing, a brandished torch of beauty.

Isaac Bickerstaff, *The Tatler*

A "torch of beauty" is an exciting way to see this card. When it appears in a reading, expect energy, action, adventure, and all the opportunities they bring with them.

## Sources

This image is taken from a picture by Czech artist Hanuse Marketa (we have no dates for this artist). It was originally titled "Morning" and, appropriately, symbolises the rays of the rising sun as they shoot into the sky. For its sister image, "Afternoon" see the Ace of Pentacles.

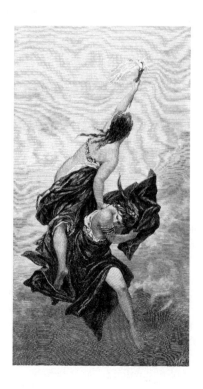

# TWO OF WANDS

## Keywords and phrases

Dreaming of better and bigger achievements • Wishing you could go further, do more • Striking out, but not too far • Recognising that your world is too small and restrictive—you can do more • The first steps have been taken successfully—now what?

## Suggestions for reversals

Realising that you ambitions are too constrained—wanting to be more ambitious • Caution and fear—you should be "out there" but you don't dare take the first step • Feeling rebellious about the smallness of your world, but with no idea how to break out.

In the traditional RWS (Rider Waite Smith) imagery, this card is so similar to the Three of Wands, that the question the two cards beg is, "What's the difference between them?" In fact, while the two are very closely related in meaning, in another sense, a gulf separates them. Essentially, the Two is about longing for more challenge in your life, the Three is about planning for this to happen. In the Two there is a sense of yearning; it's about feeling desire, but being unsure how to achieve what you long for. In contrast, the Three shows more confidence—a conviction that you'll get there, even if you still have a long way to go.

In our pictures we've tried to communicate both the similarities and the differences between these two cards. Our Two shows a young woman in rich dress, who is standing at a seashore gazing out at nothing in particular. Next to her is a wall in which there's a carving of a woman's head—she's also looking out, but in reality is just an image stuck in stone and unable to go anywhere.

The real woman smiles faintly, and has a faraway look that indicates pleasant daydreams. But will she actually make any of them happen? She can gaze out to sea, but in fact she is in a walled environment, and she, like the statue, may be quite stuck where she is.

This card is about the moment when you have achieved a certain amount and know that things are going well. You're enjoying the period of rest that you've earned, but now you look at what you've done and feel it's not enough. You

begin to long for something more exciting, thrilling, or perhaps just simply more impressive. But you feel rooted to the spot, anxious and unsure whether or not that next step is too risky.

However, there's another aspect to the symbolism of this card that opens up a broader possible interpretations and, incidentally, links it more closely to the Three of Wands. The woman holds two palm fronds in her hand, and palms have a broad range of symbolic meanings. Firstly they can stand for victory, triumph and also, at times, of festivity. Perhaps she is proud of what she's already achieved, and feeling celebratory? But palms also, in the Christian tradition, stand for martyrdom; so is she making herself into a martyr by staying behind while others leave to go out into the world and achieve great things? Then again, to the Egyptians, the palm was a symbol of long life, so the interpretation may be that this young woman feels that a long life stretches before her, there's time to do all that she dreams of.

Which interpretation is the "right" one? The answer lies in the whole reading. While the basic meaning of the Two of Wands is about yearning for the challenges of a wider world that you can't quite reach—a lack of confidence and practical plans about actually stepping out from the safety of the present constraints—the outcome indicated may vary. This card may signify that the person in question will eventually overcome their anxieties and move on to a broader world stage. Or it may—in contrast—say that they will always remain behind, watching others do what they can only dream of. Like most of the Twos in the tarot suits, these two alternative meanings are both part of the card, so in a reading, let the other cards, and your own intuition, point you in the right direction.

**Sources**

This is taken from a print of a painting by A. Schram titled "Palm". It's possible that this is the father of Abraham Schram, a slightly later painter known for landscapes.

THREE OF WANDS

# THREE OF WANDS

## Keywords and phrases

Planning ahead with confidence • Exploration and expansion • Taking your projects on to a wider stage • Longing for new horizons • Leading the way forward • Ambitions that you begin to put into practice, probably in an imaginative way.

## Suggestions for reversals

Your plans for expansion are blocked • You can't see your aims clearly, and it's frustrating • Self-doubt about your leadership abilities • Trying to move onto a more global stage, but meeting difficulties.

The Three of Wands is about expansion, exploration and ambitious plans for the future. It often, though not always, indicates business or project plans—and being a Three, it usually refers to matters that involve other people rather than just the individual. The figure on this card is leader, manager and planner, as well as explorer and, on occasions, dreamer. But the essential difference between this card and the Two of Wands, is that here we see someone who is likely to have the energy and drive to fulfil his or her dreams. The card is much less "If only," and far more about addressing the question, "How do I make this happen?"

The picture shown is of a young Greek man, dressed in red—the fiery colour of Wands, and symbolic of energy and action—and holding a lyre. The lyre was a stringed instrument much beloved in antiquity. Interestingly it is believed to have been invented by the god Hermes, who we are told created it by combining a large tortoise-shell with the intestines from a cow and the horns of an antelope. This, and the red colour of the cloak, gives the card a link, visually and symbolically, with the RWS Magician, which is also traditionally associated with Hermes. Indeed, the figure on the Three of Wands is a type of very down-to-earth magician; he makes things happen, he may make some dreams—those involving travel, expansion, exploration, come true.

The young man can also be regarded as a depiction of Apollo, the Classical Greek god of healing, the arts and of oracles. He was the leader or head of the Muses (see the Three of Cups) and was particularly associated with poetry and

music. If we think about these references when reading this card, then—very appropriately for the Three of Wands—we open the way to some expansive and poetical interpretations that may lead us to new possibilities. Instead of simple business and project planning, we might see much more imaginative and exploratory scenarios. Perhaps the young man on the card is opening his mind to the most wild and ambitious possibilities, knowing that he really may have the ability and drive to make them into reality. After all, as the writer George Bernard Shaw once said, "imagination is the beginning of creation".

**Sources**

This is taken from an aquerell print of a painting by the German artist Karl (also known as Carl) Armbrust (German, 1867-1928). It is a portrait of "Anacreon" the 6th century Greek lyric poet who played a lyre to accompany his verse.

> I traced the whole terrestrial round,
> Homing the other side;
> Then said I, "What is there to bound
> My denizenship? It seems I have found
> Its scope to be world-wide."
>
> Thomas Hardy, "His Country".

# FOUR OF WANDS

## Keywords and phrases

Changing your lifestyle in an exciting way • Kicking free from the mundane • Taking a holiday or a day out • Feeling free and prepared to take a few risks • Striking out for a better life • Something Bohemian and untamed comes into your world.

## Suggestions for reversals

Wanting to change your life, but holding back • Making only tiny changes for the better, clinging too much to old ways • A celebration or party that doesn't quite work out the way you wanted • Admiring "free spirits" but being too fearful to join them.

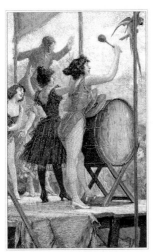

FOUR OF WANDS

The Four of Wands is about the joy and sense of freedom that comes from taking time out from the usual routine. Nowadays carnivals, parades and rock festivals are often the events that allow us to be a bit outrageous, do something daring, have fun and just forget work and responsibilities for a while. In the nineteenth century, it was more likely to be fun fairs, travelling shows and circuses that provided this temporary social liberation.

One striking thing about the image we've used on this card is the contrast between the costumed young show-women on the stage—wearing glitzy, revealing clothing, banging drums, singing and shouting exuberantly—and the much more "buttoned-up" young ladies that you can just catch a glimpse of in the audience. But it's the "ladies" who look entranced and thrilled—the women on stage are enjoying themselves, but to them it's presumably all in a day's work, whereas for the audience this is a glimpse of something free, fun and slightly shocking—and they obviously love it.

In our modern society most of us have much more freedom than would have been the case in the nineteenth century—especially if we are women, from an ethnic minority or in any other group that was particularly repressed in the Victorian era. Thankfully, we don't have to gaze longingly at a fair or a circus performer to imagine a little taste of Bohemia or unconventionality, it's generally available to us when as we need to experience it. Yet, ironically, don't many of us still get stuck in one lifestyle, or one routine? Boredom, or a sense of being constricted, is still commonplace. So many people long to try some-

thing different, but find excuses not to; "Maybe when the children are grown up I'll leave my job." "Perhaps when the mortgage is paid off I'll travel." "Once I've got my qualification in accountancy to fall back on, I might try singing in a band." This card tells us not to put off forever our dreams of non-conformity; we need to seize the moment when freedom is offered to us—even if it's just temporary, a brief opportunity to be a bit experimental or to try something new and less solid and sensible than the everyday routine. There is real joy, and simple fun, in sometimes breaking our habits and, to use the famous 1960's parlance "dropping out" of our normal life. A bit of liberation and audacious frivolity can do us all good—as long as we know that, like the circus, it may not last forever.

Still you never know. As we look at the image on this card we may well ask ourselves if any of the buttoned-up ladies did ever run away to join the circus and to wear those sparkly, spangly costumes of the girls on-stage. I rather like to think that at least one of them may have.

## Sources

This is based on an engraving of a painting by German artist Frederick Hendrik Kaemmerer (1839-1902). It is titled "Before the Idea".

> And inside the big tent the band played merrily, as only a circus band can play, jangling an accompaniment to the laughter and the shouts of the delighted multitude sitting in the blue-boarded tiers about the single ring with its earthen circumference, its sawdust carpet and its dripping lights. The smell of the thing! Who has ever forgotten it?

> The smell of the sawdust, the smell of the gleaming lights, the smell of animals and the smell of the canvas top! The smell of the damp handbills, the programs and the bags of roasted peanuts! Incense! Never-to-be-forgotten incense of our beautiful days!

> George Barr McCutcheon, *The Rose in the Ring.*

FIVE OF WANDS

# FIVE OF WANDS

## Keywords and phrases

Struggles and arguments • Fights over trivial matters • Hassles, annoyances and irritations • Testing your strength in a skirmish • Getting into pointless battles.

## Suggestions for reversals

Cooling down in time to avoid an argument • Shrugging off hassle and minor irritations • Refusing to fight over something silly • Being a peacemaker when all around you are losing their tempers.

This card is about those trivial but infuriating things that get under your skin and drive you to distraction. It could refer to a stupid argument over a parking space or a place in a queue, getting into a heated verbal battle over something that you know doesn't really matter, general headaches such as a train being delayed when you really want to be on time for a meeting, or a power-cut that happens at an awkward moment. We all have these moments when our anger flares up and we feel incredibly annoyed at something that we know, in reality, isn't really a big deal.

This card shows a fight; the result of some disagreement of imagined insult. One imagines these men have all leapt to their feet in response to a sudden burst of aggression. It's silly—one of the others is in fact trying to hold back his friend, and you can imagine that he's telling him, "It isn't worth it." But it looks as though this fight is a matter of pride now. It's pride that so often drives the refusal to back down when we know that logically we should. It's the base cause of many fights. Once we feel cross and irritable about something it's all too easy to expend energy turning it into a battle, when if our brain could control our passions we'd know quite well that fighting will solve nothing.

How many times have you lost your temper over something that you know is foolish? This card warns of this, and the message we might take from it is that pre-warned is prepared; if we know that there are irritations and annoyances on the horizon we can get ready to stay cool when they happen. If they've already occurred, then this card tells us to look back and realise that it really all was "a storm in a teacup".

**Sources**

From a picture by the Italian artist, Gustavo Simoni, (1846-1926) titled "The Argument".

> How many dream away their lives! Some upon gain, some upon pleasure, some upon petty self-interest, petty quarrels, petty ambitions, petty squabbles and jealousies about this person and that, which are no more worthy to take up a reasonable human being's time and thoughts than so many dreams would be.
>
> Charles Kingsley. *The Water of Life and Other Sermons.*

SIX OF WANDS

# SIX OF WANDS

## Keywords and phrases

Pride, enjoying being admired • Victory and triumph, usually (but not always) deserved • Basking in the glory • Great self-esteem • Showing off • Taking pride in achievement.

## Suggestions for reversals

Feeling ignored or passed over • Frustrated by lack of recognition for your achievements • A false vanity, feeling yourself more important than you are • Trying to take all the limelight for yourself, refusing to credit others • Loss of self-esteem, you doubt your own actions • Showing off, being too egotistical and sure of yourself.

A grand, festive parade; these soldiers are returning home after a successful campaign. They're dressed in their finest and carrying all the regimental banners and staves. Their proud commander rides in their centre, on a showy white horse. All in all, an impressive scene, as they bask in their moment of glory.

This card is about victory, self-esteem and a time of triumph when your accomplishments are recognised and applauded. We've shown this in a military context yet, even though the army here is historical rather than contemporary, many of us feel uncomfortable with the very idea of victory in battle or warfare. We know that such victories are not victimless, and that it's rare that, in warfare, things are truly black and white in terms of guilt and innocence. But this card is about a huge range of potential successes, not just military ones; passing exams and gaining qualifications, excelling at sports or the arts, being chosen as a community or club leader, or even just winning a debate that mattered to you. Most of these do not really mean triumphing, in any negative way, over your opponent. In fact, many sources of personal victory, such as the successful completion of a test or a difficult task, don't have any opponents at all; someone "wins" but no-one loses.

When you look at the image on this card, it brings to mind many of the dashing military heroes and anti-heroes of fiction. One of the best known is Mr. Wickham, the handsome officer in Jane Austen's *Pride and Prejudice* who is admired by all but turns out to be a callous and selfish breaker of hearts:

Mr. Denny addressed them directly, and entreated permission to introduce his friend, Mr. Wickham, who had returned with him the day before from town, and he was happy to say had accepted a commission in their corps. This was exactly as it should be; for the young man wanted only regimentals to make him completely charming. His appearance was greatly in his favour; he had all the best part of beauty, a fine countenance, a good figure, and very pleasing address.

Jane Austen, *Pride and Prejudice*

This brings us to a consideration of the whole idea of pride, triumph, awards and honours. All of these can be celebrated as positive and joyful; they only become a problem if healthy pride becomes self-absorbed vanity and the triumph involves lording it callously over others. There is a warning about vanity and egotism in this card, particularly when it's reversed—it's good to enjoy your moment of well-deserved recognition as long as you don't let it go to your head, or use it, like Mr. Wickham, to take advantage of others.

However generally the Six of Wands is a happy, festive card that indicates a time for enjoying your moment in the limelight, surrounded by friends and well-wishers.

**Sources**

The original picture is by German artist, Franz Skarbina (1849-1910). Skarbina studied at the Berlin Academy and spent two years as a teacher to two daughters of a Prussian army general. This is perhaps why he acquired some interest in painting military scenes—though in fact this is not a subject he is particularly known for. He then moved to Paris, where he continued his training and won several awards. When he later returned to Germany he became a member of the Berlin Secession art movement.

This painting shows a young Leopold I, Prince of Anhalt-Dessau, on his return from the War of the Spanish Succession (1701-1714). Leopold was a famous battle commander, and had the reputation of being both brilliant and courageous. As he rode into his final battle in 1745, he is believed to have said this prayer, "O Lord, let me not be disgraced in my old age. Or if Thou wilt not help me, then do not help these scoundrels either, but leave us to try to win ourselves." He in fact did win, survived, and died a peaceful death.

# SEVEN OF WANDS

SEVEN OF WANDS

## Keywords and phrases

Struggling to overcome enemies • Endless battles—but you know you'll win through • Fighting against the odds and prevailing • Standing firm against a determined attacker • Enjoying the struggle—perhaps too much so.

## Suggestions for reversals

Being afraid of competition • Taking a small struggle too seriously • Finding it impossible to keep up the fight • Losing a battle • Walking away from a quarrel or fight—this may be good or bad.

In the Seven of Wands, energy and enthusiasm become aggression and a love of battle. This card shows someone standing firm, and winning, against a whole host of opponents. He is relishing the battle—this is great if it's a fight worth winning, but not if it's a stupid struggle not worth engaging in. When this card comes up in a reading it's important to consider what kind of fighter it shows—a hero standing up for a just cause, or someone who just loves to get into a fight no matter what the reason.

The figure we see on the card appears aggressive rather than defensive, his wand is tipped with a spear and he looks prepared to do serious damage with it. But is his aggression justified? We can't tell. All we do know is that he is outnumbered but nevertheless seems fearless. This is admirable in a way, but it may not be entirely sensible; would a peace treaty be a better option?

This is a card that can be read as positive or negative depending on the context. There are times when we all need to stand up and fight for a belief, a person or a cause, whatever the odds. The Seven of Wands promises that in such a situation, you'll find the energy to overcome the opposition, although the battle may be fierce. However, the card can alternatively warn of a situation in which you, or someone in your life, leaps into a fight for no reason other than a love of winning.

## Sources

The central figure is adapted from part of an engraving from a painting titled "The Attack of the Macdonalds" by the Scottish artist Harrington Mann

(1865—1937). Mann studied at the Glasgow School of Art and then at the Slade in London. He's known for some beautiful stained glass windows in Trinity Church, Glasgow, as well as for his portrait and action pictures. He spent the latter part of his career in the USA, and died in New York.

# EIGHT OF WANDS

## Keywords and phrases

Things are finally within your grasp
• Opportunities and events—almost too many
• Energy, buzz, action • Travel, movement
• Reaching a thrilling conclusion • Falling
passionately and suddenly for someone.

## Suggestions for reversals

Too much happening, it feels chaotic and
overwhelming • Being stuck in one place,
either mentally or physically • Finding it hard
to bring things to a conclusion • A sudden
passion that passes very quickly, leaving you
feeling rather flat • Success, but there is more
work to do • A lot of opportunities, but you
lack the energy to take full advantage of them.

EIGHT OF WANDS

The Eight of Wands is about events happening at high speed—many things
racing at break-neck pace to their conclusion. This image, which shows
Hercules racing with the Ceryneian Deer, freezes a fleeting moment and
conveys the sense of this card with a thrilling precision. With both figures
running at full tilt, one feels that the image should be a blur, but in fact it's
crystal clear and sharp, almost as though seen from a heightened awareness,

This card signifies those exciting and challenging times in life when you feel
that opportunities are finally within your grasp—but that you have to move
quickly. This can be exhilarating and also confusing, and you may well wish
that things were not moving quite so fast, even though you feel enormously
energised by so much happening.

Usually, the card points to events—actual things taking place in your world,
rather than mental processes, although it can sometimes stand for the "Eureka"
moment when you finally perceive or "grasp" an idea. At its most literal, it can
indicate travel—actual movement by some speedy means such as a fast car,
bike or aircraft. In some contexts, it can also mean the moment of falling in
love—that sudden rush of emotion that seems to come almost from nowhere,
and sweeps you off your feet.

The picture on which our card is based shows the third task of Hercules,
which was to catch the Ceryneian Deer (in the original Greek myth, he was set

a total of twelve next to impossible challenges, all of which he managed.) The Ceryneian Deer, or Hind, was sacred to Artemis, goddess of the moon and also of the hunt. The animal was magnificent, with golden antlers like a stag and shining hooves of bronze or brass. It was so fast that it was said that it could outrun any arrow shot at it. Hercules' task was told to capture the hind alive and unharmed. It took him an entire year of following the animal before he was able to get close enough to grab her with his bare hands. But Hercules, in this depiction, does not look tired or desperate. On the contrary, he seems on the verge of laughing or shouting—completely elated at his imminent success. He is literally hurling himself alongside the hind, revelling in his ability, perhaps, finally, to catch it.

## Sources

The engraving that we adapted for this image is from a painting by Otto Schindler, a German artist whose work occasionally turns up in auction houses (particularly in Central Europe) but who otherwise seems largely forgotten. It's a shame—his work has a dynamism and modernity that was quite unusual in nineteenth century work of this type. Perhaps it was a little ahead of its time?

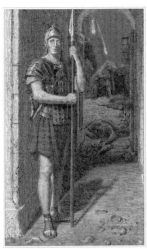

NINE OF WANDS

# NINE OF WANDS

## Keywords and phrases

Devotion to duty • Battered but not broken • Pulling yourself together for one final hard task • The strength to keep going—although you're weary • Staying at your post.

## Suggestions for reversals

Giving up—it's all too difficult • Exhaustion • Betrayal, not doing your duty • Cowardliness, though you've tried hard to be brave • Realising that the odds are overwhelming—so you surrender.

On this card, we see a terrified but bravely dutiful Roman sentry standing at his post during a disastrous volcanic eruption (the image actually depicts the eruption of Vesuvius in 79 A.D). Behind him, people hysterically try to save themselves and their possessions as burning rocks from the volcano rain down. The expression on the sentry's face is striking, he looks bewildered, scared but determined; it's a picture of someone who does feel fear, but who nevertheless manages to conquer it. He alone is not lost in panic. It's a more tragic image than usual for this card, as we know that Pompeii was devastated by this eruption and can guess that the soldier is unlikely to survive. Nevertheless, it's an inspiring depiction of courage and dutifulness in the face of an extreme challenge.

In a reading, this card needs to be interpreted carefully. It signifies bravery, an ability to stick to your duty against the odds, and to keep fighting through hard times—all of which are great qualities when the situation demands them. But much as we may admire the soldier in this image, don't we also have to ask ourselves if he is really doing the sensible thing? Is staying at his post while the nearby volcano erupts catastrophically really going to do any good? Actually, there is no straightforward answer to this question. Sometimes dogged determination to hold by one's responsibilities is the best possible course of action, at other times it may be somewhat misguided. This card asks us to think carefully about our response to struggle. Are we being brave and selfless enough? Or should we actually look after ourselves rather more and put duty second? It all depends on the circumstances in which we find ourselves.

## Sources

This is taken from an engraving that we found in a volume of the English publication, *The Art Journal* (1886). It's based on an original painting by English artist, Sir Edward Poynter (1836—1919), titled "Faithful unto Death". The painting is now in the Walker Art Gallery in Liverpool, and is described by the gallery as "the epitome of devotion to duty for Victorian morals." It was inspired by the discovery of the remains of a soldier in full armour during the excavation at Pompeii in the nineteenth century.

It would be almost impossible to imagine doing any set of Victorian images that didn't include at least one painting by Poynter. A pupil of Lord Leighton, and teacher of John Collier (see the Four of Cups), he spanned the whole period of art from the zenith of Classicism to the Pre-Raphaelites. He was long-lived and, as President of the Royal Academy, saw changes in fashion that led to the death of his beloved Victorian classicism and to the comparative obscurity of his own once-famed work. In an appropriately Nine of Wands way Poynter nevertheless stayed doggedly, determinedly and conscientiously at his post until he died, refusing to be swayed from his opinion that the classic formal style he had learned from Leighton was superior to the much sweeter, and ultimately much more popular, one of the Pre-Raphaelites.

# TEN OF WANDS

**Keywords and phrases**

Feeling burdened and crushed by work • Taking on too much • Being weighed down by responsibilities • Struggling with too many tasks, too many projects.

**Suggestions for reversals**

Throwing off some of the burdens • Letting things go—for good or bad • Refusing to take on more responsibilities • Recognising that you've been doing too much.

Have you taken on just a bit too much? Do you feel burdened, over-loaded and thoroughly over-worked? If so, you are experiencing what the Ten of Wands is all about. Coming at the end of the energetic Wands, you might expect this card to show a moment of tremendous energy, but in fact, as the culmination of Wands, it shows us a time when we have taken on a great deal, and realised now that the load is too heavy. It's a reminder that however active and energetic we are, there is a limit to what we can do. In that oh-so-descriptive metaphor, there is a "last straw that breaks the camel's back".

The woman we see in this card is loaded with wood and also carrying her child in a large cradle. Yes, she has a suitable carrier on her back, and yes, she's probably used to such hard work, but sooner or later it's going to have an impact on her, and already she looks tired and drawn. But she's a peasant worker, so does she have much choice? One nineteenth century writer, asking how on earth women could find any leisure time at all, listed some of the tasks that were expected of an average housewife of this period:

> Setting tables; clearing them off; keeping lamps or gas-fixtures in order; polishing stoves, knives, silverware, tinware, faucets, knobs, &c.; washing and wiping dishes; taking care of food left at meals; sweeping, including the grand Friday sweep, the limited daily sweep, and the oft-recurring dustpan sweep; cleaning paint; washing looking-glasses, windows, window-curtains; canning and preserving fruit; making sauces and jellies, and "catchups" and pickles; making and baking bread, cake, pies, puddings; cooking meats and vegetables;

keeping in nice order beds, bedding, and bedchambers; arranging furniture, dusting, and "picking up;" setting forth, at their due times and in due order, the three meals; washing the clothes; ironing, including doing up shirts and other "starched things;" taking care of the baby, night and day; washing and dressing children, and regulating their behavior, and making or getting made, their clothing, and seeing that the same is in good repair, in good taste, spotless from dirt, and suited both to the weather and the occasion; doing for herself what her own personal needs require; arranging flowers; entertaining company; nursing the sick; "letting down" and "letting out" to suit the growing ones; patching, darning, knitting, crocheting, braiding, quilting...

Abby Morton Diaz, *A Domestic Problem.*

It's a horrific list, but is the lot of today's woman, or man, who has to work and care for house and children necessarily all that much better?

Look again at the woman on this card, at that huge load of wood on her back and the cradle in her arms, and think about her situation for a moment. It's usual, when the Ten of Wands comes up in a reading, to advise the querent not to take on so many burdens. This is doubtless good advice, but what happens when we have little alternative? It's important to remember that some people don't choose to take on too much—they have it thrust upon them whether they want it or not. We've all met people who have a day job, an evening job, and do some freelance work on the side—simply to make ends meet. We've also all seen people who work tremendously hard and grow old before their time, stooped and withered by gruelling physical or mental work. When we draw this card in a reading, we should look at the options. If we, or our querent, are workaholic, overly ambitious, or simply the kind of person who can't say "no" when asked to take on yet another task, then the message of the card is clear; drop some of the burdens, free yourself of some tasks, and also—remembering the peasant woman in this image—be aware of your good fortune in having this choice and make the very most of it by liberating yourself of some unnecessary cares and responsibilities.

But, what if one is overwhelmed and overworked out of sheer necessity? Then the card asks us to recognise this—even if it's hard to acknowledge—and begin to plan a better future. When we take on too much it's crucial to make sure that this is only a temporary situation and doesn't become a habitual way of life.

## Sources

This is from an engraving of a painting by Italian artist Farmigiani, titled "Mother's Duties".

# MINOR ARCANA: CUPS

Cups' element is Water—emotions, feelings, sensitivity, intuition, the arts, passivity, creativity, imagination.

Like water itself, Cups can be deep, reflective and fluid, and these cards concern love, affection, sensitivity, intuition and compassion. In a reading they often point to the humane and sympathetic in all of us. However, even such good qualities can have a negative side. There are situations in which Cups suggest a tendency to be too fragile or sensitive, somewhat morose or even neurotic. Because Cups are focused on inner experience rather than outward action, they are also inclined to point to emotions that are passive and sometimes apathetic. At times, these cards may remind us that while being in touch with our emotions is vital for a happy and fulfilled life, over-emotionality is not good and needs to be tempered with some practicality and logic.

In *The Victorian Romantic Tarot* the Cups cards are particularly romantic—they're good examples of High Victoriana at its most escapist and idealistic. When we were designing the Cups, we reviewed our first sketches for this suit and realised that we'd included a high proportion of cards showing women and children. Though this wasn't a conscious decision, it arguably does suit the emotionally aware and intuitive nature of Cups. But the Cups suit isn't all sweetness and sentimentality—some of these cards are challenging and disturbing on occasions; they recognise that by opening ourselves up to emotional connection with others, we may experience heartache as well as joy.

However, the Ace of Cups is, like all the tarot Aces, almost all positive. It indicates creativity and emotion in plenty—almost overflowing in their abundance. It also hints of the beginning of a spiritual quest for a higher kind of happiness. The Two shows a first romantic meeting—at this point we see the first flush of delight, although both the Five and Eight of the suit will later show women in the more difficult throes of rifts with their lovers.

Meantime though, we see The Arts personified in the figures of the Classical Muses shown on the Three. In fact, the Ace, Two and Three set the overall suit theme of creativity, emotional relationships, the arts and, importantly, intuition and spiritual yearning.

The first doubts show in the Four, which indicates boredom and a rejection of both involvement with others and with the "good things" in life. In fact, in this card, we see depression and a "can't be bothered" attitude begin to set in.

The Five shows a continuation of this attitude, all you can see—in a relationship or a project—is what you've lost, not the good things that still remain. But the Six bring a change of feeling; it's the card, above all others in the tarot deck, that reminds us of simplicity, innocence and the importance, at times, of being as open and joyful as a small child. It councils against allowing cynicism to set in. By the Seven, optimism is rising again as a bewildering array of options and opportunities present themselves—but be careful, while it's a time to be open to possibilities, some of them may prove to be mere fantasies.

The Eight brings a definite pause for reflection; it's about walking away from a poor situation, and taking the first tentative steps towards a new beginning. It may indicate the break-up of a love affair, or point towards a change of job or a major house move. Remember that this is a time to look forward, not back.

The Nine and Ten of this suit bring us back to everyday joys and emotions. The Nine, "The Wish Card" is about pleasure in the very straightforward comforts of plenty; whether this is an abundance of food, drink, company, fun, or any of the other things that bring us straightforward enjoyment. There's nothing complex about this card; it indicates happiness of a simple sort that we can all identify with.

The Ten is in one sense a culmination of the suit. Although it doesn't mark the attainment of the spiritual search seen in the Ace (we have to wait for the Cup Courts to take up that quest again), it does show the achievement of a happy, stable family relationship—the family does not, of course, have to be a conventional one—and the resulting optimism, happiness and delight. In this final card of the numbered Cups, all is indeed sweetness and light.

# ACE OF CUPS

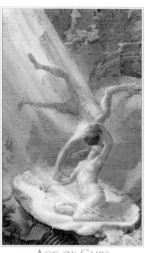

ACE OF CUPS

## Keywords and phrases

Opening to new beginnings • Over-flowing with emotions • New love, new feelings of passion • Creative and artistic projects blossom into life.

## Suggestions for reversals

Missing some wonderful opportunities • Feeling new love and passion, but still hesitating to open up to it • Wasting the gifts that you're being given • Your creativity is temporarily blocked.

The Ace of Cups, as the first card of the suit, signifies the birth of new emotions, sentiments and creativity—and these may be so intense that they're almost overwhelming. It can promise a new romantic love, but more often it points to the beginning of projects that you feel passionate about; particularly in the arts or creative fields. The card also indicates opening up to new emotions and new spirituality in your life. Perhaps you have felt rather closed off or reticent about acting on your feelings? This Ace shows a time when it's good to let emotions and intuitions flow freely—you can let down your guard.

The image on this card combines many of the symbols of this first card of Cups—the passion of a new love, the element of water and the open vessel—within its central, romantic theme, the origins of a pearl. The pearl, as a many-layered symbol, makes links to both the spirituality of the card (an aspect that's sometimes forgotten in favour of the emotionality) and—indirectly—to the Grail legend which is traditionally associated with the Ace of Cups. The image of a pearl is used in one of Jesus' most famous parables, "The Pearl of Great Price", to stand for the Kingdom of God. This metaphor was later developed into one of the most touching and delicate spiritual poems of all time in the fourteenth century allegory, *Pearl*, in which the pearl is at one and the same time a beautiful young girl who has died and the angelic creature who shows the narrator the Kingdom of God. Much later, in the Victorian age, Alfred Lord Tennyson linked the same metaphor of a pearl explicitly with the Grail legend, when he depicted the Grail as being housed in the pearl-like shining Kingdom of God:

I saw the spiritual city and all her spires
And gateways in a glory like one pearl—
No larger, though the goal of all the saints—
Strike from the sea; and from the star there shot
A rose-red sparkle to the city, and there
Dwelt, and I knew it was the Holy Grail,
Which never eyes on earth again shall see.

Alfred Lord Tennyson, *The Idylls of the King*, 1859-1885

Is this a lot of symbolism and transcendence to see in this one little card? Well yes, but then this tarot Ace does indeed overflow with meaning and spirituality. When you draw this powerful card in a reading it points to a time of enormous promise and strong feelings. It's a great moment to begin your own quest, whether this be for artistic achievement, creativity, romance or simply finding ways of opening up your deepest feelings about the issues that are most important to you. Only one small word of caution: in this wave of emotion and opportunity, do remember not to get completely swept away.

## Sources

This image is based on a painting by Albert P. R. Maignan (1845-1908) titled "The Origin of a Pearl." Maignan was born in Beaumont sur Sarthe in France and some of his works are still displayed there in the form of gobelins (woven tapestries). He produced several designs for gobelins and they tend to be in a similar format to "The Origin of a Pearl", so it's possible that this image was originally meant for that purpose.

Maignan's work was dreamlike, romantic and highly decorative. Curiously, he's now probably best known for his portrait of an absinthe drinker, titled "The Green Muse."

# TWO OF CUPS

## Keywords and Phrases

Meeting a partner or a lover • The beginning of a significant relationship • A contract between two people, perhaps a betrothal or a marriage • Finding your "soul mate" • A sudden strong attraction to someone, not necessarily romantic.

## Suggestions for reversals

Quarrels and misunderstandings in a relationship • An imbalance in feelings and passion between two people • A potentially good partnership that feels blocked or spoiled • A show of commitment that may not be honest—beware!

TWO OF CUPS

This is a simple scene, but shows what may well be a crucial moment in the relationship between the young man and woman. Has he just told her how he feels about her? He leans forward expectantly while she looks down shyly— certainly it's an intimate moment. The setting is rural and calm, they're in a garden, sitting on an ordinary bench, with two scarcely sipped little glasses of drink beside them. There is a stillness about the image, and one is sure both that they are alone, and that a sudden silence has just fallen between them— probably the pleasurable silence that, in those more modest times, might follow a declaration of love.

The psychologist Carl Jung once said, "The meeting of two personalities is like the contact of two chemical substances: if there is any reaction, both are transformed." The Two of Cups is about such a transformational meeting. It's often, though not always, about the first early encounters between two people who may become lovers. But the card can also point to the beginning of any strong and supportive relationship, especially when creativity and the emotions—ever-present characteristics of the Cups—are concerned. It's a card that signifies collaborations, co-operations and partnerships of all kinds, usually between two people, but potentially between two enterprises, groups or even two regions or countries. Because it tends to stand for the start of such a relationship, there may be a touch of immaturity sometimes—in certain contexts the card may imply an infatuation or a love that won't necessarily develop. In the typically cautious way of the Victorians, Joanna Baillie, a poet

of that period, sternly warned, "Friendship is no plant of hasty growth, Though planted in esteem's deep-fixed soil, The gradual culture of kind intercourse Must bring it to perfection." That's true, and instant friendships are not always long-lasting. But whether the feeling of mutual understanding indicated by this card turns out to be fleeting or enduring, the appearance of the Two of Cups in a reading speaks of the joy of finding new support, comradeship and a shared understanding. We can all lift our glass and drink to that.

## Sources
This painting is originally by Carlo Wostry, 1865—1943, an Italian painter based in Trieste. He studied at the Academies of Vienna and Monaco with painters Veruda and Grunhut and won the Rittmayer prize. He is known for his book, *History of the Artistic Circle of Trieste*. An eclectic artist sometimes described as an Impressionist, he in fact used a variety of styles and techniques, though his work did tend to have a broadly Impressionist feel.

THREE OF CUPS

# THREE OF CUPS

## Keywords and phrases

Harmony and collaboration • Mutual celebration and rejoicing • Friendship, comradeship • A harmonious group of people • Community and co-operation • Inspiration from the Muses • Different Arts working well together.

## Suggestions for reversals

A collaboration works, but not as well as it ought to • Problems with group dynamics • You feel lonely and can't find a suitable group to work or socialise with • Too much competition, too little co-operation • Inspiration fails.

The creativity and warmth of collaboration is the essence of the Three of Cups. The card is about the pleasure of doing things in partnership with another person or working with a group. It traditionally shows three women, and so it's sometimes considered to apply especially, though not exclusively, to the cooperation of women. It particularly applies to creative work, so it may point to actors, artists, writers or musicians working together. But it can equally be about less exalted creative work—maybe simply the joy of cooking a meal or planting a garden with others. In business, it can sometimes indicate more corporate or formal working methods, such as teamwork, collaborative groups or mergers, but as a Cups card, it's most likely to be about cooperation that involves feelings, emotions and artistic sensibilities.

*The Victorian Romantic Tarot* shows three classic muses of the Arts—music, poetry and painting. It's interesting that the Muses—and there were usually, in classical times, nine rather than three, are nearly always portrayed together. The implication is that the arts are co-dependent, and feed from and nurture one other. The Muses of antiquity were water nymphs and so the sites associated with them were usually places—appropriately for this card—where there was running water, either a spring or a fountain, which symbolised the flowing of creativity and inspiration. In one version of their myth, they were the daughters of Harmonia, Goddess of Harmony and Concord—this aligns beautifully with the meaning of this card.

In a reading, the Three of Cups carries the message that the inspiration of the Muses can flow not just from individual genius, but from the shared abilities

built up in a brilliant collaboration. It really does say that the sum is often more than the parts, where the output of creative people working together is concerned.

## Sources

Taken from an engraving from a painting by Viennese artist Carl Schweninger (1818-1887), titled "The Beautiful Arts". Carl Schweninger, Sr. was a a genre, animal and landscape painter who trained at the Royal Academy in Vienna. He painted several "Classical" scenes, such as this one. Some of his work can be seen in the National Gallery in Vienna.

The picture is a typical Victorian Classicism piece that manages to be both formal and slightly sentimental—in much of the nineteenth century it was fashionable to paint such scenes of ancient Greece and Rome, and painters like Lord Frederic Leighton and Sir Lawrence Alma-Tadema made their reputations with sumptuous and idealised picture of the classical world. The subject largely fell out of favour with the rise of the Pre-Raphaelites, who were much more interested in a romanticised medieval period style.

> Each of the Arts whose office is to refine, purify, adorn, embellish and grace life is under the patronage of a Muse, no god being found worthy to preside over them.
>
> Farnham, Eliza (nineteenth century American writer)

FOUR OF CUPS

# FOUR OF CUPS

## Keywords and phrases

Feeling that nothing tempts you any more
• Sinking into ennui and boredom • Listless
daydreaming • Having it all, but no longer
wanting any of it • A feeling that life has lost
its spice • Ignoring opportunities and invitations.

## Suggestions for reversals

Shaking off a depression • Becoming more
interested and engaged with life • Beginning to
socialise more, getting out and about again
• Being motivated by new opportunities
• Wanting to be involved in events once more.

The Four of Cups is about that feeling of flat
disinterest that can creep up on all of us. It speaks of times in our lives when
we seem, to those around us, to have all that we could ask for. We ought to be
happy, and we want to be, but all we feel is emptiness and a sense of pointlessness. This can happen to us when we really are, by any standards, rich and
privileged, but it can also occur as a result of simply feeling dissatisfied with
our achievements and possessions, however great or small they seem to other
people. The Four of Cups is not necessarily the "spoilt brat" card (though in
some readings this can indeed be its meaning), rather it's about that sense of
anti-climax and depression that can hit any of us when we have gained all that
we thought we desired, but then find ourselves looking at it and asking "So
what?" We've all experienced the periods of ennui, in which we lack energy and
enthusiasm. This can come when we know logically that we ought to be happy,
but somehow can't be. It's a moment at which life can seem pointless, and yet
there is nothing specific that you can complain of.

Does it add an extra level of meaning to this image to know that it is probably
autobiographical? The picture is by John Collier—actually the "Honorable"
John Collier—an artist who came from a very privileged background and really
did seem to have it all. In this picture, he shows himself standing in a beautiful
garden, surrounded by women who are toasting him in admiration. There are
decorative lights, a laden table, and all the accoutrements of a party, but he
looks desperately bored, even depressed—staring out blankly from the canvas,
the image of a man who has everything but wonders what it all amounts to.

However, look at his face once more; is he perhaps thinking of higher matters and rightly refusing to be drawn into party frivolity? It actually is one possible interpretation of the image and in fact occasionally this card can signify someone who is rightly absorbed in dreams of things beyond the everyday world. When it comes up in a reading, it will nearly always speak of boredom, ennui and a depressed withdrawal from life, but remember that just sometimes, a withdrawal that looks negative to those around can actually be a healthy and necessary thing.

## Sources

Taken from an engraving based on a painting by English Classicist Painter John Collier (1850-1934). The original title is "In Armida's Garden".

The Hon. John Collier, with the encouragement of his father, who himself was a good amateur artist, studied at the Slade School of Fine Art, London, under Edward John Poynter (see our Nine of Wands). He then went to study in Munich and later in Paris under Jean Paul Laurens. His father also introduced him to Lawrence Alma-Tadema and John Everett Millais, from whom he received help and encouragement. Collier became a most successful artist—he was extremely prolific and known for his accurate, if sometimes rather emotionless work. He was perhaps the ideal portrait painter for rich and influential men who wanted to look impressive rather than sensitive, and in fact this kind of portraiture was a large part of his output.

Later in life Collier was associated with the Pre-Raphaelites, and perhaps the image that we are nowadays most familiar with is his painting of Lady Godiva done in typical Pre-Raphaelite style. On the whole though, Collier's work was regarded as cold and lacking in feeling—as was the man himself, as his obituary in the Times states clearly and rather critically:

> A thin bearded man, he gave the impression of polite independence—a sort of quiet ruthlessness in personal intercourse and character which was reflected in his painting.
>
> The Times, Obituary of John Collier, April 1934

One does not get the impression of a man who was easy to like, although in fact he seems to have been socially enlightened in some respects and campaigned for legal changes such as easier divorce (at the time divorce was usually difficult and expensive to obtain whatever the circumstances)—a worthy cause, if perhaps not an immediately appealing one.

Today, several of his paintings are in the collections of museums in the United Kingdom and Australia.

# FIVE OF CUPS

## Keywords and phrases

Struggling against loss, finding it hard to move on • Deciding how to deal with the down-side of a situation • Finding it difficult to come to terms with difficulties • Focusing too much on loss, without counting your remaining blessings.

## Suggestions for reversals

Loss, but acceptance • Trying to look on the bright side • Beginning to socialise more, getting out and about again • Looking at what remains, as well as at what's gone.

FIVE OF CUPS

This card is usually characterised as "seeing the glass half-empty rather than half-full". It's about the aftermath of some mishap or set-back and doesn't focus on the events themselves, but rather on the way they are dealt with emotionally. How do you react when you've had a disappointment; do you feel that all is lost, or do you comfort yourself by thinking about the good things in your life that still remain?

The young woman that we see in the image looks saddened, downhearted and perhaps a bit sorry for herself, yet she is young, beautiful, well-dressed and, we can guess, may not really have too much to lament about. It's a sunny day, she is in a beautiful landscape; perhaps if she was less self-absorbed she could look around and take heart from the positive aspects of her situation? But at the moment we see her, she is too absorbed in her own sad thoughts to think of anything else. The Five of Cups is about real suffering and set-back, but it also suggests that our grief could be lessened if only we remember what's left to us, rather than become focused on what's been taken away.

But look again at this picture. In the background there is a broken fence; in the coy symbolism sometimes used by Victorian painters this may indicate that the girl's own "barriers" have been broken down. Maybe she has indeed lost something of value—her innocence and her reputation? In the nineteenth century this could be a huge loss for a young woman, ruining her prospects for future marriage and security. Nevertheless it certainly happened, and this poem by Browning, about an illicit affair, reminds us that perhaps the reasons for taking such a risk have always been the same

Alas,
We loved, sir—used to meet:
How sad and bad and mad it was—
But then, how it was sweet!

Robert Browning, "Confessions".

The more optimistic counsel of the Five of Cups is, however, to look at the good things that are still there for us. Maybe even if this young woman has lost her "virtue", as the Victorians would term it, she may still retain her all-important reputation? Perhaps she can learn to sacrifice less and instead be more protective of herself in future. It's an odd concept perhaps for a modern woman to think about—sexual morality was so very different in Victorian times—but we can see parallels in our own lives. Perhaps we've been through a relationship split-up that made us feel like the world had come to an end, or we've lost a job we loved, or had to move from a place where we were happy. But, without being too glib about it, let's consider the upside for a moment. One relationship finishes, and clears the way for a new and better one to start. Losing one job can often propel us into looking for something more secure—or even into the wild risks, but great rewards, of starting our own business. We may be forced to move, only to find that the new place actually has its own benefits and attractions.

When these set-backs happen, we don't have to let them impact negatively on our own sense of self-worth and self-image. Sometimes optimism is a self-fulfilling prophecy and confidence can achieve wonders—if we expect things to work out well, it's more likely that they will. So where it's possible to see the bright side, you may find it's not only the most comforting viewpoint, but also the wisest.

## Sources

This is based on an engraving from a painting by K. von Bodenhausen (we have no dates for this artist) titled "First Love".

# SIX OF CUPS

## Keywords and phrases

A childlike innocence • Nostalgia and sweet memories • Caring for someone more vulnerable • Issues about children • Simple, childish pleasures.

## Suggestions for reversals

Some loss of innocence • Cynicism, or even corruption • Leaving childish interests behind you • An unhappy childhood • Becoming lost in nostalgia • Refusing to grow up.

The Six of Cups in about innocence, especially the pure innocence of childhood. If you live in a country where it snows, you'll know that the first snowfall of the year brings back childhood—a child-like thrill and delight—as almost nothing else can. When we look at this card, we can well imagine the wonder of the children seeing their city transformed by the first pristine blanket of snow.

One little girl gazes upwards, maybe more snowflakes are beginning to fall. She also clutches her friend's (or sister's) dress, needing a little reassurance. There is both trust as well as innocence here and the scene provokes in us a desire to protect these children. However, we know that what we see is only one touching moment that may not last for long. Children are individuals living in the real world and they can be both naughty and difficult as well as sweet and open.; we shouldn't expect them to be perfect little beings.

However, we take it for granted nowadays that childhood is a special time, and that children need and deserve to be treated quite differently from adults. It's quite startling to realise that this was not the case at the beginning of the nineteenth century; children were regarded more or less as small adults and could even be tried and sentenced to death for petty crime (a child of only eight years old was hung at London's Old Bailey in 1814). If they came from poor families, they were also expected to work from a very young age, sometimes at dangerous jobs such as chimney-sweeping and cleaning unguarded factory machines. All in all, in spite of the sentimentalisation of children in much art and literature, it could be a brutal time in which to grow up—unless, of course, you were from a privileged family. But a dawning realisation of the rights of children was one of the major achievement of nineteenth century

Europe. By the end of the century, children were recognised as being different from adults, and were more protected than they had been previously. Although child labour was still common, better provisions for education began to be made, and in general, attitudes towards children became far more enlightened.

When this card comes up in a reading it can refer directly to children and childhood, or it can ask us to think back on our own childhood. It may point to memories of wonder and simple joy—do you remember the first time you saw snow? Or alternatively it might ask us to let down our guard and become, at least for a short time, as innocent and trusting as children.

Unfortunately innocence is not always appropriate, and sometimes this card comes as a warning. The children in this scene are entranced by the snow, but we adults know, sadly, that with snow may come hazardous ice, extreme cold and all the difficulties of a severe winter. The Six of Cups reminds us that being childlike in a hard world is dangerous; we need to judge carefully when and whom to trust. While we don't have to fall into cynicism or suspicion, sometimes we do have to be a little wary in order to protect ourselves and our dependants.

## Sources

Based on an engraving from a painting by German artist Hugo Konig (1856-1899), titled "New Year's Morning". Konig specialised in rather sentimental, but well executed, scenes of children.

# SEVEN OF CUPS

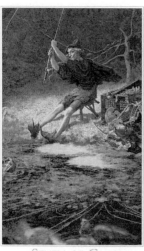

SEVEN OF CUPS

## Keywords and phrases

Daydreams and hopes • Fantasies and illusions • Choices—will you be able to choose well? • Wishful thinking • Allowing yourself to dream • Confusing reality with fantasy • "Fairy favours"—but will they turn to nothing in the cold light of day?

## Suggestions for reversals

Refusing to fantasise, being fiercely logical about something • Believing illusions to be reality • Confusion, an inability to choose between options • A dreamer, someone who is lost in impossible plans and unrealisable ambitions.

Arthur Waite, in his original commentary to the RWS deck, assigned the meaning "fairy favours" to this card, and as we know, fairies can be tricky and unpredictable folk—generous at times, but at others giving riches that turn to leaves the next day. This card reminds us that we've all fallen for the bait of "fool's gold" at times, allowing ourselves to be hooked by mere dreams and illusions.

The image for this card is quite unlike the conventional RWS one. Instead of cups filled with various delights, it shows a somewhat devilish character (who is also a little reminiscent of the tarot Fool) who is merrily using a wide variety of lures to catch the people, or spirits, who swim in the river. It's an intriguing, but also disquieting, depiction. Is the strange little man fishing for souls? Certainly, some of the figures dimly seen in the water may be tempted by the lures of money, power, art or beauty with which he baits his hook.

Such fairy gifts may, in folk-belief, fade like the mist when morning comes. Or... they may all come true. Perhaps some of the temptations and opportunities shown are real—and just waiting to be grasped? The Seven of Cups is about possibilities; it points to all sorts of daydreams, desires and ambitions. It challenges us to choose between them, and to separate the possible from those which are mere illusions. It's a card in which the reversed and upright readings may not differ hugely, because the possible interpretation depends so much on context in any case.

Remember though that, just as sadly, we can also fool ourselves into rejecting or dismissing as unobtainable some ambition that we later realise we could have achieved. Sometimes we can't believe the opportunities that are open to us, we think they're too fanciful, too optimistic or just too unlikely. Yet what seems unobtainable may not be—if we choose to believe it's possible. Perhaps all we have to do is reach out to accept what's on offer?

**Sources**

This is based on an engraving of a painting by H. Christie (we have no dates for this artist), titled "The Red Fisherman".

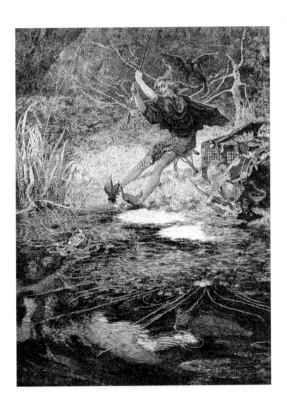

# EIGHT OF CUPS

EIGHT OF CUPS

## Keywords and phrases

Leaving one thing to move on to the next • A sad parting but a new beginning • Mingled regret and anticipation • Making the steps that are necessary, even though it's hard.

## Suggestions for reversals

Finding it hard to move on • Being pulled back by regrets • Stuck in a situation that you know you need to leave • Clinging to old habits and old ways.

In this card, we see a woman walking resolutely away—out of the picture—while the dog that follows here pauses momentarily to look back. We can only see the woman's back, but if we look closely, we can just make out the handkerchief that she holds to her face. She is obviously weeping, but she is equally obviously not going to change her mind and return—bowed and saddened she is nevertheless determined. However, the little dog that follows her hesitates in some anxiety, unsure whether to stay or go.

The Eight of Cups is about the difficulties of leaving something behind, and even at its most positive, it tends to have a trace of sadness about it. It is also about "moving on" to use the much over-used phrase of today, and it recognises that we need to look both backward, in regret, and forward, in anticipation. It might refer to the moment when you voluntarily leave a job that you know had become dull and restricting. It might be about walking away from a relationship that has gone stale, or simply moving from a place you've lived in, loved, but feel can no longer offer what you need. The card indicates those times when you leave something behind with difficulty and some pain—and yet know it's for the best.

The story of Elizabeth Barrett Browning is a famous true tale from the nineteenth century of someone who gathered up her strength to escape from an impossible living situation. Elizabeth was the beloved, but totally controlled, daughter of a tyrannical father, who encouraged her to see herself as an invalid, and to stay inside, a virtual prisoner in her own room. Yet her father seems to have done this partly from a misplaced desire to both protect her and keep her to himself, rather than to cause hurt. Eventually, after much anguish about

defying her father's orders, Elizabeth ran away to marry the poet, Robert Browning. This caused a scandal, and the two remained exiles for many years, wandering continental Europe. Was her decision the right one, and was her heart-rending escape worth it in the end? Here is Elizabeth writing to a dear friend back in England:

> England, what with the past and the present, is a place of bitterness to me, bitter enough to turn all her seas round to wormwood! Airs and hearts, all are against me in England; yet don't let me be ungrateful. No love is forgotten or less prized, certainly not yours. Only I'm a citizeness of the world now, you see, and float loose.
>
> Frank Kenyon (editor) *The Letters of Elizabeth Barrett Browning.*

I think reading this, we can conclude that to "float loose", and to be free at last, was indeed worth the cost.

This card is usually about walking away from something to which you have emotional ties—family, home, friends or a job or place that you've loved. It can also signal the end of a love affair. The leave-taking or finalisation is therefore hard, but the message is that it's necessary. Be strong, take the first step and the next will be easier. Like Elizabeth, you now have a chance to float loose.

## Sources

Based on an engraving from a painting by J. Berger (we have no dates for this artist) originally titled "The First Conflict". In the original painting the young woman is walking away from a bench on which a boy sits; he looks pensive and is stirring a packet of letters, love letters we assume, lying abandoned on the ground.

> Dearest, three months ago
> When we loved each other so,
> Lived and loved the same
> Till an evening came
> When a shaft from the devil's bow
> Pierced to our ingle-glow,
> And the friends were friend and foe!
>
> Robert Browning, "A Lover's Quarrel".

# NINE OF CUPS

NINE OF CUPS

## Keywords and phrases

Pleasure from good, basic things • Contentment and happiness in a down-to-earth way • Satisfaction and well-being • Small indulgences • Enjoying yourself in a straightforward way • Simple wishes are fulfilled.

## Suggestions for reversals

Being strict with yourself, going on a diet or abstaining from alcohol • Not appreciated simple pleasures—wanting more • Overindulging.

There's nothing complex about the Nine of Cups, it signifies pleasure in simple, earthy things; food, drink, good company, material and domestic comforts—in short, all the kinds of things you might find at your local pub, cafe or in your own living room when you've invited friends or family around.

Standing for such earthly delights, it might at first sight seem odd that it's a Cups card, rather than one of the more material and prosaic Pentacles. But when you realise that the Nine of Cups isn't so much about acquiring things, but instead asks us to think about our feelings of contentment and satisfaction in simple enjoyment, then it's more clear that it deals primarily with emotions, and so it's a natural part of the Cups suit.

In this picture, we see a man contentedly sitting in a cosy room at an inn, gazing into his large tankard of beer. Is it full or empty? Well, in the Nine, which is very unlike the Five of Cups, the question isn't really important, as one way or the other, he can always order another if or when he wants to; there is absolutely no hint of self-sacrifice in this picture. However, the Nine of Cups definitely isn't about drinking as much as you can, or indulging in excess of any kind; it symbolises small treats, gratifications that do no real harm and worldly pleasures that are enjoyable but not risky. It may advise letting the diet go for a few days, buying those new shoes—though you know they're pretty rather than practical—or having a holiday where you really pamper yourself. Of course, it can also mean simply going out with a few friends and enjoying good food, wine, a bit of frivolous shopping or some laughter and conversation. As this jolly author points out, a really good inn has always been a place

that provides not simply food and drink, but more importantly a feeling of community, comfort and welcome:

> The outside appearance of an inn alone was in those times so well considered that it addressed a cheerful front towards the traveller "as a home of entertainment ought, and tempted him with many mute but significant assurances of a comfortable welcome." Its very signboard promised good cheer and meant it; the attractive furnishing of the homely windows, the bright flowers on the sills seemed to beckon one to "come in"; and when one did enter, one was greeted and cared for as a guest and not merely as a customer.
>
> B.W. Matz, *The Inns and Taverns of Pickwick*

There's nothing very serious about any of this, and yet the Nine of Cups is often called by the rather fairytale and grandiose name of "The Wish Card". Well, perhaps all that tells us is that most people basically do wish for simple things—we may dream big, but often all it really takes to make us happy is the basic comforts in life. After all if we have good food, shelter, company and the odd luxury (when, after all, so many people in the world have none of these) is there really much else that we can desire?

## Sources

This is based on an engraving from a painting by Czech artist, Vojtecha Bartonka, titled "The Last Draught".

# TEN OF CUPS

## Keywords and phrases

Recognising the simple joys in life • Counting your blessings • Happiness in domestic and family matters • Pleasure in simple, homely achievements.

## Suggestions for reversals

Domestic happiness, but mixed with some discontent or sadness • Family problems though probably of a minor kind • Some discontent about your home situation, feeling you need a broader stage • Not counting your blessings as you should.

The "Happy Family" card of the tarot deck, the Ten of Cups has a straightforward message about domestic harmony, parents and children, happy endings and love and trust within families. The picture that we've chosen shows a new baby being celebrated by an extended "family" of friends and relatives, old and young, which is the kind of family that many of us now build around ourselves.

When the Victorians talked of family, however, they nearly always meant a traditional nuclear family; including only married husband and wife, their children and immediate relatives. This unit was a critical part of nineteenth century life, in fact the whole of society and culture was to some degree built on it. It was also seen as a reflection of the Kingdom of Heaven, as William A Alcott, an opinionated writer of advice books, asserted, "There is no place on earth so nearly resembling the heaven above, as a well ordered and happy family." He went on to underline what he regarded as the unique godliness of family, "The family and the church are God's own institutions. All else, is more or less of human origin: not, therefore, of necessity, useless—but more or less imperfect." (William A. Alcott, *A Young Woman's Guide*).

These days, we may take a less traditional view of family, and define it in broader terms. Nevertheless, for most people it's still a central part of life, and a happy family or home life—whatever that means to each of us—is usually essential to our feeling of wellbeing.

In a reading, this card usually promises simple, straightforward joy with those near and dear to us. However, it can sometimes imply that we expect a little

too much of these close relationships, and need to be a bit more realistic about the fact that no-one does live "happily ever after" constantly. Even the most harmonious relationships with those we love can't be entirely smooth all the time, nor should we demand this of them. But if we're willing to be flexible and to give and take a bit, then there can be intense, lasting joy from the simple everyday company of family and close friends.

## Sources

From an engraving based on a painting by Italian artist Arturo Ricci (1854-1919). Ricci is known for painting scenes of the 18th century, although in fact he was working in the late Victorian era. His work is highly decorative and somewhat light in tone and content.

> Where there are young people forming a part of the evening circle, interesting and agreeable pastimes should especially be promoted. It is of incalculable benefit to them that their homes should possess all the attractions of healthful amusement, comfort, and happiness; for if they do not find pleasure there, they will seek it elsewhere. It ought, therefore, to enter into the domestic policy of every parent, to make her children feel that home is the happiest place in the world; that to imbue them with this delicious home-feeling is one of the choicest gifts a parent can bestow.
>
> Mrs. Isabella Beeton, *The Book of Household Management.*

# MINOR ARCANA: SWORDS

Swords' element is Air—thought, intellect, analysis, logic, conflict, anger, willpower.

The Swords suit specifically refers to mental powers of analysis, debate and problem-solving, rather than the less rational areas of emotions and intuitions. In some situations, this means that a Swords card can indicate a person or an action that seems unfeeling, cold and calculating. But more positively, Swords also provide the sharp, incisive thinking that tempers pure emotion with logic, reason and rationale.

Swords has a strong reputation as the difficult or problematic suit of the tarot and readers are sometimes concerned if they see a reading that includes mainly Swords. It's true that this suit does include cards that are about sorrow and mental disquiet. However, as with all tarot cards, the significance of any one card—whether positive or negative—is greatly influenced by those around it, and by the focus and purpose of a reading. Sometimes the incisive intellect indicated by Swords is entirely positive, at others, it can point to difficulties that can be overcome or lessened by clear thinking and a rational strategy.

The Ace of Swords, in common with all the tarot Aces, is generally a positive card. It's an especially strong indication of success if you're beginning an enterprise, project or task that requires clear, logical thought and analysis. However, this is one card that changes its meaning startlingly when it's reversed; then it usually points to failure and muddled thinking and advises, "Don't do it."

The Two is about barriers and protection, and the meaning entirely depends on the context; perhaps you should let down the barrier, or, in a different situation, you may need to maintain your guard—this is a card that has to be read carefully according to the situation. The Three shows what may happen if you give up your self-protection at the wrong time; it's a card about sorrow, betrayal, grief and heartbreak, often, though not always, brought about by a love affair gone wrong—like all the Threes, it refers to interaction with other people. The Four is much less dramatic, in fact it's about taking a pause, allowing yourself time to recover, and switching off for a while, both mentally and physically.

With the Five, Six and Seven, struggles begin again and you're challenged by some hard situations. In the Five, there is some real nastiness; bullying, deceit

or a battle won by underhand means. The victor gloats over the victim in a vengeful way—whichever role you identify with, this is not a good place to be.

The Six is much less conflictual, but it's also about going through difficult times; in this case, the card points to the need to carry on calmly and quietly, until you reach a safer and easier place. The Seven of Swords is again about deceit, but this time it's a rather silly form of petty revenge, taken on the spur of the moment, and unlikely to cause any real harm.

With the Eight, the Swords' cards swing back towards inaction; this card is somewhat similar to the Two, but this time the restriction and restraints are imposed from outside. You feel trapped, but if only you could clear your mind and recognise the real situation, you'd understand that you could simply walk away from this prison—should you choose to.

The Nine and Ten of Swords are the culmination of the conflict and mental stress that runs through parts of this suit. The Nine isn't a card of disaster, but it may feel that way. It indicates that you have allowed your own anxieties to take hold; you feel that everything is nightmarish and confused, but in fact, things may be a good deal less catastrophic than you imagine.

In the Ten, however, real disaster strikes; it's still mostly psychological, but it's real, not imagined. This is a time when you may feel that you've reached a low point, and even your powerful intellect may not save you. But don't despair, this won't last forever, and soon it will be time to get back on your feet and begin to build things anew, and perhaps, who knows, better than before.

In *The Victorian Romantic Tarot*, the Swords tend to show dramatic, emotional images. Here we see pictures that include a scene of bullying, a drowned man in the arms of a mermaid, a hopelessly passive slave-girl and a sleep walker wandering perilously on the high rooftops of a city. They're disturbing, uncomfortable cards that challenge us to think about our conflicts, our motivations and our attitudes to friends and enemies. Yet, having said this, this suit of Swords also has its own edgy beauty; they indicate intellect as well as struggle, and clear, clever thought alongside a certain brutal forcefulness.

# ACE OF SWORDS

## Keywords and phrases

Turning your mind to new and exciting matters • Mental energy and action • A new opportunity to develop intellectually • Using your willpower and forceful thinking • Winning an argument or debate • Clear, sharp analysis at the start of a project.

## Suggestions for reversals

New opportunities are unlikely to work out, be careful • Feeling hostile or cross about something new in your life • Winning an argument through aggression rather than logic. • Muddled thinking—though the person concerned is convinced they are right.

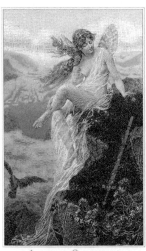

ACE OF SWORDS

The Swords is the suit of Air, and it stands for all things mental—analysis, intellect, and, on occasions, conflict. In the Ace these qualities are at their most dynamic, fresh and positive. This card is about new ideas, creative thinking, sudden insights and intellectual opportunities. It's a great card to see when you've asked a question about a new enterprise that needs some smart thinking, when you are beginning new studies, creative work that demands mental agility, or even when you're setting out to invent something that's never been done before. It isn't about hard academic slog or endless intellectual musings however; it tends to point towards quick thinking, fast insights and flashes of cleverness—and encouragingly it also suggests that anything you achieve as a result may in fact be substantial and lasting.

Our card emphasises the airy quality of this card, and shows a thoughtful-looking fairy, or spirit of the air, sitting far above the clouds on a high mountain, gazing at a splendid sword. She's a distinctly Victorian-style fae, elegant, human-sized and far from waif-like. She's beautiful, not at all frilly or girly, and looks intelligent. All in all, she's a serious, mythic and adult figure rather than the kind of girly fairy that you'd expect to see dancing around a toadstool. She is, in a sense, first cousin to the Lady of the Lake, the powerful fairy queen who supplied King Arthur with his magical sword, Excalibur. Maybe soon she will pick up the sword, fly down below the clouds and bestow it on some deserving mortal hero? Certainly, this card speaks of the gift of sharp and

clever thinking—use this moment well as it may be the beginning of new intellectual, analytical and even heroic achievements in your life.

This card is one that traditionally changes its meaning dramatically when it appears reversed. In this case, the message is clearly that things won't work out. The reversal of the Ace of Swords warns that a new enterprise, particularly one involving a high degree of thought, is likely to fail. Beware, it may be better to put off beginning any such activities until a more fortuitous time.

## Sources

The fairy is taken from an engraving of a painting by Czech/German artist Konstanz Dielitze (we have no dates for this artist). It's titled "The Hunter and The Air Spirit". We did not use the original figure of the hunter himself.

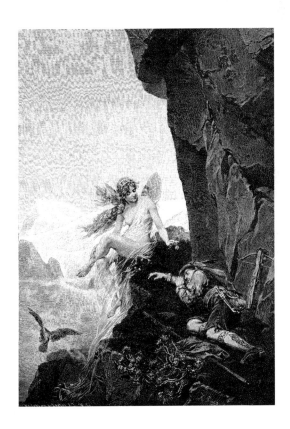

TWO OF SWORDS

## Two of Swords

### Keywords and phrases

Taking control—at some cost to yourself • Holding back the world • Putting up a defence against attack • Freezing yourself in space and time, at least for a while.

### Suggestions for reversals

Letting down your barriers—this could be good or bad according to the situation • Feeling too tired to go on defending yourself • Finally relaxing and letting yourself make contact with others • Making moves to come back into the mainstream again.

The Two of Swords concerns barriers, blocks and protections. It indicates a situation in which you draw the boundaries and keep others from stepping across them. Is this a good thing? The answer is that it entirely depends on the circumstances. Sometimes it's sensible and necessary to keep the world out, and to project yourself from intrusion or attack. But at other times, it may be a form of unnecessary defensiveness or even paranoia.

The woman on this card looks as though she is protecting herself—her arms are in a defensive gesture, although it's also a gesture of prayer or meditation. It's a stance that seems curiously old-fashioned, and also theatrical, rather than naturalistic. It's a posture that she may not be able to hold for very long, and indeed, this card tells us that blocking out the world, while useful at times, is always a temporary measure. The scene behind her is in complete contrast; a stormy sea full of treacherous rocks, but for now, she turns her back on this, and instead seems to stare at something more other-worldly. Maybe later she'll turn to face the dangers that the sea represents?

When this card appears in a reading, it's important to ask whether the barriers and self-protection are necessary. In some circumstances it's crucial to be able to put up a physical, psychological or spiritual defence, even for a short period. But if defensiveness becomes habitual it can cause more damage than it prevents. We've all met people who seem to block the world out, maintaining a distance between themselves and others and never allowing anyone to get close emotionally; such people risk becoming increasingly lonely and isolated. The Two of Swords shows a situation, or an attitude to the world, that should only

be temporary. For a short time it may be very functional and helpful to keep your barriers up, but remember that there's also a time to let them down and either face up to what you need to confront, or simply find an easier, and perhaps less solitary, way to protect yourself.

## Sources

This is based on a print of a painting by E. Eroli (we have no dates for this artist), titled "The Christmas Angel".

# THREE OF SWORDS

## Keywords and phrases

Emotional pain • Feeling stabbed in the heart • Sorrow • Grief over someone or something you love • A betrayal that shocks you to the core.

## Suggestions for reversals

You avoid some emotional hurt • Recovery from a period of grief • Refusing to give in to sorrow—this may be good or bad • Your worst fears are not realised, things are not as serious as you thought.

Sadness, hurt and pain, the Three of Swords is a card that symbolises these realities of life— which are ones that we would often rather not

THREE OF SWORDS

face up to. Coming after the Two, it may imply that the barrier and protection has come down, leaving one open to an emotional attack that pierces right to the heart.

In the picture, a girl weeps bitterly while her anxious dog tries to comfort her. In the background a man rides away—is he the reason she's crying? When we look at this picture we see an emotion that all of us can identify with—we've all "been there" as the phrase goes. This is what's important to remember about such feelings, they are part of everyone's life, and they pass. However awful we can feel about the hurt we are ourselves suffering at this moment, the comforting fact is that we know we can look for sympathy and compassion from others, and that over time we will recover and begin to feel better.

The Three of Swords is nearly always about real emotional pain, rather than something that's just exaggerated in the mind. It symbolises sorrow in response to an actual situation, and as such it's a hard card to see in a reading. It very often shows the heart-break of an unsuccessful love, or a passion that's been disappointed. It can also suggest an emotional triangle—the unfaithfulness of a lover is sometimes indicated in this card, but it can also point more generally to betrayal, abandonment or separation involving three people. The card catches the moment of heartbreak—in the traditional RWS image a heart literally pierced by swords is shown. But what are we to do to avoid this? Should we simply avoid love? The Scottish poet Robert Burns, tells us that pain is the risk we run whenever we love deeply:

Had we never loved sae kindly,
Had we never loved sae blindly,
Never met—or never parted,
We had ne'er been broken-hearted.

Robert Burns, "Ae Fond Kiss and then We Sever".

When this card appears in a reading, one question to ask is whether the querent is the one who may experience the heartache or the one who will cause it. The Three of Swords asks us to accept honestly the grim realities of heartbreak and either to prepare ourselves to deal with this—because the truth is that while it can feel like the end of the world at the time, life does go on—or to ask ourselves if we really want to be the cause of such pain. Perhaps there is a gentler and better way?

## Sources

The card is based on an engraving of a picture by A. Werner (we have no dates for this artist). In the original, the girl was shown crying under a crucifix. We changed this, to make the image less specifically Christian in reference, and also added the figure riding away in the background.

# FOUR OF SWORDS

## Keywords and phrases

Time out, forced or voluntary • Rest and recuperation • Mental silence and stillness • A pause to retreat and reflect • Putting life on hold for a while.

## Suggestions for reversals

Finding it hard to relax, though you know you need to • Returning to everyday matters after a period of introspection and withdrawal • Taking time out, but instead of relaxing you fall into worry and anxiety • Feeling harassed and hassled when all you want is some peace.

FOUR OF SWORDS

This is the "taking a break" card of the tarot. In the midst of the fiercely intellectual, incisive and strong-willed Swords, the Four stands for the time when you need to step aside from the fray and just rest awhile. It reminds us that no-one can struggle or think all the time—nor should we even try to. We need periods when we can simply forget all our cares and problems and just switch off. This card may signify taking a break from work—in order to rest rather than holiday, removing yourself from some ongoing conflict for a while, stopping for a short period during a long journey, or simply letting up from your studies if you're a student. Often, it's rest from mental rather than physical exertion that's indicated here.

The image here shows a young woman sleeping peacefully. She's dressed in the heavy clothes of a Russian aristocrat and the room she's lying in, which is probably in a castle, is walled in thick stone and hung with rich tapestries. What's her story? She seems to have lain down, still fully dressed, perhaps in exhaustion. Yet her expression is calm, almost smiling, and the scene looks still and quiet; we get the impression that she is sleeping deeply and will awaken refreshed. Behind her is a window—probably if she looked through it she'd see the world going on in its usual busy way, but right now she isn't interested in what's happening outside, she is content to stay quiet, warm and safe behind the thick castle walls.

The traditional RWS Four of Swords shows a man lying in a church, in the classic posture of a tomb-effigy; it's unclear whether he is dead or merely asleep. Our card appears much less severe, (although, ironically, the original painting on which this is based does in fact depict a death scene). I've always found it

perplexing that the RWS image implies the possibility of death, rather than rest and refuge, but then, perhaps a picture of a tomb is one of the most powerful ways to show a silence and retreat from the world. After all, we do use the expression, "silent as the grave".

But there may be another aspect to this also. When we think about tombs we tend to imagine the epitaph written on them—the epitaph that sums up a whole life in a few words. This leads us to a more profound way of thinking about the Four of Swords; as a break from the world, a time of retreat, that allows us to think about our purpose and our aims in life. In some readings, this may be the truest interpretation of this card.

## Sources

The girl is taken from an engraving of a painting by Russian artist Georgiy Sedov (we have no dates for this artist) titled "Tsar Ivan the Terrible at the Deathbed of his Wife Vasilisa". We've also used this engraving for the King of Wands.

> Alien tears will fill for him
> Pity's long-broken ern,
> For his mourners will be outcast men,
> And outcasts always mourn.

The epitaph carved on the tomb of Oscar Wilde.

# FIVE OF SWORDS

FIVE OF SWORDS

## Keywords and phrases

Fights and conflict • A victory won by dubious tactics • Abuse and bullying • Humiliation • "All's fair in love and war"—or is it?

## Suggestions for reversals

Quiet mourning after a lost battle • Getting hopelessly embroiled in stupid fights • You spot some treachery or double-dealing • You ignore abuse instead of trying to prevent or stop it.

Here we see two rather nasty little boys teasing a younger one. All three are dressed as clowns or pierrots and look as though they've been taking part in a theatrical performance. Only the two older boys have instruments—perhaps they have taken their younger victim's drum or tambourine? It also looks as though they may have taken his toy sword; there are two swords lying abandoned on the ground, and one of them is under the feet of the bullies. The little child is weeping and upset but the two bigger boys just laugh. It's a classic scene of bullying, larger children ganging up to pick on a smaller one. The look of smugness on the face of the blond boy, egged on by his friend, is unfortunately something we've probably all witnessed in playgrounds.

The Five of Swords is a card that often has a distinctly nasty meaning; it points to victories gained dishonourably, vindictive acts, spite and maliciousness. In situations like these, no-one really wins; as we all know, people who bully may end up being quite as damaged by it as their victims, and those who have been abused sometimes go on to become abusers. Bullying is often also a cowardly act, as Charles Dickens reminds us in his description of the awful "Mr. Bumble, the beadle" in *Oliver Twist*:

> He had a decided propensity for bullying: derived no inconsiderable pleasure from the exercise of petty cruelty; and, consequently, was (it is needless to say) a coward.
>
> Charles Dickens, *Oliver Twist*.

When interpreting this Five in a reading, ask first which of the people you, or your querent, identifies with. Are you the bully, the victim or the bystander who eggs on the bully? None of us wants to admit to being abusive, but perhaps

we're intimidating or making a mockery of someone without even realising the damage it's doing? Whichever of the participants you feel you are though, this is an unhealthy game; it's time to stop and find better, more honest ways of interacting. If you're the one who has been bullied or abused, sometimes the best thing is simply to walk away—don't give your tormentors the satisfaction of seeing how upset you are. But if you are bullying someone, or simply watching while someone else does this, please stop and look critically at your behaviour. You're hurting yourself as much as anyone else.

## Sources

Based on an engraving from an original painting by Edmond Louyot (1861-1920). It is titled "Laughed At". Louyot is best remembered for his clever and charming paintings of children and his landscapes of his native Lorraine. Although French, he studied art in Germany, at both Dusseldorf and Munich art schools. He lived between Lorraine and Munich for most of his life. Some of his work can now be seen in Le Musée Georges de La Tour at Vic-sur-Seille in France.

# SIX OF SWORDS

## Keywords and phrases

Going quietly through a hard transition
* Accepting a challenge without complaint
* A mental "journey" or shift in perspective
* Believing that you will arrive at a better place though the travel to get there may be sorrowful
* Travel or a move.

## Suggestions for reversals

Struggling against a hard time • "Rocking the boat", fighting against changes • Fear of travel or a move • Wanting to stay where you are, mentally and physically.

SIX OF SWORDS

The Six of Swords always strikes me as rather melancholy. Maybe this seems odd, because it certainly isn't regarded as one of the more troubling or tragic Swords cards. It doesn't refer to conflict, turmoil or mental struggle, it's merely about a journey of transition, and yet a quiet wistfulness pervades this card. Perhaps this is because, in the classic RWS imagery, it shows a scene reminiscent of King Arthur's final journey to his resting place on the Isle of Avalon. It may also remind us of the Greek belief that souls would be ferried across the river Styx to their final home in Hades. But whatever our associations, it may be simply that images of transition and "passing" are inevitably sad, at least in part.

The picture we've used does not show the classic ferryman—instead the boat is rowed and steered by lovely young women, dressed in Grecian-style flowing gowns. Their passenger stands by the mast, she's wrapped up, and her head is covered so that we can't see her face. She appears to be quietly gazing forward to their destination. In front of her a fire burns; it casts a beautiful light over the figures of the women. Apart from the people in the boat, the scene is deserted, there is no obvious life in the half-ruined buildings that they travel towards, and no breath of wind to furl the sail of the boat. All is still. We can see this, not as a picture of a real-life boat, but instead as an image of a myth, a dream-like scene of a journey in an enchanted landscape. The fire can be regarded as an emblem of the soul and so this is a scene about a transition of the inner self, a "rite of passage" perhaps. In the distance there is a winding stair leading upwards from the river to the buildings and we can imagine the woman in the boat climbing these stairs when they dock. It could almost be an

illustration to the famous poem by W.B.Yeats (himself a user of the tarot, and a prominent member of The Golden Dawn esoteric group):

*My Soul*. I summon to the winding ancient stair;
Set all your mind upon the steep ascent,
Upon the broken, crumbling battlement,
Upon the breathless starlit air,
Upon the star that marks the hidden pole;
Fix every wandering thought upon
That quarter where all thought is done:
Who can distinguish darkness from the soul?

W.B. Yeats, "A Dialogue of Self and Soul", from *The Winding Stair*.

This card can, in a reading, indicate a time of soul-searching, but also the eventual attainment of quiet serenity. Although it does point towards a troubled and turbulent phase, it also holds the promise of a safe passage and a peaceful conclusion. The Six of Swords is sometimes interpreted as pointing to actual physical travel, but remember that it more often indicates a journey of the mind or spirit, usually, though not always, caused by difficulties or challenges. It advises us to pass through such times of change with patience and calm— there may be no point in struggling or attempting to take much action. Whether the transition is caused by an upheaval in our job, relationships or general circumstances, reassuringly this card tells us that eventually we'll find ourselves in a better, more stable situation in which we again feel at peace with ourselves and with the world.

## Sources
This is from an engraving of a painting by French artist Henri Louis Philippe Le Roux (1872-1942) titled "The Flight from Rome".

Then murmured Arthur, "Place me in the barge." So to the barge
they came...

Then loudly cried the bold Sir Bedivere: "Ah! my Lord Arthur,
whither shall I go?"...

And slowly answered Arthur from the barge: "The old order changeth, yielding place to new, And God fulfils himself in many ways, Lest one good custom should corrupt the world."

Alfred Lord Tennyson, *Idylls of the King*.

# SEVEN OF SWORDS

## Keywords and phrases

Being spiteful or petty • "Going it alone" without seeking wiser advice • A small act of betrayal • Dishonourable or rather cowardly action • Taking a mean type of revenge.

## Suggestions for reversals

Taking advice before dashing into a rash act • Refusing to take revenge • Taking some action that's effective, although it may be rather nasty.

This card is mostly about small thefts, petty revenges and actions taken on impulse rather than as the results of either planning or sound reasoning. Usually, it indicates the kind of action that we'd call "sneaky" rather than catastrophic. It might refer, for instance, to someone deliberately breaking your favourite vase, spreading some unpleasant gossip about you, pouring weed-killer on your prize roses, scratching the paintwork on your car, or playing loud music at night to annoy you. All these things are nasty and vindictive, but they won't do you lasting harm, however upsetting they are at the time. In fact, the damage that results is often to the person who does these things as much as to their victim. The Seven of Swords shows someone who acts alone, without first seeking some wiser and more moderate advice. Often, once the vindictive act is done, the perpetrator may recognise their own pettiness and feel some shame; and certainly, they risk ruining friendships and reputation if they are found out.

The image on our Seven of Swords shows a soldier, laiden with guns and swords, walking away from a village. It's very reminiscent of the original RWS imagery and similarly leaves some ambiguity about what's going on. Has the man stolen these weapons? He's carrying far too many for them all to be his, and he looks furtive. Is he a deserter (certainly it's odd that he is on his own, away from the rest of the army)? Whatever the situation, it's obvious that the soldier feels some anxiety about being seen; he looks over his shoulder, checking that he isn't being watched or followed.

Though this card usually indicates some secret nastiness, it's good to remember that while the acts symbolised by the Seven of Swords are annoying, irritating and perhaps angering, they are, in the end, ineffective. Often the best

advice, if these are acts committed against you, is to limit your reaction and instead dismiss them as the silliness they really are. On the other hand if you are the one doing these things, then it's time to consider whether it makes any sense; however satisfying petty revenge or "point scoring" can be at the time, it's only a temporary victory and one that can, in the long-term, hurt you as much as your adversary. Maybe it would make more sense to cool down, talk it over and decide on a more sensible course of action.

## Sources

This is based on an engraving of a picture by German artist and illustrator, Gustav Adolf Karl Closs (1864-1938). It is titled "The Destruction of the Abbey of Hirschau by the French under Melac "(this is a famous attack that took place in 1692 at an abbey near Stuttgart). Closs was a lawyer, who also worked as an illustrator for popular magazine and a painter of historical scenes and heraldry.

# EIGHT OF SWORDS

EIGHT OF SWORDS

## Keywords and phrases

Being trapped, mentally or physically • Being controlled by people or circumstances • Tending to be a willing victim • The need to recognise your situation and take action • A refusal or inability to see that freedom is possible.

## Suggestions for reversals

Releasing yourself from damaging restrictions • Taking control of your own life • Refusing to be a victim any longer • Regaining your self-confidence.

The theme of the chained or bound woman was quite a popular one in Victorian art, always made more palatably respectable by being presented in a mythical or classical setting. As long as the chained woman was passive, and either Andromeda about to be rescued by Perseus, or a more generalised figure of a Greek female slave, then the viewer could presumably enjoy the spectacle while feeling themselves to be an art lover rather than a voyeur. The popularity of such imagery probably reflects the general nineteenth century attitude towards women, which is that they were a "weaker sex" that had to be kept under control for their own good—most women were expected to lead lives that were extremely restricted by modern standards. Here, the bound woman is hardly bound at all, the rope around her wrist seems a gesture rather than a restraint, but then again, she looks utterly passive and as though she hardly needs to be held captive in physical terms.

It's a much less extreme image than that of the traditional RWS card, which shows a woman firmly bound and blind-folded, but it is perhaps even more challenging in its depiction of a woman who looks content to be a captive. The Eight of Wands often refers to the willing victim, the kind of person who says "If only I could..." with a sigh, but who never takes any action to change their situation. The picture was originally titled "Longing" and indeed, what we see on this woman's face is desire and dreaming—but mixed with a strange kind of smugness. She may long to be elsewhere, but we suspect that she rather likes the pose of the suffering—and very picturesque—captive. Behind her a full moon shines on a ship that's tied to the dock. One day soon, the moorings will

be cast and the ship will sale off, but we wonder if the same will ever apply to the young woman—will she throw off her bonds and leave for new places, new adventures?

Compare her for a moment with some of the other women in this deck—the proud and dramatic Queen of Wands, the strong, intelligent and forbidding Queen of Swords, or even the free young sideshow girls in the Four of Wands. In contrast, this young woman is the kind of person who makes you want to give them a good shake and say something like, "Stop wallowing in it!" She's pretty, but also pretty vapid, and one wishes that she would make the tiny effort needed to free herself and start doing instead of dreamily longing for things simply to happen.

When this card comes up in a reading, it may indicate real restraints, albeit usually only temporary ones. But it's more likely to point to restrictions in your own mind, or to someone who has become a collaborator in their own victimisation and imprisonment.

**Sources**
The original engraving is from a painting by German artist Willibald Winck (1867-1932). It's titled "Longing".

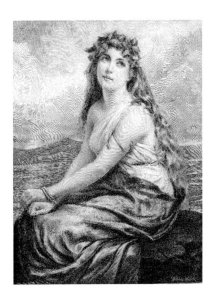

# NINE OF SWORDS

## Keywords and phrases

Nightmares and night terrors • Temporary loss of mental control • Hysteria and panic • Fear and phobia • Making yourself vulnerable or a victim.

## Suggestions for reversals

Fighting back against phobias and fears • Refusing to be a victim • Feeling anxious, but not giving in to it • Recovery from mental turmoil or hysteria • Learning from your nightmares—using them positively to give insight into your own mind.

Sleep-walking is an unusual theme in art. We've probably all seen book illustrations of this phenomenon, but to make it the subject of a picture is now strikingly rare. The scene here is of a young woman, clutching her thin nightdress to her, who walks with closed eyes across the very edge a high roof. Far below lies the city. It's a chilling picture, contrasting the young woman's blank, almost calm, expression with the perilous place in which she walks. In reality, most actual sleep-walking is far less dramatic than this, yet somehow the idea of finding yourself walking across the roof-tops of a gothic city is an almost archetypal image of what it means to walk in your sleep—somehow this is a phenomenon that many of us find disturbing.

The Nine of Swords is a card about disasters and catastrophes that are mainly in the mind. It's often considered to be the card of hysteria, nightmare and delusions—a little like The Moon card, but without the overtone of psychic insights or creative imaginings. The Nine is about letting our fears get out of control, and believing the worst. It's the feeling of "the darkest hour before the dawn", when your mind is clouded and even small troubles can become magnified into nightmarish threats.

Sleep-walking, regarded as a symptom of mental disturbance or disquiet, is often associated with hysterical tendencies, although medically this is quite debatable. Certainly, the Victorians saw it as both fascinating and rather shocking—and a sign of being nervous or even "moonstruck" (the word "lunatic" also comes from "luna" the moon). It's not surprising that the subject

of sleep-walking is dealt with in *The Diary of a Young Girl* a book that Sigmund Freud described as "a gem":

> August 14th. Today when Ada was having a bath Mother said to *us two*: "Girls, I've something to tell you; I don't want you to get a fright in the night. Ada's mother told me that Ada is very nervous, and often walks in her sleep." "I say," said I, "that's frightfully interesting, she must be *moonstruck*; I suppose it always happens when the moon is full.".....
>
> August 20th. *Last night Ada really did walk in her sleep*, probably we should never have noticed it, but she began to recite Joan of Arc's speech from The Maid of Orleans, and Dora recognised it at once and said: "I say, *Rita*, Ada really is walking in her sleep."... Dora said we had better pretend that we had not noticed it, for otherwise we should upset Ada. Not a bit of it, after breakfast she said: "I suppose I gave you an awful fright last night; don't be vexed with me, I often get up and walk about at night, I simply can't stay in bed. Mother says I always recite when I am walking like that; do I? Did I say anything?" "Yes," I said, "you recited Joan of Arc's speech." "Did I really," said she, "that is because they won't let me go on the stage; I'm certain I shall go off my head; if I do, you will know the real reason at any rate." This sleep-walking is certainly very interesting, but it makes me feel a little creepy towards Ada... It would be awful if she were really to go off her head. I've just remembered that her mother was once in an asylum. I do hope she won't go mad while she is staying here.
>
> (preface by Sigmund Freud), *The Diary of a Young Girl*.

Clearly, sleep-walking was considered a rather dire sign of possible future mental illness—though at the same time it was fascinating. If you look again at the image on this card however, you'll see that the girl, as I've mentioned, looks blank, she's not raving or anguished but simply "not there". What will happen next, will she just go back to bed quietly, will she wake and be terrified, or will she fall from the roof? It's a picture that's full of threat and portent—but the worst fears won't necessarily come true and all may yet end well.

When this card comes up in a reading it's time to question your fears and anxieties. Are they honestly as bad as they seem? Or are you going through a vulnerable time in which everything has got out of proportion? If you calm down, think clearly and use your logic rather than allowing yourself to imagine the worst, then you may well be able to control these worries. Don't mistake imagined horrors or fears for the real thing.

## Sources

This is taken from an engraving based on a picture by a Czech artist, L Suchdolska. Originally titled "The Sleep-walker". Interestingly, the theme and presentation in some ways anticipates the great early German expressionist horror films such as *The Cabinet of Dr. Caligari* and *Nosferatu*. This image may in fact have been originally intended as an illustration for Bellini's opera about a maiden who sleep-walks, "La Sonnambula", although there is no way of knowing this for sure.

# TEN OF SWORDS

## Keywords and phrases

Giving up and giving in • Reaching a point of despair • Sorrow and desolation • A psychological breakdown • The lowest point in the cycle, but from here things should begin to improve • Emotional exhaustion.

## Suggestions for reversals

Getting back on your feet—against the odds • Realising that life will go on in spite of difficult events • Avoiding a breakdown, taking control mentally • Sorrow and tiredness, but you are coping well.

TEN OF SWORDS

I once heard the original RWS image of this card (it shows a man lying face down by the sea, with ten swords buried in his back) described as looking like a jellyfish lying beached up with sticks poked into its body. An image at once blackly comic and rather horrifying. Ever since, I've tended to see the nightmarish quality of this card arising in part from kitsch and overstatement. The Ten of Swords' imagery often makes us giggle and gasp at the same time—just as modern teen-horror films often use kitsch to provoke laughter just before the shock of the inevitable violent horror.

There was a traditional belief among some fishing communities that if you saw a mermaid it was a portent of doom that meant that you were bound to die shortly by drowning. In this wonderful exchange from a book (dated 1911) by L. Frank Baum, the logical problem of this is pointed out by "Trot", a curious child:

"How does anybody know about mermaids if those who have seen them never lived to tell about them?" she asked again. "Know what about 'em, Trot?" "About their green and pink scales and pretty songs and wet hair." "They don't know, I guess. But mermaids jes' natcherly has to be like that, or they wouldn't be mermaids." She thought this over. "Somebody MUST have lived, Cap'n Bill," she declared positively. "Other fairies have been seen by mortals; why not mermaids?" "P'raps they have, Trot, p'raps they have," he answered musingly. "I'm tellin' you as it was told to me, but I never stopped to inquire into the

matter so close before. Seems like folks wouldn't know so much about mermaids if they hadn't seen 'em; an' yet accordin' to all accounts the victim is bound to get drownded." "P'raps," suggested Trot softly, "someone found a fotygraph of one of 'em."

L. Frank Baum, *The Sea Fairies*

It's interesting that although Swords is traditionally considered the suit of Air, this card is often associated with the sea, which here is definitely a "cruel sea" bleak and dangerous. This can perhaps be taken as an indication of its link with emotionalism, rather than pure logic, water being the element of the emotions in tarot. The mermaid who holds the drowned man is herself hardly a substantial being at all—she seems to be partly made of sea foam, or perhaps she's the stuff of dreams and nightmares.

The image on this card is certainly beautiful and sorrowful—but isn't there also something just slightly laughable about it too? It's both melodramatic and overstated—though with power to touch the heart nonetheless. This indicates an aspect of the Ten of Swords that it's important to take into account in a reading. The card does indeed stand for disaster, reaching the lowest point, feeling totally defeated and crushed. But there is an element of mental collapse to it too—the defeat may not be actual, it just feels that way. The victim may be collapsing as much because of a belief in their own doom, rather than because doom has actually occurred.

While this card is not as much about psychological terrors as the Nine of Swords, neither does it necessarily refer to a real catastrophic event as, for example, The Tower usually does. The Ten of Swords has overtones of melo-drama, exaggeration and of giving in and giving up. It says that you are defeated, yes, but that this may partly be because you've been your own worst enemy. Aleister Crowley said that this card was about the dissolution of the mind, and of course, while a psychological collapse can be every bit as real and devastating as something more physical, it's important to realise that the answer to recovery may lie inside yourself first and foremost. Don't just give up and decide that you're finished—get through this rough time calmly, and you may find that things soon begin to look much better. If you can find even some small vestige of humour somewhere in the situation, that may help to speed your recovery and chase away the shadows of doubt and fear. As we all know, laughter is a good healer.

It may be useful to compare this image with the one that we have used for The Tower. Both show the result of shipwrecks, but in The Tower picture the sailors

are very solid and ordinary-looking—and one feels that they may well survive through sheer guts and a bit of good luck. Here the image is entirely different, more mythic or fairytale, less like a scene of reportage and more one of imagination. This shipwreck isn't a real-world event; it's a fantasy of disaster, and as such, it can be overcome partly by facing up to what's happened and taking a strong mental attitude. It'll soon be time to get back on your feet, face the real world again and put these bad times behind you.

## Sources

The engraving is from a painting by Wilhem Kotarbinski (1849—1922) a Polish artist who also painted Classical and Biblical scenes. Some of his work can now be seen in the National Museum in Warsaw.

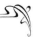

# MINOR ARCANA: PENTACLES

Pentacles' element is Earth—practicality, skills, reliability, hard work, conscientiousness, routine, finances, growth and nature.

There is sometimes a slightly dismissive attitude to this suit which can be seen as being all about money or mundane materialism. But this is to dismiss "earthy" things, such as matters of the body, as being inferior to matters of the mind, emotions and spirit. Is this really true? Aren't all aspects of life of equal value, and isn't the important thing to keep them in balance? We live in a world where there often seems to be an obsessive focus on money, possessions and surface appearance, but when these matters are kept in perspective, they play an important role.

It's easy to relate to the general message of this suit, which is that most achievements demand a degree of common sense, hard work, and a good deal of prudence and practicality. There is a certain warmth about Pentacles—they talk to us about things that we are very familiar with in everyday life. However, having said this, it is also true an overabundance of these cards in a reading may indeed indicate too much concern with material matters. As ever, the tarot tells us that we should strive to achieve a good balance.

In *The Victorian Romantic Tarot*, the pictures on the Pentacles cards are, appropriately enough, a bit more down to earth and less mythic or magic than those on the rest of the deck. They tend, more often, to show scenes of everyday life rather than gods, fairies or chimerical beasts (though these are not entirely absent). The Ace, however, has a touch of magic hanging over it, as all the tarot Aces do. It depicts a nymph rising up into the sky, an image that indicates promise and optimism, particularly in all new business or practical ventures. This card also implies that this may be the start of a golden path to prosperity and achievement. The Two is more playful and down-to-earth, and at the same time talks of both the challenges and pleasures of juggling a lot of tasks at once—it's fun to do, but it also takes some perseverance and hard work. The Three, always a card of cooperation and community in the Minors, shows the summit of craft skill and ability. If it seems odd to have a card of attainment, rather than effort, this early on in the suit, the explanation is that this card is telling us that "individual mastery" is always in reality a joint effort. Whether you rely on teachers, fellow-workers, an arts or trade organisation, or simply the audience or market for your work, to attain the peak of your craft or skill, you need to work both with and for other people.

But there's a real change of tone in the Four. This card is about keeping all your money, possessions and abilities to yourself. Is this a good thing? Yes, at times, but often it's just meanness that's not only miserable for those around you, but also a self-made prison, trapping you in miserliness; there's a tangible lack of energy in the image on this card. You need to think hard about whether you're simply sensibly conserving your energies and material goods, or slipping into becoming an isolated penny pincher. In the Five and Six the theme is still material possessions, but these two cards deal with giving and receiving, the haves and have-nots. In the Five, we see two people in desperate need, reduced to begging. However, they have one another, and this card tells us that we can be poor financially but rich in love, support and friendship. The Six shows a similar situation in reverse; this time we see charity from the point of view of the giver—the question is, however, whether the gift is given with good-grace and intent, or doled out pompously, to make the giver look and feel good. Charity is a wonderful thing, the Six says, but it has to be done in the right spirit.

Another change of focus comes with the Seven; we turn back to thinking more about skills and practical achievements rather than possessions and finances. This card tells us to assess what we've done so far and choose wisely and well what to do next. It can be a more important moment than it seems at first, so take your time. The Eight is also about patience, although in this case it refers to the diligence and endurance needed to learn a skill or craft. It advises us that training and practice, practice, practice is the only way to attain the mastery we saw in the Three.

The Nine brings the rewards and relaxation that are the just deserts of all your hard work. It shows a scene of prosperity, ease and confidence—you finally got there, so now you can enjoy your comfortable life, and feel rather proud of yourself. And the Ten, the culmination of the suit? Well, in one reading it seems largely to repeat the message of the Nine, that after a life of working, learning and being both practical and sensible, you attain all the good things of life; wealth, security and retirement. But is it that simple? Maybe not. There is something strange about this card that hints of alchemy and magic—maybe everything isn't quite so material and worldly after all? Perhaps there's something else going on, and the message is that once we achieve everything we desire materially, we may find ourselves longing for something altogether more mysterious and alluring.

ACE OF PENTACLES

# ACE OF PENTACLES

## Keywords and phrases

Opportunities in practical or business matters • Tremendous creativity in some manual or hands-on field • A promise of prosperity and contentment • Reaping the rewards • The beginning of an enterprise that will bring well-being and maybe wealth.

## Suggestions for reversals

Focusing too much on the financial or material sides of a new project • Everything pays off, riches shower down, maybe even too much so? • Instead of soaring to new heights in your skills, you focus on making money • There is an obstacle or a pause before your new business gets off the ground.

The Pentacles are the most earthly of the tarot suits, and as such, they are often associated with money and materialism. The Ace is therefore a great card to see in a reading if you are asking a question about the likely success of a new job, investment or business, and it's often characterised as a promise of money to come. However, it would be simplistic to see it as being connected only with money; of all the Pentacles it's arguably the one that as well as being pragmatic also carries a strong sense of alchemy, magic and the fruits of the earth in all their abundance. It can imply a positive start to any material and practical matters—not just those directly about finance. It might point towards the successful outcome of a new course you're about to take in order to learn a skill or craft. Or you may be beginning a house renovation, planting a new garden, starting to make a piece of clothing or furniture. You may also be about to begin some new physical project, maybe learning to dance, joining a walking club or starting a "keep fit" regime. The Ace of Pentacles indicates that any new activity or enterprise in practical, health or financial areas is likely to work out wonderfully well.

In this picture we see a nymph rising up lightly from a flower-covered meadow. She is dressed in green, with a shining golden disc around her arm and a pentacle in one hand; with her lush hair and softly rounded body she seems to epitomise the spirit of nature and natural abundance.

## Sources

This image is taken from a picture by Hanuse Marketa. It was originally titled "Afternoon". For its sister image, "Morning" see the Ace of Wands.

> The young man gave a twist
> And turned about, and in the amethyst
> Moonlight he saw her like a nymph half-risen
> From the green bushes which had been her prison.
>
> Amy Lowell, "Men, Women and Ghosts".

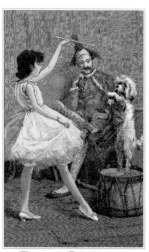

TWO OF PENTACLES

# TWO OF PENTACLES

## Keywords and phrases

Juggling many things at once • Keeping on your toes • Multi-tasking—and making it look easy • Enjoying a little bit of chaos and risk.

## Suggestions for reversals

Trying to juggle too much in your life • Things become too chaotic • Losing your sense of good humour about all the tasks you're doing • Falling flat on your face over work—though not in any disastrous way • Deciding to let things take care of themselves—you need a break!

The young circus girl who trains her dog in this picture looks a mix of serious and playful. While she is concentrating hard on her task, at the same time she is almost dancing with delight at the fun of the whole process. Her companion watches on with a distinctly sardonic look—obviously ever so slightly sceptical that her efforts will succeed. The dog? It seems to be enjoying itself—after all, a circus dog's life is at least an interesting one.

The Two of Pentacles is the card of the juggler—the person who can manage many tasks at once and rather likes to show off this ability in front of other people. He or she is the one who can make a few phone-calls and get tickets to the sold-out event, while simultaneously rustling up a delightful little pre-theatre snack—phone in one hand, saucepan in the other. The juggler may be able to manage a demanding full-time profession and a little part-time "fun" job in the evening. Or she may simply be able to organise a chaotically busy household, a frenetic social life and still have time for a hobby or two. So is this the card of the modern "superman" (or woman)? Well, no, not quite. The typical Two of Pentacles moment isn't about momentous or enduring success so much as just those fleeting but fun times when you have a lot going on and are thoroughly enjoying making it all work. Like the circus girl training the dog, the tasks themselves don't have to be particularly impressive—the point is rather that there is some demand and even some risk of failure involved, and yet you're having fun all the way and taking none of it too seriously. This card is very different from the Ten of Wands—in which the multiplicity of tasks has become a burden, or the Eight of Wands, in which it's thrilling but perhaps

confusing and out of control. The Two of Pentacles is the card of the consummate "multi-tasker"; your ability to keep it all going like a wonderfully complex piece of clockwork feels good—and you probably hope that some others are appreciating the brilliant little spectacle.

We've used a circus image to show both the playful and the performance aspects of this Two. The circus was hugely popular in the nineteenth century all over Europe and America, although it was considered by many people to be rather disreputable. But it was irresistible too—in a world of rules, regulations and rather conventionalised ideas about respectable behaviour, circuses, funfairs and the music hall gave people an opportunity to break out and be a little outrageous—or at least to have fun watching others doing outrageous things. Circus people were certainly not considered part of respectable society; I've mentioned, in the discussion of The Fool card the shame with which a character from Dickens' *Hard Times* confesses that her father is—horrors—a circus clown. In fact, circuses in general were seen as disreputable places where it was perilous to go. Here's another scene in which young boys are warned of the dangers:

> "I want to go to the circus, too, Uncle, when it comes here...I'll work and earn the money. I can go in the evening after my work is finished. Please let me go, Uncle."
>
> For a full minute Abner Adams was too overcome with his emotions to speak. He hobbled about in a circle, smiting the ground with his cane, alternately brandishing it threateningly in the air over the head of the unflinching Phil.
>
> "Circus!" he shouted. "I might have known it! I might have known it! You and that Tucker boy are two of a kind. You'll both come to some bad ending. Only fools and questionable characters go to such places."
>
> Edgar Darlington, *The Circus Boys on the Flying Rings*

Yet one senses that while upstanding citizens frowned on circus people they may also sometimes have envied them. To dress in scandalous costume, carry a wand and show your legs—as the girl in this card does—must have seemed shocking, but also quite thrilling. It truly is a picture of freedom, and of an opportunity to do all sorts of things that were entirely off-limits to respectable ladies. Oh to throw away the corsets, kick off respectability and become a juggler or animal trainer—it must have been, to the more stiff and repressed Victorians, the stuff of dreams.

## Sources

This is based on an engraving of a work by M. Grieyson (we have no dates for this artist) titled, "Dancing Lessons". Unfortunately, like several of the artists whose work we've used in this deck, this person now seems largely forgotten.

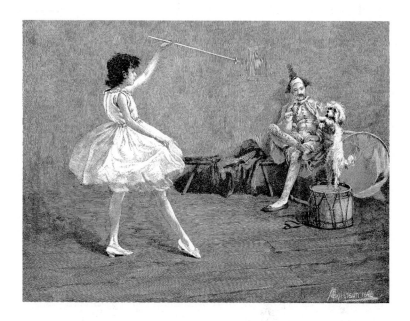

THREE OF PENTACLES

# THREE OF PENTACLES

## Keywords and phrases

A maestro or master of an art of craft • Being recognised in your chosen field • Taking pride in your attainment • Creating a masterpiece • Reaching the peak of your trade or profession • Enjoying your own artistry and accomplishment • Working with others to acquire or practise a skill or craft.

## Suggestions for reversals

Mastery of a lesser craft—maybe something quite simple • Feeling that you can't reach the level of achievement you're aiming for • Your skills are not fully recognised or used • Work problems, maybe poor-quality work • Co-workers or sponsors are being unhelpful.

This is the card of the master artisan. It can indicate any area that requires knowledge, skill and craft. It symbolises someone who has reached a stage at which they are recognised by others—they may be famous, or simply respected and recognised as expert by their peers. It traditionally also stands for monetary success and the ability to earn a good living by craftsmanship or artistry. As a tarot Three, the card also acknowledges the impact of other people and points to teamwork; although the skilled crafts-person may work alone, it's only by learning from others that she or he has attained their peak of perfection. This is an aspect that is sometimes forgotten but can be important in a reading.

In the traditional RWS card, a master mason is shown at work in a monastery, watched by two onlookers (the image is thought to have Masonic references). Our image is altogether more humble—an elderly man makes a little carving from the wood of a Christmas tree, while a pair of children watch, enthralled. We get the impression that this is a yearly activity; the man works with confidence as the carving grows in his hands. There is a nice implication of recycling in this; not everything beautiful needs to come from expensive materials.

The Three of Pentacles might, in some readings, ask us to consider our attitude to craft skills of all kinds—do we value them highly enough? Of course, whittling a tree trunk may not be high art (although it may seem so to the

thrilled children) but many of the craft and manual skills seem unjustly devalued. This was the subject of a debate that raged in the Victorian era, when luminaries of the Arts and Crafts movement demanded a return to the medieval approach, in which no distinctions of relative importance were made between artist and artisan:

> The handicraftsman, left behind by the artist when the arts sundered, must come up with him, must work side by side with him: apart from the difference between a great master and a scholar, apart from the differences of the natural bent of men's minds, which would make one man an imitative, and another an architectural or decorative artist, there should be no difference between those employed on strictly ornamental work; and the body of artists dealing with this should quicken with their art all makers of things into artists also, in proportion to the necessities and uses of the things they would make.
>
> William Morris, *Hopes and Fears for Art*

In some ways, this card is all about acknowledging the importance and beauty of manual and craft skills. In our modern society, in which there is so much desire for fast gratification, we should especially value the ability to take the time and care to make things well. This applies whether we're talking about a musical performance, a cathedral, a great meal, a beautiful painting, a garden—or just a little carving whittled from a Christmas tree.

## Sources

Based on an engraving of a painting by Otto Pilz (German, 1876-1934), titled "Christmas Ending". Otto Pilz produced some very charming bronze sculptures, often depicting youths or children. As he was a sculptor himself, one wonders if this picture is actually a self-portrait of the maestro himself doing a simple piece to amuse the children.

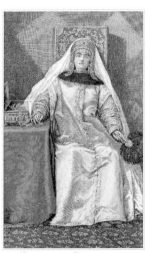

FOUR OF PENTACLES

# FOUR OF PENTACLES

**Keywords and phrases**

Greed • Caring too much about material things • Saving and investing • Anxieties about money, which may or may not be justified • Holding so tightly to your possessions that you can take no pleasure from them.

**Suggestions for reversals**

Generosity • Relaxing your grip on possessions, sharing more • Spending too freely • A theft of your possessions • Realising that there's more to life than money.

After the liveliness and achievement of the first three cards of Pentacles, things suddenly slow to a halt with the Four. In fact the next three cards, the Four, Five and Six of Pentacles, all deal with behaviour and attitudes towards material possessions, and with the true meaning of giving, taking or accumulating money.

The message of the Four is one of holding fast, keeping your possessions safe and sound, conserving money and energy and avoiding extravagance or risk taking. These solid, practical aspects are often positive, and this card should be interpreted carefully according to the cards around it—the message can sometimes be one of sensibly managing your resources and putting some savings aside.

But beware—all the caution and care with your wealth and possessions can easily turn into miserliness and an obsession with keeping everything you have for yourself alone. This card is in fact an echo of the Four of Cups, although while the Cups card signifies a general boredom and depression, the Pentacles' Four is more about being too suspicious and cautious for your own good. At its most extreme, it can point to behaviour like that of the famous Dickens' character Ebenezer Scrooge, whose meanness and determination to protect his fortune made him miserable, friendless and uncaring. This card is in fact sometimes referred to as the "Scrooge Card". Here's a scene in which a gentleman comes to Scrooge's house to raise money to help the poor at Christmas:

"A few of us are endeavouring to raise a fund to buy the Poor some meat and drink, and means of warmth. We choose this time, because it is a time, of all others, when Want is keenly felt, and Abundance rejoices. What shall I put you down for?"

"Nothing!" Scrooge replied.

"You wish to be anonymous?"

"I wish to be left alone," said Scrooge. "Since you ask me what I wish, gentlemen, that is my answer. I don't make merry myself at Christmas and I can't afford to make idle people merry. I help to support the establishments I have mentioned—they cost enough; and those who are badly off must go there."

"Many can't go there; and many would rather die."

"If they would rather die," said Scrooge, "they had better do it, and decrease the surplus population. Besides—excuse me—I don't know that."

"But you might know it," observed the gentleman.

"It's not my business," Scrooge returned.

Charles Dickens, *A Christmas Carol*

The "establishments" that Scrooge is referring to are the poor-houses or workhouses and we'll come back to the role of these in nineteenth century society in the Five of Pentacles. Here it's sufficient to say that they were dreaded places and Scrooge's suggestion that all the poor should be sent there only serves to underline his callous meanness.

The image that we have chosen for this card shows a character who doesn't appear, on the surface, a bit like the miserly and miserable Scrooge; she's young, beautifully dressed and sits on a grand chair in apparent luxury. But as her hand trails the gold in her jewel-box by her side she looks listless—slumped in her chair with a dull expression on her face. A happy woman? No, in spite of her material riches. She looks trapped by all her layers of expensive clothing, and the overall image is slightly claustrophobic. This woman appears isolated and imprisoned by her wealth.

Having said all this, I'd emphasise again that this card isn't always negative. But when reading the Four of Pentacles you should ask whether it indicates—as it can do—a real need to save and conserve resources or if, to the contrary, it's warning of a tendency to meanness and an irrational fear of losing money and possessions. Remember that while riches can indeed be a great liberator they can also, if taken too seriously, become a prison.

## Sources

Based on an engraving of a painting by Russian artist Klawdy Wassilievitch Lebedeff (Russian 1852-1916), titled "Barina".

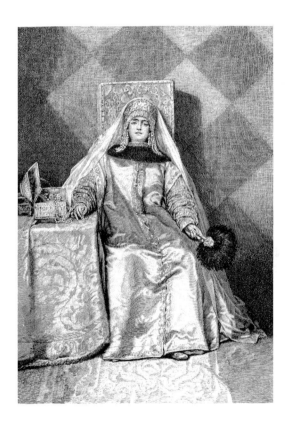

# FIVE OF PENTACLES

### Keywords and phrases

Needing help • Being reduced to poverty, perhaps temporarily • Unsure whether times will get better • Getting support from an unexpected source • Sticking to your loved ones through thick and thin.

### Suggestions for reversals

Your troubles begin to ease • You have some unexpected luck that eases your difficult situation • You lose control and damage your own financial and material well-being • Your problems provoke tensions with friends and family.

It's the face of the woman on this card that is both the most striking and the most haunting part of the image. She seems to have reached that stage of despair and resignation that has hardened her expression to the point of blankness—she stares out to another place beyond the horrible situation in which she finds herself. Yet her emotions are not quite frozen—she holds her child, wrapped in a rough blanket, with an almost fierce intensity. Behind them the heavy wooden door of a church is firmly shut.

This card is, on the face of it, about poverty, insecurity and despair. But it's also about love, and about asking for help, not for yourself only, but also for those you care for. It can seem an unnerving card to draw in a reading as it usually warns of hard times, financial difficulties and a tough struggle. But it also carries the promise of enduring love, and of finding help. The church is close at hand, though the door is shut. But perhaps the door will open, maybe someone will come and offer support and shelter.

To the Victorians, there was special fear of being reduced to depending on charity as it could eventually lead to the "poor-house" a hard institution often not much better than a prison and generally regarded with dread and shame:

> Over the hill to the poor-house—I can't quite make it clear!
> Over the hill to the poor-house—it seems so horrid queer!
> Many a step I've taken a-toilin' to and fro,
> But this is a sort of journey I never thought to go.

What is the use of heapin' on me a pauper's shame?
Am I lazy or crazy? am I blind or lame?
True, I am not so supple, nor yet so awful stout;
But charity ain't no favor, if one can live without.

Will Carlton, "Over the Hill to the Poor-house".

In the traditional RWS image of this card, two people, apparently homeless beggars, battle their way through the snow; a church stands closed behind them. Our image is very similar but it has one variation that I very much like. In this picture, the woman is not begging, but rather is selling her branches of spring catkins. What she is offering is humble, but one feels that this still provides her a way to keep her pride—to give as well as take. As I look at this picture I want her basket to be empty and her pockets full. Will it happen? At this moment, she obviously thinks not, she looks almost at the end of her tether. But in one odd sense, help may already have come. The artist who drew this picture was helping, in his way, by drawing attention to all such situations—the image demands our compassion.

When we receive the Five of Pentacles in a reading, we are being asked to think about charity, neediness and assistance. It also reminds us that love can be at its most powerful in times of trouble. If this card warns us of hard times ahead, it also reassures us that we won't be alone, and that help may be found. It tells us to retain both our love for others and our pride, and to trust in these.

Sometimes, the card is not pointing directly to our own situation, but instead urges us to look around and find compassion for others. Have you walked past someone today who needed—really needed—some help? Maybe you should stop and offer your assistance? Even a small act of generosity may make a large difference.

**Sources**

The artist is G. Raff. We found this print in a copy of the German periodical, *Die Gartenlaube* from 1893. It is titled "At the Church Door."

# SIX OF PENTACLES

## Keywords and phrases

Charity, both give and take • Generosity brings its own rewards • True benevolence does not expect thanks • Charitable institutions • "It's better to give than to receive".

## Suggestions for reversals

Giving charity grudgingly • Demanding material help—when perhaps you don't really need it • Expecting too much gratitude for small favours • Finding yourself the recipient of charity when you used to be the giver • Problems with the running of charities and benevolent organisations.

SIX OF PENTACLES

The word "charity" stirs up such a variety of reactions; when we think of the large charitable institutions and trusts, our response is generally very positive, but when it comes to begging—and giving—in a more personal way, on the street perhaps, then we tend to be much more ambivalent. The Six of Pentacles is about charity, benevolence, donating and receiving—and it's one of the cards of tarot that no-one seems to be particularly fond of. This seems to be because it leaves us with some slight discomfort, perhaps in the back of our minds there is still something of the eighteenth and nineteenth century horror of becoming the recipient of such charities as work-houses and soup kitchens. We all want to stand on our own two feet, yet we know that it's not always possible for everyone. There are times when charity is absolutely necessary.

Our chosen image for this card aptly conveys some of the tensions we feel about face-to-face charity. It's set in a churchyard, so it can be seen as a natural continuation of the scene in the Five of Pentacles. Here, we see a moment of charity, which should be heartening. But the young woman who buys a little posy from the poor little beggar-girl seems to do so with condescension. One rather gets the impression that she is hoping someone sees her kindness. Stiff, elegant and spotlessly dressed, she peers down her nose at the ragged girl who, in contrast, stares at her benefactor with a hungry intensity—almost a glare. Neither person smiles.

What a pity. Wouldn't it be better if this charity was given with a little human warmth? Yes, it's a good thing that the lady has stopped to buy some flowers (or

at least to look, in fact there is no coin in her hand) but couldn't she give some emotional support in addition to the small financial contribution?

In the nineteenth century, children who were reduced to hawking cheap items on the streets faced a miserable life. Hans Andersen's tragic tale of "The Little Match Girl" reminded his readers of just how very harsh such a life could be:

> She carried a quantity of matches in an old apron, and she held a bundle of them in her hand. Nobody had bought anything of her the whole livelong day; no one had given her a single farthing. She crept along trembling with cold and hunger—a very picture of sorrow, the poor little thing!
>
> Hans Andersen, "The Little Match Girl".

Looking at this portrayal of the flower seller on our card may help us to consider out own experiences of both giving and receiving. Whichever side we're on in this transaction, let's try to make it an occasion of joy, rather than a demonstration of either superiority or resentment. When we draw this card in a reading, we might think how much the scene would change if the elegant lady bent a little—literally or metaphorically, and came down to the girl's level. Perhaps that glare on the child's face would vanish and be replaced by a smile?

I'll leave the last word to Mrs. Beeton, a lady who was a veritable treasure chest of good advice:

> Charity and benevolence are duties which a mistress owes to herself as well as to her fellow-creatures; and there is scarcely any income so small, but something may be spared from it, even if it be but "the widow's mite." It is to be always remembered, however, that it is the "spirit" of charity which imparts to the gift a value far beyond its actual amount, and is by far its better part.
>
> Mrs. Isabella Beeton, *The Book of Household Management*.

## Sources

This is taken from an engraving based on a drawing by German/Czech artist Ludvik Marold (we have no dates for this artist), titled "Buy a Violet."

# SEVEN OF PENTACLES

SEVEN OF PENTACLES

## Keywords and phrases

Building on your achievements • A pause while you assess your situation • Using novel strategies • Pleased by a job you did well • Looking out for the next sensible step.

## Suggestions for reversals

Instead of calmly assessing your situation, you become anxious about it • Finding it hard to make plans, fussing instead of deciding what to do • Throwing away opportunities because you don't see them clearly • Allowing your current achievements to stagnate, when you should be building on them • Carrying on with a project when it might be better to stop and analyse what's been done.

The Seven of Pentacles is a card that few people seem to have strong feelings about. There's no doubt that some cards in the tarot raise powerful responses in many people while some seem to be, well, much less emotive, even less interesting; the Seven of Pentacles seems to be one of those "take it or leave it" cards. It's not much discussed by tarot enthusiasts and just doesn't seem to evoke much excitement. I think this is for two reasons; firstly that the card's usual meaning—which is broadly about pausing to assess your work in progress—isn't, at first sight, all that thrilling. Secondly, the card's wider potential range of interpretations can seem a bit vague, and this can be rather off-putting. This isn't one of the clearest cards in the deck; Arthur Waite described the potential meanings as "exceedingly contradictory" and even today the correct interpretation of this card in a reading tends to be debatable.

Originally, the RWS meanings of this card were very broad and oddly varied; they could range from innocence and ingenuity to quarrels and conflict—all in addition to the more usual interpretations about business achievements and trade. Coming just before the "Apprenticeship Card", the Eight of Pentacles, it can also be seen as indicating that an important decision needs to be made— carry on as before, or take a definite step towards acquiring new skills, new training and perhaps a fresh way of doing things.

In *The Victorian Romantic Tarot* Seven of Pentacles we see a young woman who is gathering fruit. She is well wrapped up in a shawl and this, together with the

yellow leaves behind her, tells us that this is early autumn, harvest time. She has paused to look at the small bunch of flowers in her hands; they almost certainly aren't part of the harvest that she's picking but they represent something else, beauty rather than practicality perhaps. It's a moment to pause, reflect and perhaps dream a little.

However you interpret this card, it's this sense of pause that's important. In a reading it indicates a time to stop, take stock and assess what you have; in a sense to gather in your harvest and work out how best to put it to use. Don't rush, but instead give yourself time to muse, imagine and plan.

## Sources

This is based on an engraving of a painting by the Italian artist, A. Ferragutti, titled "Blondchen". It's possible that this is intended as an illustration of Blondchen from Mozart's opera *Abduction from the Seraglio.*, although the girl seems rather too young to be this character.

Incidentally, it's a nice coincidence to have an image by a Visconti; the first ever known tarot cards were painted, in the mid fifteenth century, as a gift for a Visconti wedding.

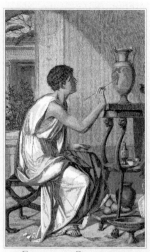

EIGHT OF PENTACLES

# EIGHT OF PENTACLES

## Keywords and phrases

Apprenticeship, particularly in a craft
• Exquisite, detailed work • "Practice makes
perfect" • Satisfaction from a job well done.

## Suggestions for reversals

Getting impatient with a skill you're learning
• Giving up on a training course or an appren-
ticeship • Doing things rather roughly • Not
taking care • Feeling down about the time it's
taking you to get to the level of achievement
you aim for.

After the reflection and assessment of the
Seven, things move on again in the Eight of
Pentacles—this card is about the hard, but
satisfying work of apprenticeship and learning a skill. The picture shows a
young Greek man concentrating hard as he paints a vase. Around him are
other vases, either waiting to be painted or newly done. This young man is
obviously highly-skilled, but perhaps still has more to learn. He seems fasci-
nated by his work.

It takes time, patience and perseverance to excel at a practical skill, and one of
the main messages of this card is that things don't happen overnight; you have
to be prepared to keep working and improving whether your chosen field is
something down to earth such as gardening or building, or a more artistic area
such as music, painting or literature. Though it was no less a person than the
great Arts and Crafts artist and writer, William Morris, who pointed out that
we should question such distinctions in any case:

> As to the bricklayer, the mason, and the like—these would be artists,
> and doing not only necessary, but beautiful, and therefore happy work,
> if art were anything like what it should be.
>
> William Morris, *Hopes and Fears for Art*

This card is not, like the Three of Pentacles, about mastering a skill, instead it's
about the effort you need to make to gain such mastery; apprenticeship, a
willingness to learn by doing, steady application and practice. As Morris
reminds us, any work that is both useful and beautiful is a pleasure in itself,

and the process of learning can bring great satisfaction, although it also requires patience and perseverance.

Yet apprenticeship is a notion that went out of favour in the second half of the twentieth century; we tend now to see it as rather lowly, and we're more happy with the less hierarchical concept of teacher and pupil than master and apprentice. Perhaps we've simply become more snobbish about manual skills, and feel more comfortable when these are taught in colleges and other formal education institutions rather than by the long hard slog of following a master. We've also, arguably, become much less patient with the whole process of acquiring a skill by practice and want everything to happen quickly. But practice takes time, even if time is one thing that many of us are short of these days. This card reminds us of this, and also encourages us to take pleasure in the process.

## Sources
This is based on a print of a painting by Czech artist Vaclav Bartonek, titled "Greek Vase Painter".

> I am glad a task to me is given,
> To labor at day by day,
> For it brings me health and strength and hope,
> And I cheerfully learn to say,
> "Head, you may think, Heart, you may feel,
> But, Hand, you shall work alway!"
>
> Louisa May Alcott, Jo's "A Song from the Suds", from *Little Women*.

# NINE OF PENTACLES

## Keywords and phrases

Material prosperity • Comfort and contentment • A refined and privileged way of life • Independence and self-reliance • Achieving a civilised lifestyle.

## Suggestions for reversals

Losing some self-confidence • You have it all, but for some reason you're not really satisfied • The facade of your life is perfect, but underneath there are some difficulties • Longing for the material and emotional security that you haven't quite attained yet.

NINE OF PENTACLES

It's interesting to see how many strong, confident women feature in Victorian art; the notion that women in the nineteenth century always had to present themselves as frail, dependent creatures is hard to support when you look at some of the images in this deck. It's true that women had very many restrictions both socially and legally, and to be considered respectable they had to be eternally "proper" in appearance and behaviour. As Jo, the rebellious girl in Louisa May Alcott's classic *Little Women* complained, "I hate to think I've got to grow up, and be Miss March, and wear long gowns, and look as prim as a China Aster!" Yet, although women might have been expected to look prim, they did not, it seems, have to appear weak.

The Nine of Pentacles is a good example of a portrait of a strong, confident-looking woman; she gazes out at the viewer with perfect assurance. This card is about reaching a stage in life—or in an enterprise, project or business—when you can take some ease and enjoy your achievements, and maybe show them off a little too. The woman is elegantly dressed in a fashionably rural mode, and the flower basket over her arm shows that she pursues her hobbies and interests with style. The whole card is sunny, bright and just a little showy—this woman is happy to display her success, although she doesn't look boastful. If you compare her with the Seven of Pentacles, you can see that she is much more leisured; in the Seven the young woman (dressed in much less refined clothes) is gathering in the harvest for real. In our Nine, the prosperous lady picks flowers more, we can assume, as a picturesque pastime rather than because there's any actual need.

The original RWS imagery for the Nine of Pentacles shows a woman standing holding a hooded falcon. She is framed by two formal topiary trees (trees cut to a specific shape) and in the far, far distance, you can just see the tops of a line of mountains. The implication is that this is someone who has a prosperous, civilised life which is fully under control—the wilder sides of nature are either tamed, as represented by the falcon, or a long way away, as represented by the misty mountain tops. In our card, we see not shaped, but pollarded trees; that is, trees that have been cut back in order to restrict their growth. This was usually done to manage trees growing in grazing meadows—incidentally, it was a very popular technique in the nineteenth century. The pollarding shows us that our lady stands in a carefully managed parkland or meadow; this is not a wild field, everything is under perfect control. In the far distance, the blue peaks of mountains can be seen, a reminder, as I've already discussed, of the wildness that lies outside this civilised world.

## Sources

This is based on an engraving from a beautiful painting by German artist Conrad Kiesel (1846-1921) who was known for his portraits of society women. It is titled "Field Flowers". We've used another of his pictures in the Queen of Wands. We changed the background in order to give the imagery the added depth of meaning needed for this card.

# TEN OF PENTACLES

## Keywords and phrases

Affluence and material well-being, within conventional limits • Choosing material success over art and imagination • Finding "Magic at the gate"—seeing that if you're willing to seek it out, there's more to life than the material and practical.

## Suggestions for reversals

Some disruption to your financial and material well-being • Being wealthy but discontent—a yearning for something more spiritual or intangible • Throwing away some of your security in order to pursue something more exciting.

TEN OF PENTACLES

As the very last non-Court card of the Pentacles, one might expect the Ten of Pentacles to indicate the greatest degree of practicality, riches and material comfort. Many people do read the card this way, and interpret it as being about prosperity and reaching a mature, stable situation of well-being. But in the traditional RWS card, the imagery is complex and far from earthy, instead it carries an air of mystery and ambiguity. Our image follows this tradition and shows a man, elaborately dressed, sitting in front of an old stone archway and apparently selling apples. In the background two young lovers can be seen, happy and utterly wrapped up in one another.

Apples are a complex symbol, which fits this rather intricate card. The classical Biblical reference to the apple is the fruit of the Tree of Knowledge; eating it caused Adam and Eve to be thrown out of paradise. But when the poet W.B. Yeats (who was a prominent member of the Golden Dawn, and believed to have been involved in advising on symbolism for the RWS tarot) talked of:

> The golden apples of the Sun,
> The silver apples of the Moon
>
> W. B Yeats, The Song of Wandering Aengus

he was referring to Celtic legends of the Sidhe (the fairy folk) who were believed often to bring with them either silver or golden apples when they visiting the world of mortals.

So who is the figure on this card? Is he simply an old man or does he have

magical or fairy qualities? He's dressed in oddly elaborate clothes for a market trader; he appears to be a prosperous, worldly gypsy, someone who has seen much in his life. But he also seems separated from his surroundings, he looks straight out, beyond the world of the card. Behind him, in contrast, the young couple are totally self-absorbed and inward-looking. Well-dressed and handsome, they seem to have everything; they don't even notice the old man in the archway. We can read this as a juxtaposition of the material and the mystical— the couple are down to earth, prosperous, handsome and concerned with practical matters, they see only the real world. The unnoticed old man is something altogether more strange. He meets our eyes with an amused questioning as he holds up his apples. He looks as though he may be about to juggle them; there is something reminiscent of the tarot Magician about him. Maybe he's asking if we are willing to bite the fruit and visit another reality, the world of fairy and the Sidhe perhaps?

In a reading, this card can take a very straightforward meaning, indicating material and financial well-being and a general prosperity in home-life and relationships. However, in some contexts its more arcane, mysterious side may come to the fore. Then it can be read as a questioning of materialism and the mundane and as a call for us to embrace the possibilities of magic and enchantment.

### Sources
This is based on an engraving of a picture by Enrico Serry (we have no dates for this artist) titled " Spanish Orange Seller ". The original picture has been quite significantly altered for this card.

# THE COURT CARDS

Oh, those troublesome Royals! The Court cards of tarot are very often the ones that readers have most problems with, even to the extent of saying that they dread seeing a spread filled with several Courts. It's true that in both the Marseille and RWS traditional imagery, the Courts can initially seem very similar to one another, with few strongly distinguishing features beyond the suit symbols. This can make them hard to interpret intuitively from the picture, so there is a tendency, with the Courts, perhaps more than any of the other cards, for readers to learn the meanings by rote. This may be at the root of why people feel less confident when dealing with the Courts—often the interpretation is learned rather than experienced, leaving readers feeling somewhat distant from these cards and unable to develop their own personal relationship and range of interpretations for them.

In *The Victorian Romantic Tarot* cards we've tried to depict the characteristics and significance of each Court in a clearer way, in the hope that this will encourage readers to work directly from the pictures, as well as draw on learned interpretations. We also hope that the discussion of the similarities and differences in our Courts in this section will help to empower readers to work with these cards more confidently.

Firstly though, a few general remarks. The way that Courts are approached these days is usually to regard them as not necessarily being of any specific gender; you can find that a Knight card indicates certain traits in a woman, or a Queen can stand for qualities in a man. It's true that the Courts are still usually interpreted as symbolising individual people—or aspects of their personalities or sphere of influence—rather than archetypes or events. However, even this doesn't always hold true (as ever, tarot is very flexible in its potential interpretations) and it's good to consider a wide range of possible ways of reading any Court that shows up in a reading; sometimes these cards can stand for a general mood or theme rather than an influence specifically attached to one person.

## The Victorian Romantic Courts

When we design cards, we believe that it's important to bring out the distinct qualities of each Court—it helps even the most experienced reader if the Court cards "speak" for themselves. Choosing and composing the Courts for *The Victorian Romantic Tarot* required some hard decisions though; many Victorian artists were fascinated by both royalty and ideas of medieval chivalry,

so there are knights, queens and kings aplenty in the art of that period. However, we decided early on that for this deck, we didn't want to use portraits of real European royalty, interesting as some of these were, but instead we wanted to show nineteenth century art at its most romantic and evocative, by choosing pictures set in a medieval mythical fantasy world. After all, the Victorians painted such a world so very well, perhaps better than anyone before or since.

## The Pages

The Pages of our deck are somewhat androgynous—they look a little like the girls-dressed-as-boys that were so popular in Victorian pantomime and music-hall. This makes them rather touching—it gives the images a certain vulnerability and youthfulness, entirely appropriate to the tarot Pages, who are enthusiastic but inexperienced. When you look at the original RWS Pages, they have a similar "pantomime boy" look—Pamela Colman Smith, the artist for that deck, worked in theatre and so would have been very aware of both this tradition, and of the Elizabethan use of young boys to play girls on stage. We were particularly pleased to make this reference to Colman Smith's view of the Pages, as we feel it adds greatly to their sense of youth, tenderness and naivety.

The cheeky Page of Wands is perhaps not as beautiful as the others, but he's definitely the joker and the performer of the four. He's sociable, and has a tendency to try to be the centre of attention—he may not always notice when this irritates his companions. His costume is somewhat theatrical, and in fact he is shown taking part in a performance or parade.

The Pages of Cups and Swords are the most sensitive. The Cups' Page shows a high degree of emotional intelligence, he's musical, romantic, and loves the company of others. In contrast, the Swords' Page is sensitive, not to people, but to the risks and dangers around him, he's always hyper-alert and on-guard. The Page of Pentacles is much more cut-off in his feelings and emotions, he looks inward and may seem quite indifferent to events and people that don't seem to have any practical function in his life.

The Page of Cups is gentle, direct and approachable. Though dressed as a Pageboy, it's obvious that this is probably a girl, enjoying the company of a friend who is concentrating on playing music. She smiles straight out at the viewer, as though inviting you to join in this merry scene. The image is literally in close-up, so that, indeed, you feel almost part of it. Our Cups' Page is also relaxed, dreamy, almost sleepy—we feel that she meets our eyes and welcomes us into her world.

The Wands' Page also stares out, not dreamily however, but cheekily, as though inviting us to admire his sheer bravado and chutzpah. The Swords' Page is wide awake, confident, but keeps us at more of a distance., he stares not out of the card but behind his shoulder at an unseen threat. It's a somewhat cold image. Pentacles is the only Page who sits rather than stands—in fact he is almost slumped, and in his case, the tunic and tights that all four wear is covered by an oversized and immensely heavy-looking ermine cloak. One might say that his Courtly responsibilities sit—literally—heavily on his shoulders. He looks older than the others, mainly because of his serious expression.

In summary, then, the Pages are:

- Page of Wands: Active, direct, confident, "cocky", challenging, theatrically dressed.
- Page of Cups: Passive, dreamy, relaxed, welcoming, artistic, ornamentally dressed.
- Page of Swords: Active, direct, on-guard, tense, dressed as though for a fight..
- Page of Pentacles: Passive, thoughtful, seated, absorbed, very richly dressed.

## The Knights

All of our Knights cards demonstrate the Victorian love of medieval, Gothic fantasy. All are very much in the mode of classic Courtly knights—young, handsome, armoured, chivalrous. All four are shown in a relationship with a woman or women, and each approaches this in an entirely different way.

The Knight of Cups, a classic knight in shining armour (in fact so shiny as to be mirror-like), is surrounded by seductive flower-maidens, but he is entirely oblivious, wrapped in his own dream world—he thinks only of his quest. He's the perfect Grail knight and as such is disconnected from the real world; totally caught up in visions, idealism and the search for the pure and perfect.

The Knight of Pentacles is quite different, not at all the dreamer, he is entirely practical; he's rescued the fair maiden, slain the monster and he is now... rather downcast. This is a knight who has forgotten the thrill and fun of the quest and instead has begun to see it just as hard work. He isn't even interested in the fair maiden—in fact, this isn't surprising, as this Knight is actually, in an odd inversion of our Pages, a woman-dressed-as-a-man. Her femininity is stifled and cut off by all that armour and she's become stiffly and uncomfortably androgynous. This Knight is trapped in duty.

The Knights of Wands and Swords are more lively and more interested in their ladies. Sir Wands looks enraptured at the young woman he has just met and meets her gaze with his own handsome dark eyes. It's definitely he who seduces her, not the other way around, and she may not yet have realised that he has a lady in every castle, a maiden in every town. He's noble and well-meaning in a way, but dangerously flighty. Meanwhile his horse grabs a bite to eat, knowing that its rider will soon be on his way again.

The Knight of Swords is startlingly dynamic; he sees his whole mission as one of conflict and riding to the rescue. But he isn't really rescuing a woman, so much as an abstract idea. His "lady" is flung, naked and vulnerable, across his horse while he turns to his main focus, the ensuing battle. But is his rescuee a woman at all? She is a winged, diaphanous fairy figure, not a real and solid human. This Knight is probably not interested in anything so mundane as a real-life woman, instead he loves ideas, notions, theories and ideals; it's these, rather than an actual person, that he's defending.

We can summarise the Knights:

- Knight of Wands: Active, direct, attractive, seductive, dressed for travel.
- Knight of Cups: Passive, dreamy, searching, vague, dressed in mirrored armour (which is reflecting girls and flowers).
- Knight of Swords: Active, fierce, severe, challenging, dressed plainly and as though for battle.
- Knight of Pentacles: Passive, depressed, dutiful, stuff, dressed for the duties of a knight.

## The Queens

The Queens in this deck look strikingly different from one another. To begin with, their postures are very distinct; the Queens of Wands and Swords are standing, looking straight out at the viewer, whereas the Queens of Cups and Pentacles are seated, and look away, inwards towards their own realms. They are of different time periods also; the Queens of Cups and Swords look mythic and medieval, but their sister Queens are modern Victorians. All are well-dressed, as befits royalty, but whereas the Queen of Swords wears an armoured breastplate and plain robe, the others are all much more decoratively dressed, and the Queen of Wands is actually in theatrical costume. Finally, they vary in age, the Queen of Cups being the youngest, the Queen of Swords the oldest.

To summarise their appearances:

- Queen of Wands: Active, direct, modern, mature, theatrically dressed.

- Queen of Cups: Passive, dreamy, mythical, young/mature, ornamentally dressed.
- Queen of Swords: Active, direct, mythical, older, severe, dressed plainly and as though for battle.
- Queen of Pentacles: Passive, dreamy, modern, young/mature, informal, sensually dressed.

It's worth saying that the ages of the Queens on our cards should not be taken necessarily to indicate the age of a person indicated in a reading. All the Queens can be any physical age, the point is rather that the Queen of Swords is the oldest and most experienced in outlook, the Queen of Wands tends to be mature (and likely to be experienced in terms of passionate relationships), whereas the Queens of Cups and Pentacles may be either "womanly" or quite "girlish" in their thinking. There's sometimes more than a touch of playfulness in these last two Queens, although they can also both show a well-balanced maturity and responsibility when it's needed.

## The Kings

The Kings of this deck show mature men in postures and dress that fit our classic idea of what a story-book king should look like. Set in a kind of Victorian fantasy of history, they arguably share more characteristics in common than any of the other Courts. We can understand from this that the overwhelming burden of kingdom to some extent outweighs the more indi-vidual influence of the suit characteristics. In other words, all the tarot Kings are first and foremost about authority, responsibility, self-sacrifice and leader-ship. The visual characteristics of these Kings could be summed up as follows:

- King of Wands: Average build, elderly, richly and warmly dressed, shown seated in an elaborately carved chair, watching a musical performance, and surrounded by people.
- King of Cups: Plump, well-fed, elderly, social, quite richly dressed, a "bon viveur", shown seated at table at Court, telling a story to amused companions.
- King of Swords: Thin, gaunt, thoughtful, mature, isolated, quite plainly dressed, shown in a ruinous stony landscape, completely alone apart from a small snake nearby.
- King of Pentacles: Heavily-built, serious, elderly, very richly dressed, accompanied by servants, shown riding in his lands (rich castle in the background).

# PAGE OF WANDS

### Keywords and phrases

A confident energetic and brave personality
• A message that requires action to be taken
• Innovation, liking to try things out
• A natural performer who loves the limelight
• An enthusiastic messenger.

### Suggestions for reversals

Listless and lacking in energy • A "butterfly mind", always flitting on to the next new thing • A message that is mis-communicated • Someone who appears courageous but has some inner doubts • Attracted by new things, but at the same time wary of them—inclined to be conservative.

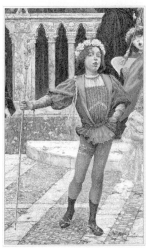

PAGE OF WANDS

In terms of the pictures on the cards, this is the youngest of the four tarot Pages in our deck, and yet he is also the most confident-looking of them all. In fact, he may be rather too cocksure of himself, with all the supreme self-assurance that comes from lack of experience. Certainly he looks fun, and the kind of boy who would probably throw himself into any activity at the drop of a hat. But already you can detect some of the tendency—that becomes stronger in the Knight of Wands—to take action before he really thinks about it. He's also a bit of a showman—gazing out from the picture straight at the viewer and striking a pose, hand on hips—he seems to be taking part in a parade or performance, and obviously expects to be admired.

When you look closely at this picture, you also realise that there are angels everywhere, on the columns behind there are cherubim, and a full figure of an angel sits atop the Page's wand. One role of angels is as messengers between our world and the celestial or heavenly realm—the angels here may serve to remind us that the Page of Wands is traditionally associated with messages and news. To some extent all the Pages can be news-bringers, but it's an aspect particularly strongly associated with the Page of Wands, and in a reading this card can often herald a communication of some sort.

When you're interpreting this Page in a reading, bear in mind that he is still, like all the Pages, someone with limited experience who can be naive. He is very confident about him or herself, but some of this confidence may be misplaced. He loves to stand out from the crowd, to be a fashion setter and

arbiter of "cool"—he adores being the first to take up something novel and rather daring. But he still has a lot to learn about the importance of follow-through, he's inclined to be restless and always looking for the next new thing. He's also frank to the point of fault—he hasn't yet realised how important tact can be, and as a bringer of news he is likely to blurt out everything excitedly, without thinking about the possible consequences or impact. He's lovely in many ways; appealing, passionate, honest and attractively unconventional. But do remember that he's still got a lot to learn.

## Sources

This is based on an engraving of a painting by Spanish artist Juan Villegas (we have no dates for this artist), titled "Palm Sunday in Venice". Villegas seems to have specialised in religious subjects.

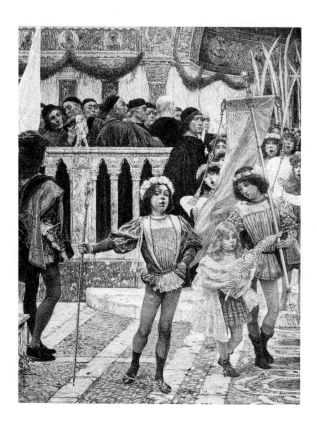

KNIGHT OF WANDS

# KNIGHT OF WANDS

### Keywords and phrases

A real charmer • A magnetically attractive person • Optimism and energy, but inclined to recklessness • 'Just do it", whatever the consequences • Someone of immense charisma, but less commitment • Emigration, making a major move.

### Suggestions for reversals

The "ladies' man" finally makes a commitment • Someone who uses his charms in manipulative ways • Some caution—perhaps justified • Deciding to stay put and not move home or job.

The Knight of Wands combines the energy and verve of the Wands with the dashing and daring action of the Knights. He is inclined to rush in where others might hesitate, not because he is aggressive, but simply because he's so energetic that he is inclined to act before he thinks. His sheer drive and liveliness make him charismatic and many women are likely to fall for his charms, unaware, at least initially, that while he is indeed a "Prince Charming" he isn't likely to stick around. This Knight is not callous, but he is easily bored and inclined to be restless. While he probably means well, before too long he's likely to move on to the next project, country or even affair. Enjoy his energy, enthusiasm and verve for life, but be cautious about relying on him.

All the Knights of this deck are attractive, but this is the one who is the most strikingly good-looking—classically tall, dark and handsome. In the traditional RWS image for this card, we see the Knight of Wands journeying through foreign lands, and in our picture, he is also a traveller. It seems as though he has just arrived and dismounted from his horse, to be greeted by the surprised, and obviously rather enamoured young woman, who seems to have risen to her feet suddenly, her lap still full of the roses she's been picking. She gazes at him, and we wonder if this is the beginning of a long-lasting relationship. Probably, however, the Knight will soon be on his way to new adventures, leaving her alone in her garden again. Still, at the moment captured here, he is certainly welcome in her life and you can see the possibility of a strong passion between them.

In the background are two blossoming rose trees, which remind us of the flowering wand carried by this Knight in the RWS card. The roses are orange, which traditionally, in the "Language of Flowers", signify passion and energy; two of the notable qualities of this Knight.

## Sources

Based on an engraving of a painting titled "Romance" by Franz Muller-Munster (1867-?). Muller-Munster is probably best known for his illustrations to a late nineteenth-century edition of *Grimms' Tales*. It's possible that the painting here was related to these fairytale illustrations, but this isn't certain. It does, however, have a distinctly fairytale style.

# QUEEN OF WANDS

## Keywords and phrases

An adored woman • A passionate, energetic person, probably with good athletic abilities • A creative approach to practical and business matters • Sheer joy in living • Warmth, especially towards others.

## Suggestions for reversals

A woman who uses her charms to get her own way • A loss of enthusiasm and energy • Being rather "offish" or snobbish with others • "Hell hath no fury like a woman scorned" • Magic, spells and witchcraft unkindly meant—the intent to harm is present even if there is no practical effect.

QUEEN OF WANDS

Beautiful, confident, energetic and a touch theatrical—the Queen of Wands is to many people the most captivating woman of the tarot. She certainly isn't as sensitive as the Queen of Cups, nor as clever as the Queen of Swords, but this is someone that you can imagine finding both stimulating and fun in the real world. She may love to be the centre of attention, and to have some melodrama going on around her, but she's also kind-hearted and can be surprisingly down to earth when it's necessary. So while she'll play the drama queen from time to time, she knows when it's time to take off her mask, smile broadly, and reveal the very real person behind it.

This striking portrait by Conrad Kiesel shows a woman—definitely all woman, rather than girl—who is proud but not vain. She seems to have only just taken off her carnival mask, but when she wears it you feel that it isn't something to hide behind, instead we can guess that it just adds teasingly to the theatrical allure that she often enjoys. She holds a decorated cane in her left hand, from which orange ribbons—in the fiery colours associated with Wands—stream. Her stance gives us a chance to see the ruby ring that she wears on her fourth finger; this is a lady who is not single, and yet we get the impression that she has certainly retained her independence.

She stands against a late summer landscape and directly behind her sunflowers are at the peak of their blossoming. They're included in part as a nod to the sunflower that was shown in the RWS depiction of this card, but mainly because in the Victorian "Language of Flowers" these smaller sunflowers meant

"Adoration" and the Queen of Wands is the most attractive, adored and, indeed, the most ardent of the tarot Queens.

And the posy that tops her cane? I think the flowers are Forget-me-nots, and what could be more appropriate? This Queen is confident that she is indeed unforgettable.

**Sources**

Based on an engraving from a portrait by German artist Conrad Kiesel, (1846-1921). Born at Düsseldorf in 1846, Conrad Kiesel first studied sculpture and then switched to painting. His technical skill, fine composition and colouring made him famous. and much sought after as a portraitist of society beauties. He also became an expert at genre pieces.

We've also used a picture by Kiesel for The Nine of Pentacles.

# KING OF WANDS

### Keywords and phrases

Theatrical and charismatic—a showman • A leader who attracts followers with sheer energy • Someone who never follows the pack and is always out in front • Unconventional and often inspiring • A communicator who can carry off eccentricity with panache.

### Suggestions for reversals

The charisma drains away from someone • A formerly energetic person who has become more conservative and cautious later in life • Someone so attention-seeking that at times it's unbearable • Communication and rhetoric that doesn't work or backfires • Someone too fond of the sound of their own voice.

The King of Wands is the most active and energetic of the tarot Kings. He can be inspiring, especially when he's leading projects and new endeavours. But he also tends to take charge of everything and everyone, sometimes to the point of being overpowering. He loves attention and adventure and gets bored easily, so he's usually at the centre of events and adores the drama and excitement that goes along with that.

Our King of Wands is shown in a relatively quiet moment, enjoying a musical performance. He's surrounded by others, showing his highly social nature, and is richly and rather showily dressed, his robe and boots covered in lavish embroidery and his cap in pearls.

This King is highly creative and may well indicate someone successfully involved in the Arts, usually in an entrepreneurial and organisational way. Typically, he is rather a showman and a natural performer; having an appreciative audience, and a "following", is important to him. He's proud, and can be vain, although this isn't usually indicated to a problematic degree unless the card is reversed. All in all, this card stands for someone of great charisma and strong character. He's fun, inspiring and will often surprise you with his innovative ways of doing things. But don't try to share his limelight or his leadership; this King will always insist on being the one in control and at centre stage.

## Sources

The king is taken from an engraving of a painting by Russian artist Georgiy Sedov (we have no dates for this artist) titled "Tsar Ivan the Terrible at the Deathbed of his Wife Vasilisa". We've also used this painting for the Four of Swords.

Mr. Barnum once said: "The show business has all phases and grades of dignity, from the exhibition of a monkey to the exposition of that highest art in music or the drama which entrances empires and secures for the gifted artist a worldwide fame which princes well might envy. Men, women and children, who cannot live on gravity alone, need something to satisfy their gayer, lighter moods and hours, and he who ministers to this want is in a business established by the Author of our nature. If he worthily fulfils his mission, and amuses without corrupting, he need never feel that he has lived in vain."

Joel Benton, *A Unique Story of a Marvellous Career Life of Hon. Phineas T. Barnum.*

# PAGE OF CUPS

PAGE OF CUPS

## Keywords and phrases

Intuition and compassionate emotions
• Artistic creativity • A connection with
fantasy and gentle magic • Opportunities that
require imagination and sensitivity • Love,
faithfulness and the happiness these bring.

## Suggestions for reversals

Lost in fantasy, albeit in a gentle and harmless
way • Creativity that has much potential but
fails to make anything real • A selfish love—
wanting someone all to yourself in a childish
way • Becoming too vulnerable, letting yourself
be a victim in an emotional relationship
• Needing constant love and reassurance.

The Cups' Page is the most sensitive, compassionate, emotional and artistic of
the four tarot Pages—sometimes in fact he (or she) is too vulnerable to his
feelings, and takes things a little too much to heart. This card is about the
enthusiasm, imagination and sheer happiness that can come at the learning
stage of a new creative endeavour. Sometimes the process really is better than
the product, and for the Page of Cups, starting, desiring and dreaming about
possibilities is what he loves far more than the slog of day-to-day work. Having
said this, while this Page is a bit of a dreamer and even a fantasist at times, he
can also work hard when he is working cooperatively with others. He's usually
best in a setting in which he can supply the hopes, aspirations and vision for a
project, and others can do the organisation and production.

*The Victorian Romantic Tarot* Page of Cups looks like a page in a pageant, or a
play. She—for surely this is a girl in boy's clothes—turns briefly away from the
harpsichord player to smile out at us as though to an audience—or is she
inviting us to join in? There is an aristocratic, refined, but slightly fragile
beauty about this image that's typically Pre-Raphaelite, and that also sums up
the Page of Cups' characteristics—and his/her appeal. This card also seems to
me to make a vivid and touching link to the drawings of Pamela Colman Smith
in the RWS deck. The RWS Pages are also drawn as though upon a stage, and
seem equally theatrical, androgynous—and irresistible.

When you, or someone in your life, is in a Page of Cups mode expect people

to notice you—but also to be flirted with, patronised, told to "grow up" and generally treated as a pretty, but silly, dreamer. Yet also expect to be regarded, in some contexts, as an artistic prodigy, the carrier of the idea that seeds a project, or the creative visionary who isn't afraid to be laughed at. This Page is touching and likeable, and tends, without trying, to motivate people into feeling protective towards him. This means that naive as he can be, he rarely gets into any serious trouble.

## Sources

Adapted from an engraving based on a painting by Italian artist Cesare Saccaggi, (1868-1934), titled "Devotion". This romantic Italian artist painted delightfully quixotic portrait, genre and landscape scenes in gentle pastels and water-colours.

He was born at Tortone in Italy in 1868 and was a student of the Royal Albertine Academy. Remaining in Paris following his studies, Saccaggi featured in the Salon des Artistes Français and was awarded a bronze medal in 1900 at the Exposition Universelle. He won a medal of the Third Class in 1903 and exhibited between 1895 and 1927.

The principal collection of paintings by this artist is kept by the Municipal Museum of Turin.

# KNIGHT OF CUPS

## Keywords and phrases

A sensitive and slightly other-worldly person
• Dreamy, "arty" type • Plunging enthusiastically into projects that appeal on an emotional level • Someone good at imagination and beginnings, not so good at completing anything • A belief in love, beauty and the Arts • A dreamer with great ideas that may, however, not come to much.

## Suggestions for reversals

The dreamer finally wakes up and gets something practical done! • Realising that emotions and feelings have to be combined with some action • Letting all your imagination go to waste—you just can't "get it together".

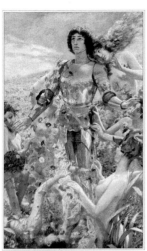

KNIGHT OF CUPS

The true romantic of the tarot, the Knight of Cups, like all the Cups Courts, is creative, imaginative, sensitive and emotional. However, while he combines this with the drive and energy of the tarot Knights he does have a flaw; he is terribly dreamy and impractical. When this card symbolises an actual person (as the Courts often, though not inevitably, do) he is likely to be very appealing, the kind of person with whom one could easily form a romantic attachment—but do remember that he may not be very reliable. It isn't that he'd be callous, quite the contrary, but he may simply never come down to earth for long enough to develop much of a home life or career—he's much more likely to be off chasing down rainbows or questing for some mythic, magic or artistic object of desire.

The Knight of Cups is, nowadays, often associated with the Quest for the Holy Grail. This is a relatively recent correlation for this Court card, although the suit of Cups has for a much longer time been linked to the Grail, and many decks from the last decades of the twentieth century show some reference to the Grail in several of the Cups cards. Our choice for the Knight is a most wonderfully lush and extravagant portrait of Parsifal, one of the pure "Grail Knights" of the Arthurian legend (the other is Galahad). In this scene the young Parsifal encounters the Flower Maidens who try, unsuccessfully, to seduce him and divert him from his quest. There is something phantasmagorical about this scene, with its knight in armour so shining that it literally reflects fields of

flowers. It's an extraordinary picture, at once fanciful and—in it's own right—seductive.

When you draw this card, the first question is, just who is this Knight? Is it you, or one aspect of your own character, or does it symbolise someone you know? If the latter, then are you one of the Flower Maidens, hanging on to the Knight with no hope of ever really being noticed? Or are you just an observer, admiring the Grail-quester but with no illusions about his lack of realism? If you are involved with this Knight, by all means enjoy his romanticism, creativity and idealism, but do remember that he's unlikely to achieve anything very practical. He's a lovely person with whom to share your dreams, but don't expect too much common sense from him.

## Sources

The card is based on an engraving taken from a painting by Georges Antoine Rochegrosse (1859-1938) originally titled "Parsifal, The Knight of the Flowers". The painting was completed in 1894 and is now on show in the Musee d'Orsay in Paris. Rochegrosse is also known for a splendidly decadent portrait of Sarah Bernhardt.

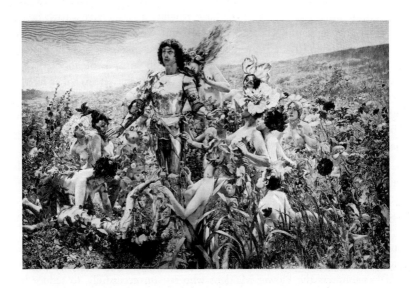

# QUEEN OF CUPS

## Keywords and phrases

Sensibility matched with common sense
• Productive creativity • Intelligence combined
with warmth and sensitivity • A harmonious
ability to combine artistry with real-world
success • A love of beauty and the Arts
• A good humoured person who inspires and
lights up your life.

## Suggestions for reversals

Over-sensitivity, perhaps neurosis and anxiety
• Someone too quick to give their love and
affection—to their own detriment • Delicacy
to the point of fragility, this person may be
quite vulnerable • Friendly, creative personality, who is nevertheless quite silly and shallow.

The Queen of Cups is perhaps the most balanced, loving and immediately appealing of all the tarot Courts. Here she is seen sitting enthroned surrounded by symbols of love, creativity and emotion—flowers, a sleeping cherub and a musical instrument (there is also a sleeping eagle, who appears to have passed out while reading—we will come back to him). Although it's a dreamy scene, this Queen is able to combine emotionality with practicality and good sense, and the book at her feet reminds us that she is clever as well as sensitive.

In the traditional Rider Waite Smith card, the Queen of Cups sits on a a large throne—much as she does here. However, what's unusual about our image is that it specifically associates this Queen with the idea of hope and expectation. If you look again at the objects and figures around her, you'll see that they can be interpreted as sleeping love, sleeping intellect (that eagle) and silenced creativity—the abandoned musical instrument. In other words, there is potential at hand, but none of it is currently active. It isn't destroyed or damaged though, it's merely sleeping and refreshing itself. The silent figures do not seem to bother the Queen, who gazes far into the sky serenely. She is assured that all will be fulfilled in good time, and so she can calmly wait for her companions to awaken again. She knows that love, intellect and creativity will always be hers to command when the situation calls for them.

It's usual, in tarot, to see the Queen of Cups as being similar to The Empress,

although she's less an archetype of Mother Nature, and more an everyday manifestation of all things natural, warm and well balanced emotionally. However, our choice of image for this card also links it to subtly to The Star, the traditional symbol of hope and optimism in the tarot.

When the Queen of Cups appears in a reading she brings the promise of a glorious combination of perception, creativity and empathy, all working together to make things happen. You can feel justifiably optimistic when she is acting as an influence in your life. This Queen has warm affection, emotional intelligence and enough practicality to open up many possibilities for growth and development. Does she have any down side? Well, she can be rather too emotional at times and a little overwhelming—the cherub is, after all, quite exhausted by the sheer amount of love that can circulate around this Queen. When the card is reversed it can indicate someone who is rather attention-seeking, insecure and neurotic, although still warm and caring— in recent years the reversal has sometimes been characterised as the "Princess Diana" card. Usually, however, this is one of the most entirely positive of the Courts.

### Sources

Based on an engraving of a painting by French artist Gabriel Ferrier (1847-?) The original painting was charmingly titled "Hope Always Wins". Ferrer worked as a portraitist, painter, and decorative artist. In 1872 he won the prestigious Grand Prix de Rome, and later taught at the Ecole des Beaux-Arts. He is now probably best known, curiously enough, for his excellent and distinctive version of the Mona Lisa, which is owned by the Louvre, which keeps a collection of various artists' reproductions of the painting.

KING OF CUPS

# KING OF CUPS

### Keywords and phrases

Creativity and imagination that is held back by a sense of duty • Repressing desire in favour of responsibilities • Balancing sense and sensibility, though at times it's hard • Occasional outbursts of anger—a result of emotional repression.

### Suggestions for reversals

Becoming resentful and bad-tempered because your personal sacrifice is not appreciated • Breaking out of your self-control and doing what you really want—for good or bad • Feeling sorry for yourself—nobody understands what you've given up • Turning to drugs and alcohol because you feel repressed.

The King of Cups is a recognisable figure to most of us nowadays—and would certainly have been a very familiar "pater familias" ("father of the family") in Victorian times. He is the mature person, usually a man, who has given up his earlier dreams of creativity and, most likely, his hopes of becoming an artist, musician or writer, in order to fulfil responsibilities to those around him, usually his immediate family. He could be the politician who really wanted to be a painter, the business executive who once busked on the street, the accountant who planned, as a boy, to become an actor. His self-sacrifice and attention to duty is his own decision, but nevertheless, at times he feel repressed and constricted, and longs to break out and chase even a few of his former dreams.

Our image shows an elderly king seated at his table telling a story to an attentive audience. He waves his hand in the air, emphasising his descriptions, and the people around him laugh and smile, entranced. The only person who looks serious is the king himself. We can guess that he's a good raconteur and story-teller, but we may also wonder how much he really enjoys the role. Perhaps he'd rather be doing something that he'd find more creative, rather than adapting his talents to amusing his companions? But as ever with this tarot King, he's ruled by duty. He may long one day to break out, throw off all his responsibilities and become a wild Bohemian artist, but the truth is that he's unlikely ever to do so, and perhaps this is just as well. However, being con-

vivial and social, and having plenty of opportunities to eat, drink and amuse those around him isn't such a bad life. While we may occasionally feel sorry for the way that the King of Cups has had to restrict his ambitions, on the whole he's found a good balance between duty and desire.

## Sources

The original picture on which we based this card is an illustration for a Grimms' fairytale called, "The Giant's Toy". It's based on an engraving by German artist, H Knopf (we have no dates for this artist).

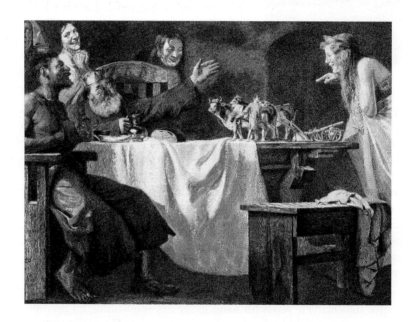

PAGE OF SWORDS

# PAGE OF SWORDS

### Keywords and phrases

Faithfulness • Staying on the alert • Wary and watchful • Guarding someone or something that matters to you • Fairness, and a passion for justice • Using your wits and your keen sight.

### Suggestions for reversals

You are so much on the alert that it's close to paranoia • Betraying someone, or being betrayed, and feeling awful about it • Laying down your guard • Leaping in to defend someone who may not be worthy of defence • Your rationale lets you down and you throw your passion into the wrong fight.

All the Pages in tarot point to an inexperienced but enthusiastic approach. In the Swords suit this is applied to both intellect and conflict; this Page is intelligent, sharp-witted and ready to spring into action to defend what he (or she) believes in. But he doesn't always have the judgement to know when a battle is really worth fighting. He tends to be a little fanatical about the causes he takes up, and will respond—sometimes spitefully—to any perceived slur or criticism.

The Page of Swords is brave, cunning, clever and active, all useful qualities when they're applied in the right circumstances. He can be a powerful and faithful advocate for a movement or enterprise, especially when it's one based on intellectual or philosophical convictions. He can also be a passionate student, capable of hard work and creative thinking. But he finds it hard to relax and to compromise, and will cause quarrels—often intellectual ones—that could have been avoided.

When this card appears in a spread it may tell you to be on your guard, or that there is someone in your life who is on your side or taking up your cause, ready to defend you. It indicates courage, loyalty and good faith. The Page of Swords is a good friend but sometimes, like all the tarot Pages, naive and inexperienced. It's always worth asking yourself if it's really worth springing into action in the current situation or if the Page is perhaps being unnecessarily defensive. Not every controversy needs to become a conflict and not every difference of opinion should be treated as an argument.

## Sources

This is a very composite card that we put together from a number of different images. The face of the Page is based on a small section of an engraving that shows Saint Joan being questioned by her judges. The original painting is by Fred Roe (London, 1864—1947) who was an English genre painter and illustrator. He exhibited at the prestigious Royal Academy in 1877 and was elected to the Royal Institute of British Painters in 1909. Roe was known for painting large historical compositions.

KNIGHT OF SWORDS

# KNIGHT OF SWORDS

## Keywords and phrases

Defending your beliefs with courage • Exerting your own opinion and wishes beyond all • Vigorous action—with a tendency to exert force • Sharp intellect combined with ruthless self-confidence • Imposing your own judgement—whatever the consequences • "Might is right" • Sharp logic should always win the day.

## Suggestions for reversals

Softening a little and listening to others • Unsuccessful leadership, battles are lost • Wondering if you really are on the right side • Using violence to enforce your will, even though you know you're in the wrong.

All the Knights in *The Victorian Romantic Tarot* are seen in the company of women, but it's only in this card that the scene between Knight and lady is disturbing, even shocking. The Knight has clearly rescued the woman—who is in fact not mortal woman at all, but an ethereal fairy—but now he seems much more intent on the thrill of the fight than on actually caring for his rescuee. Tarot scholar and writer Mary Greer has memorably described this card as signifying someone who likes to rescue "an idea in distress". It makes for a superb way of interpreting this image—the fairy slung unconscious over the horse, her butterfly wings streaming out behind her, could be seen as an abstract idea, while the battling knight is not that concerned about the idea itself, but simply loves the cut and thrust of hard argument—the battle, not the outcome, is what drives him.

The image is based on a legend about the "Dragon's Gorge" in Germany, a real place which is believed to have once been the lair of a dragon. A knight, who many have seen as a Germanic version of Saint George, is believed to have slain the beast. Historically it's likely that both legends stem from a much older Indo-European tale of a brave dragon slayer, an archetypal hero who rescues a personified concept or ideal, rather than a real person. In the case of the Swedish version of the tale, for instance, he saves a princess who is, oddly enough, not a real mortal woman but rather "the kingdom of Sweden", in female form. Conceptualising a country in the form of a person—Mother Russia, John Bull, Uncle Sam—is very familiar to us, although the notion of

personifying an abstract concept is slightly harder to grasp. But this Knight fights not for a lady but an idea or an ideal, shown in female form. The message is that it's his passion for theories and abstractions, rather than personal relationships, that drives him.

The Knight of Swords combines the intellectualism, logic and mental agility of the Swords with the devil-may-care recklessness and urge to action of the tarot Knights. The meaning of the card therefore ranges from someone who enjoys passionate and fiery debate, to a person with a complete inability ever to admit a mistake in the beliefs that he or she is championing. It's the card of the "angry young man"—the person who can't take part in calm discussion and exchange, but instead tries to win his point through a mixture of intellectual brilliance and sheer intimidation. We can well imagine this Knight beginning his counter-attack to any disagreement by screaming, "How can you be so stupid?!" to his opponent. While this kind of forcefulness can make for very effective leadership—if, that is, you want to crush everything in your path—pity anyone who is on the receiving end of it.

But while the Knight of Swords is often a challenging and conflictual influence in your life, he isn't all bad—after all, in this card he does, in his odd manner, defend the maiden fae—or the idea that she represents. When you need someone to jump into an argument with real fervour and determination to win, then this Knight is your man. He isn't sly or deceitful—he really believes in what he fights for—and he can be extremely clever, with a sharp wit that he uses to cut down any opposing opinions. But when the card appears in a reading, you need to think carefully about which side this Knight will be on—for you or against you (sadly he does tend to think in such very black and white terms). Of course if it turns out that you are yourself the person signified, then do consider whether you really need to approach every argument as though you're going to war. Sometimes, you know, it doesn't really matter who wins.

## Sources

Based on an engraving from a painting by Henri Courselles-Dumont, a French artist (1856-?) about whom we can find little information. It shows the legendary slaying of the dragon at "Dragon's Gorge" near Wartburg Castle in Germany.

# QUEEN OF SWORDS

## Keywords and phrases

Drawing wisdom from hard experience • The ability to make keen judgements—even under pressure • A sharp wit, sometimes cutting • Some harshness towards fools or anyone trying to take advantage • Surviving—even thriving—by using your wits • Maturity at an early age—you had to grow up fast.

## Suggestions for reversals

Embittered and vengeful about past experiences • Using your caustic wit to hurt or scar others • Feeling that you've been damaged by what you've been through, unable to rediscover your self-confidence • Using anger rather than logic to win an argument • Finally laying down your barriers and guard, softening and allowing emotion into your life.

QUEEN OF SWORDS

If I had to sum up the Queen of Swords in one short description, I think I'd choose, "she doesn't suffer fools gladly." This is someone who has seen and done a lot—in many cases things that she'd rather not have experienced. She's suffered, she's learned and she's survived. Now she is mature, well able to defend herself, and as sharp as a blade when it comes to spotting deceptions, threats or just plain old silliness. This makes her demanding, and often a bit alarming, to be around. She has high standards of ethics and honesty and she'll demand the same of you—so watch out, she won't think twice about telling you off with her quick tongue.

Our card shows a severe woman dressed in a way that is almost as austere as a nun's habit, although she also wears an armoured breastplate and leans on a large, heavy sword. Standing in front of an imposing landscape, she glares out from the picture with a hard, challenging expression that makes her look completely unapproachable. She in fact has rather a beautiful face when you look closely—if you can look closely that is, for her whole persona signals "don't come too near." The mountainous lands behind her are impressive but harsh. It's all a far cry from the refined, theatrical Queen of Wands in her meadow, or the gorgeous Queen of Cups and her tired pet of a cupid—this lady of Swords isn't sweet, picturesque or pretty in any way. She may be hard to warm to, but she's utterly regal, and commands respect.

It may well be hazardous to relax too much in this Queen's company, and you should never, ever take her for granted or treat her as a bird-brain. Nevertheless, she can be surprisingly witty and she has a great sense of wry humour—on her own terms. She's brittle and critical at times, yet one of her greatest qualities is that she's managed to get through a difficult life without becoming bitter and she can often find an amusing side to even the most awkward situations. Her remarks, while cutting at times, are always intelligent and fair; in fact, in many of her aspects she is a real-life personification of the archetype of Justice.

## Sources

The painting is by the French artist Alfred-Pierre Agache (1843-1915) and is titled appropriately enough for this card, "The Law". Agache exhibited frequently in Paris during his life and was a member of the Société des Artistes Français. He was awarded the Légion d'honneur. However, he has since largely been forgotten. In the context of our tarot it's interesting to note that he painting one picture called, "The Fortune-teller".

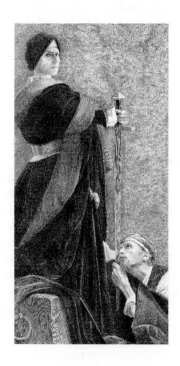

# KING OF SWORDS

## Keywords and phrases

A leader of high intelligence • A natural commander • Firm but fair • Demanding— but its worth trying to live up to the standards set • A good, but uncompromising, judge.

## Suggestions for reversals

Dictatorship or fanatical rule • Unable to take advice, convinced you are utterly correct • An unfair or biased judge • A leader who is too quick to charge into battle instead of using diplomacy • Some weakening of the intellect, possibly through old age or illness—someone who is not as in charge of their mind as usual.

KING OF SWORDS

The King of Swords indicates a mature intelligence; the combination of experience with a good, sharp mind means that this King has an excellent intellect and sense of judgement. However, he's very aware of his own mental powers and he expects to be followed without question in all his decisions. Mostly this is fine, he's a bold and courageous leader, but he may not understand situations that require an emotional or intuitive response rather than a logical one, and so at times he can seem cold or even ruthless.

The image that we've used on this card shows a rather gaunt king sitting in a pose of deep contemplation. He is surrounded by rocks and stone columns, some of which are broken—it's a harsh and forbidding landscape.

The broken column is a symbol of the death of a fellow member in Freemasonry. It originated from the early Judaic use of a column to symbolise a noble, prince or other person in authority, hence the expression, "Pillar of the Church". It became a popular emblem to show on gravestones in the Victorian era. In this card it indicates loss; the King of Swords, like the Queen, has gained some of his wisdom by living through some harsh experiences. Unlike the Queen however, the King is less likely to have developed a sharp wit as a result; on the contrary, he may be inclined to show bitterness and anger when provoked by any disagreement.

Like many strong leaders, this King is admirably decisive, brave and single-minded in times of trouble, but may turn into a tyrant when he wants to

impose his will. It's usually best to treat him with respect—and a considerable degree of caution.

## Sources

This is adapted from an engraving of a painting by Evelyn De Morgan, (1855-1919) titled "Valley of the Shadows". De Morgan was a remarkable artist and activist. She was involved, with her husband William De Morgan, with the suffragette movement (William was Vice President of the "Men's League for Women's Suffrage" in 1913), prison reform, pacifism and spiritualism.

One famous quote from Evelyn De Morgan is the declaration she wrote in her diary on the morning of her seventeenth birthday, "Art is eternal, but life is short...I will make up for it now, I have not a moment to lose."

> We passed on our way through the winding avenues, presenting their striking and varied emblems, speaking so forcibly to the mind. The white dove with open beak and half spread wing; the harp with the broken string, and the broken column, are all beautiful and significant representations, preaching loudly for the silent dust that slumbers beneath them.

> Abigail Stanley Hanna, *Withered Leaves from Memory's Garland.*

# PAGE OF PENTACLES

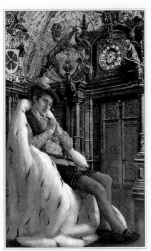

PAGE OF PENTACLES

## Keywords and phrases

Practical and sensible • Quick to learn, but rather overly thorough about facts and figures • Building on an opportunity to acquire wealth • Making things happen—in a practical way • Sticking by a decision • Taking life very seriously—acting a little old for your age.

## Suggestions for reversals

Uncharacteristically rushing your research or planning • Unreliability, perhaps letting someone down • A youth who takes himself too seriously—others may find him dull • Losing an opportunity for material success because you are too cautious • Losing interest in money and practical matters and instead looking for something more exciting or experimental.

The Page of Pentacles is the most studious and serious of the Pages. Of the four, he's also the one most interested in material things—not just possessions and money, but also machines, inventions, and all things made by skill and artifice. He isn't as sharply intellectual as the Page of Swords, but he works hard at his studies and he's solid and sensible.

We show him seated, thoughtful and serious. He looks somewhat slumped in his chair; maybe held down by the sheer magnificence and volume of his rich robes—and especially by his excessively large cloak in royal ermine. He looks rather old before his time; has he become too cautious and careful before he really needs to? Certainly, it's hard to imagine him throwing off that cloak and having fun like the Page of Cups or the showy little Page of Wands. In a modern day view, this would be the type of young man or woman who is already planning their whole future career—pension plan included. Their light relief will be something rather serious that requires skill and patience; we can imagine him or her building models, learning an instrument (which this Page will do by the book—no jazz improvisation or wild flights of musical fancy), or taking up a well-researched interest in organic gardening.

Everything in this young person's life will be done properly and she or he may also have already begun to build a business, which you may be sure will have a sound financial and development plan. The clock in the background reminds

us just how important planning and scheduling is to them.

However, looking at this picture it's hard not to wish that this Page would sometimes "act their age" and be a little more carefree and irresponsible. There's plenty of time for dogged duty later in life—surely in our youth we need to play as well as work?

**Sources**

From an engraving taken from a picture by J. Bettie (we have no dates for this artist). In the original, the Page is actually a depiction of King Edward VI of England.

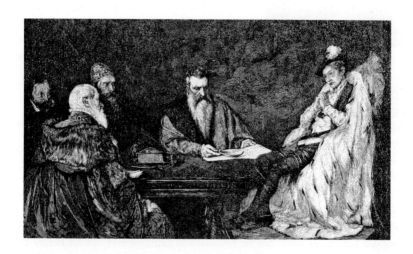

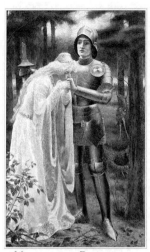

# KNIGHT OF PENTACLES

### Keywords and phrases

Routine and predictable cycles • Following rules and method • Trustworthiness • An earthy and earnest practicality • Doing the "right thing" but not getting much joy from it.

### Suggestions for reversals

Breaking out of the routine • Throwing caution to the winds and throwing yourself into the thick of the action • Becoming so rule-obsessed that you cease to be able to do anything • Having a laugh and forgetting duty for a while • An eager but inefficient crafts-man • Becoming sluggish and overweight.

KNIGHT OF PENTACLES

So you get the job done, you journey to a far country, defeat the monstrous enchanter, rescue the fair maiden, win her undying affection and you feel... bored and somewhat depressed? This is our Knight of Pentacles, practical, skilled, reliable, but not someone who gets a whole lot of joy from his achievements.

The Knight of Pentacles combines the drive and action of the tarot Knights with the practicality and ability to stick to the job that's so typical of the Pentacles suit. The only problem is that unlike the other Knights, he doesn't really get much pleasure from his abilities. He feels stuck and even bored, he focuses too much on detail and process to appreciate a larger view of his accomplishments, he wishes he could sometimes be just a little irresponsible and less driven by duty.

The knight in the picture we have chosen for this card is not from the Arthu-rian cycle that was so much loved by the Victorians; "he" is in fact not a man at all, but the brave female knight Britomart, described in the much older epic poem, the sixteenth century *Faerie Queene* by Edmund Spenser. At the moment depicted in our card, she has just rescued the fair Princess Armoret from an evil enchanter in the form of a monster. She is now about to inform the maiden that she is in fact a woman in knight's clothing, and therefore cannot marry her; an awkward situation, but potentially rather a funny one too. The broken lance that Britomart carries may be a rather sly reference to her lack of manhood—certainly it implies that she has now spent her energy and is exhausted.

While the whole story may be far too dashing to symbolise the Knight of Pentacles, this particular moment—with Britomart having done her duty, but far from happy—is a good visual image for this Court. This Knight will always work hard and do his (or her) best, but often finds the sheer dutifulness of their life slightly depressing. He can be very successful because he's so hard-working and patient when it comes to achieving anything practical, but his problem is that he often can't find happiness in his abilities, and instead may simply say dolefully, "I tried my best." He's the most reliable of all the tarot Knights by far, but he needs to balance this with some fun. When we look at the image on this card we see someone who is in fact in a very amusing situation; wouldn't it be nice if instead of taking it all so seriously, our Knight shared a laugh with the Princess about his/her farcical mistaken identity?

Sources

This remarkable picture is by English artist Mary Raphael, and was originally titled "Britomart and Amoret". It's one of the better-known pictures in our deck, and nowadays you can find it in reproduction and various forms—there's even a version done as a beadwork pattern.

The story, as previously mentioned, is taken from Edmund Spenser's *The Faerie Queene*. Although this Elizabethan poem was rewritten in late Victorian England to make it accessible to a wider readership, it never had the same success in the nineteenth century as Tennyson's Arthurian saga.

In the original story, Britomart is a brilliant fighter, brave and skilled. In fact, early in the tale she easily wins a large tournament:

> Many others likewise ran at the Knight, but in like manner they were all dismounted; and of a truth it was no wonder. No power of man could stay the force of that enchanted spear, for the stranger was no other than the famous Britomart.

> Thus the warrior Princess restored that day to the Knights of Maidenhood the prize which was well-nigh lost, and bore away the prize of prowess from them all.

> Mary Macleod, *Stories from the Faerie Queene* [1916]

# QUEEN OF PENTACLES

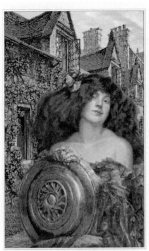

QUEEN OF PENTACLES

## Keywords and phrases

Skilful and industrious • Able to provide for yourself • Good sense combined with intelligence • Kind and caring, especially with children • Natural and at ease with earthy things • Manually or practically very skilled—perhaps in the crafts or the practical arts.

## Suggestions for reversals

Domestic matters are disorganised and badly managed • "Butter-fingers" someone who is clumsy—though they try hard to master a craft skill • Impatience with children, animals or any other being who requires care • Inclined to be lazy and slipshod • A lack of sound common sense, inclined to silliness.

As a Pentacles' Queen, this card stands for a woman who is down to earth, practical and, on occasions, inclined to be materialistic. Like all the Queens of the tarot, she tends to be well-balanced, so even when she focuses a little too much on material comforts, she also has empathy and concern for people, and an ability to appreciate beauty in simple, natural things.

She's a comforting person to be around, because her home always seems to be full of children, pets, flowers and the smell of good home-cooking. She likes company too and so tends to be surrounded by people of all ages.

The image on this card shows a sensual young woman holding a large golden disc in her lap. She looks content, even perhaps a little smug, and very confident in herself. She's the most relaxed of all our Queens, her hair and dress quite informal, although both give the impression of being rich and luxuriant. Behind her, you can see a street of quirky old houses—the Queen of Pentacles is the most domestic of the tarot Queens and while she's likely to be someone comfortably off, her home life is cosy and comfortable rather than grand or palatial.

This image emphasises the prosperous and well-to-do aspect of this Queen, but in a reading, remember that she may also stand for someone who is highly skilled in practical matters. She might be an excellent gardener, craftsperson, mechanic or cook, and while she may not be as creative as the Queen of Cups,

she's particularly good at making her ideas into reality. She also likes to share what she produces, and can be both generous and nurturing. When she comes into your life she's likely to make you feel more secure, well cared-for and comfortable in all material ways.

## Sources

This is based on an engraving of a painting by Italian artist Juana Romani (1869-1924) titled "Salomé". The painting is now in the Museum of Mulhouse. Romani studied in France. Ferdinand Roybet was her tutor (he showed his own portrait of her at the Salon des Champs-Elysees in 1892) and she exhibited and won art medals in Paris. This picture is very similar to several self-portraits which Romani painted, so it is probably based on her own image.

# King of Pentacles

King of Pentacles

## Keywords and phrases

A consummate business person • Grounded, responsible "Head of the family" • Knowing what is both correct and sensible • Very sensible, but a little boring • Seeing things from an accountant's stance, looking at the figures • Good with money, but not obsessed with it.

## Suggestions for reversals

Someone who believes themselves to be a great business-person, but in fact lacks these skills • Refusal to take on responsibilities • Becoming obsessed with money and status • Feeling that you've reached a mature age but all you have is a dull, respectable, unchallenging life • Giving in to corruption to accumulate wealth—losing your ethics.

The King of Pentacles isn't the most exciting of the tarot Kings, but he's certainly the most reliable. Solid, sensible, good with all things practical, including finance, he may well be the head of a company, or, even more likely, the CFO (Chief Financial Officer). If he has interests outside work they will be mostly of a very practical nature. He's the kind of businessman who may enjoy gardening, some manual skill, which to others may seem dull, such as clock restoration, or perhaps he likes to do a bit of home renovation. He isn't particularly imaginative or artistic, but anything he makes, he makes well.

In our card, the King sits firmly seated on a massive, strong but, one suspects, rather plodding horse. He himself seems lost in earnest thought, and doesn't heed his attentive servant, or the rich lands around him. He certainly doesn't look as though he's about to go galloping off anywhere, but, solid and utterly serious about his responsibilities, he gives the impression that he will always get where he's going.

If a reading indicates the King of Pentacles in your life, then you can expect an influence that is grounded, sensible, hard-headed in business and practical terms—and perhaps just a touch dull. There are times when this is just what's needed; at the moment when a business is mature and needs firm guidance rather than inspirational ideas, or perhaps when you need to manage resources and skills with care, without attempting to take risks or be too innovative.

There is something immensely reassuring about the King of Pentacles; slowly, steadily and thoroughly, he applies his tremendous ability to all practical matters. You can rely on him utterly, particularly if he sees you as his personal responsibility—just don't expect him to set your heart racing or to bring thrills, or spills, into your life.

## Sources

Based on an engraving of a painting by German artist Christian Speyer, (1855-1929) Stuttgart titled "The Three Magi". Speyer was a particularly fine painter of horses, as this picture shows. In the original painting, our King was one of the Magi, travelling to see the baby Jesus, although the setting looks entirely European.

> The inordinate love of money, no doubt, may be and is "the root of all evil," but money itself, when properly used, is not only a "handy thing to have in the house," but affords the gratification of blessing our race by enabling its possessor to enlarge the scope of human happiness and human influence. The desire for wealth is nearly universal, and none can say it is not laudable, provided the possessor of it accepts its responsibilities, and uses it as a friend to humanity.
>
> P. T. Barnum, *The Art of Money Getting.*

# BIBLIOGRAPHY

**Jerrold E Hagle.** *The Cambridge Companion to Gothic Fiction.* Cambridge: Cambridge University Press, 2002.

**Greer, Mary K.** *The Complete Book of Tarot Reversals.* Minnesota: Llewellyn, 2003.

**Jenkyns, Richard.** *Dignity and Decadence,* London: Harper Collins, 1991.

**Mahony, Karen.** *The Tarot of Prague Companion Book.* Prague: Magic Realist Press, 2003.

**Mahony, Karen.** *The Fairytale Tarot Companion Book.* Prague: Magic Realist Press, 2005.

**O'Neill, Robert V..** *Tarot Symbolism.* Melbourne: Association for Tarot Studies, 2004.

**Place, Robert.** *The Tarot: History, Symbolism, and Divination.* New York: Jeremy P. Tarcher 2005.

**Pollack, Rachel.** *Seventy Eight Degrees of Wisdom.* London: Thorsons, 1997.

**Pollack, Rachel.** *The Forest of Souls.* Minnesota: Llewellyn, 2003.

**Waite, Edward Arthur.** *The Pictorial Key to the Tarot..* York Beach, Maine: Samuel Weiser Inc 2000.

**Waite, Edward Arthur.** *Alchemists Through the Ages.* New York: Rudolph Steiner Publications 1970.

The following websites are also valuable resources:

http://www.victorianromantic.com—the official website of the deck.

http://www.aeclectic.net—Aeclectic Tarot, many reviews of decks and other information about reading, creating and using tarot.

http://www.tarotforum.net—the Aeclectic Tarot forum, the largest international tarot forum.

http://www.learntarot.com—Joan Bunning's useful site is great for beginners.

# THE VICTORIAN FLOWER ORACLE

## The Wit and Wisdom of JJ Grandville's 'Flowers Personified'

By Karen Mahony and Alex Ukolov

ISBN: 1-905572-00-X
Includes 40 Full-Color Cards and engaging Companion Book.

Magic Realist Press

Also available as a deck with booklet
ISBN: 1-905572-01-8

A gorgeous, evocative deck of forty oracle cards. Based on illustrations by famed Victorian artist JJ Grandville, taken from an original 1847 hand-colored copy of his *Fleurs Animee* (Flowers Personified). Designed by the creators of *The Tarot of Prague* and *The Fantastic Menagerie Tarot*.

This beautiful deck draws on age-old beliefs about the special magic and symbolism of flowers. Every flower is exquisitely depicted as a woman, and each card is a small work of art. It will appeal to everyone who loves flowers, gardens and Victoriana, and at the same times it's also an extraordinarily beautiful and insightful oracle deck that will give readings of magical charm and down-to-earth insight.

**Complete with a Companion Book that includes:**

- the symbolic meaning of each flower
- the story of the Victorian craze for 'The Language of Flowers'
- the history of the Grandville illustrations
- instructions for using the deck as a gentle, insightful oracle.